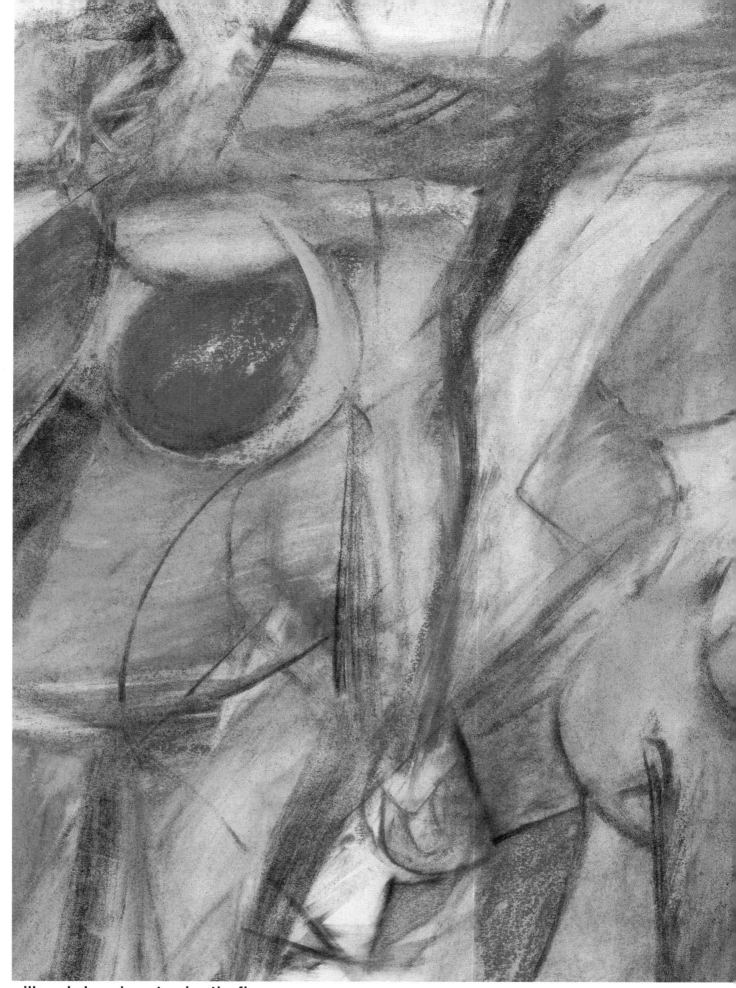

willem de kooning tracing the figure

willem de kooning

organized by cornelia h. butler and paul schimmel the museum of contemporary art, los angeles

princeton university press, princeton and oxford

tracing the figure

essays by cornelia h. butler, paul schimmel, richard shiff, and anne m. wagner

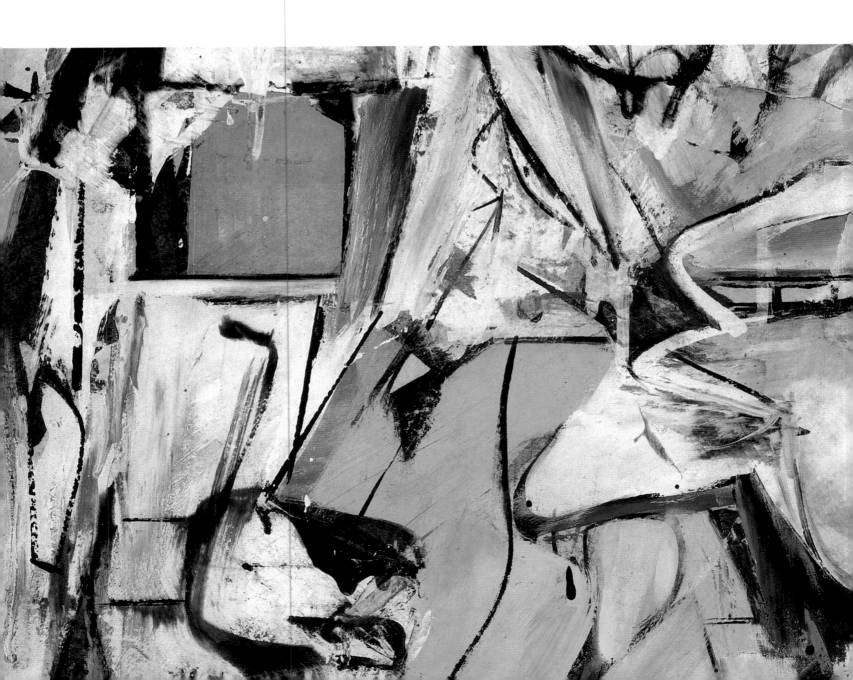

plates 8

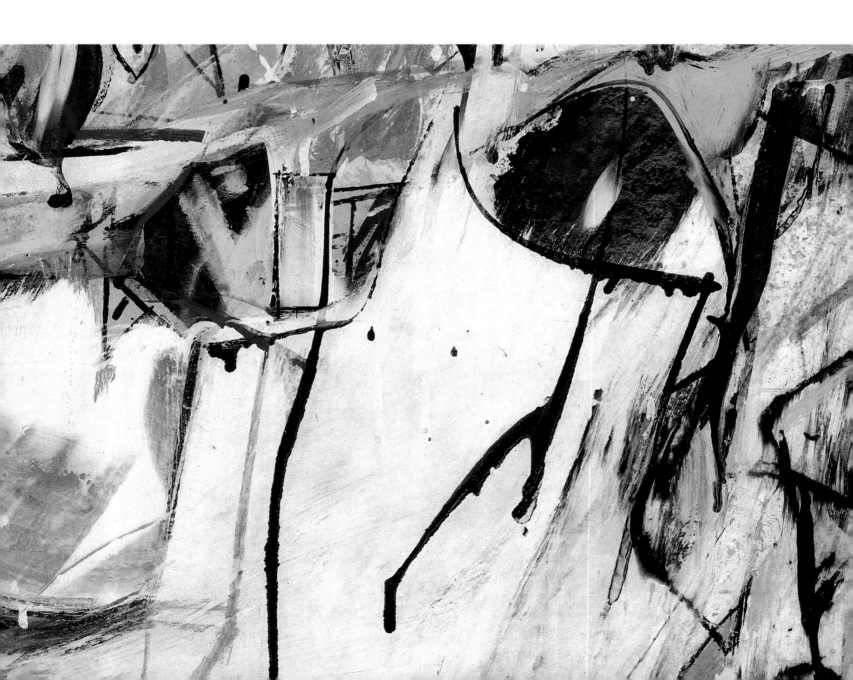

director's foreword

In 1996 an extraordinary collection of eighty-three contemporary works on paper came to The Museum of Contemporary Art, Los Angeles, from the Estate of Marcia Simon Weisman. The bequest reflected the extent of Weisman's collecting interests, ranging from Abstract Expressionism and Pop Art to contemporary work by the many Californian artists she had befriended. By making this bequest, Weisman assured that MOCA—a museum she had helped found and worked tirelessly to foster—would make drawings a significant part of its program. MOCA's commitment to drawings is evident in its exhibitions and collections, as well as in the Marcia Simon Weisman Works on Paper Study Center, a facility dedicated to supporting the research and conservation of contemporary works on paper.

Among the many masterworks in the Marcia Simon Weisman bequest, Willem de Kooning's *Two Women with Still Life* (1952) stands out as one of the greatest. Composed of vivid shards of form and color, executed in both pastel and charcoal, *Two Women with Still Life* reminds us of the crucial place of drawing in de Kooning's oeuvre. A celebrated painter, de Kooning not only used drawing to develop and elaborate his ideas, he frequently blurred the distinction between drawing and painting by applying the techniques and materials of one medium to the other. *Two Women with Still Life* also reminds us that, for many of his most significant works, de Kooning took the female form as his central subject. It is this signal masterpiece that inspired the current exhibition "Willem de Kooning: Tracing the Figure."

Throughout MOCA's history a number of important exhibitions have been stimulated by works in the permanent collection. "Tracing the Figure" suggests once again the crucial role played by a distinguished collection in generating the most significant exhibitions and scholarship. "Willem de Kooning: Tracing the Figure" is co-organized by MOCA Curator Cornelia H. Butler and Chief Curator Paul Schimmel. They have brought together a number of exceptional, rarely seen works of art and have made possible a significant reassessment of a crucial aspect of de Kooning's oeuvre. Paul and Connie were ably supported in their efforts by Curatorial Assistant Rebecca Morse.

A number of sponsors have come together to support this project. I would like to thank The Sydney Irmas Exhibition Endowment, Maria Hummer and Bob Tuttle, the National Endowment for the Arts, Genevieve and Ivan Reitman, Audrey M. Irmas, Beatrice and Philip Gersh, The Mnuchin Foundation, and Betye Monell Burton for their generous contributions. My gratitude also extends to Wells Fargo for their assistance with the tour and to the Frederick R. Weisman Art Foundation for their support of this exhibition catalogue.

MOCA's Board of Trustees has been particularly supportive of and engaged by this project. I would like to thank in particular our Chair Robert Tuttle, President Gilbert B. Friesen, and Vice Chairs Clifford Einstein, Audrey M. Irmas, and Dallas P. Price for their unwavering support.

Jeremy Strick, The Museum of Contemporary Art, Los Angeles

plates

1938.1955

plate *reclining nude (juliette brauner)*, c. 1938

1

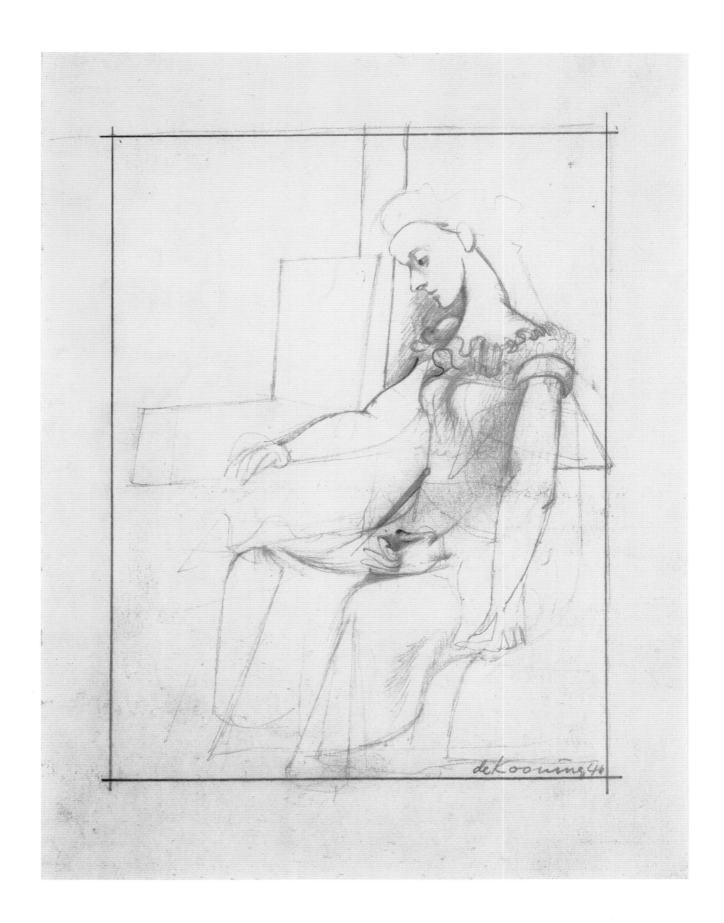

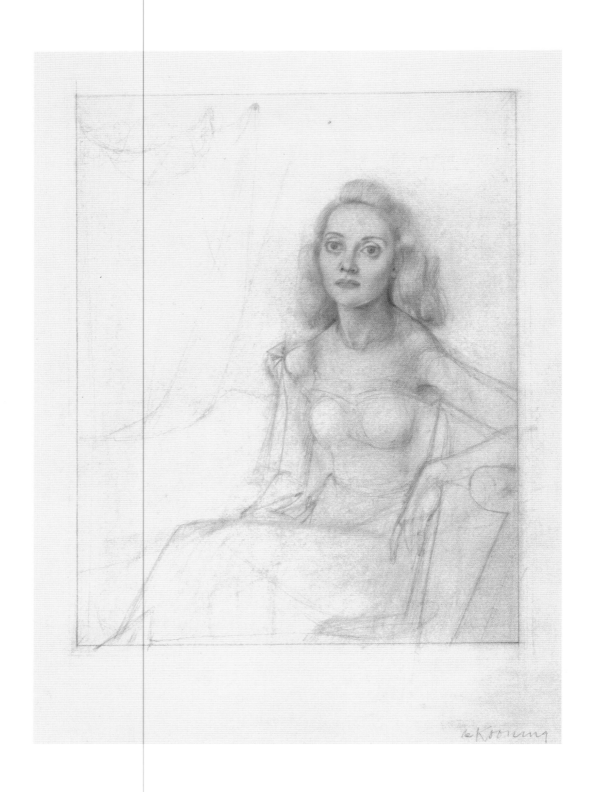

plate *portrait of a woman, c. 1940*

3

plate *elaine de kooning, c. 1940–41*

4

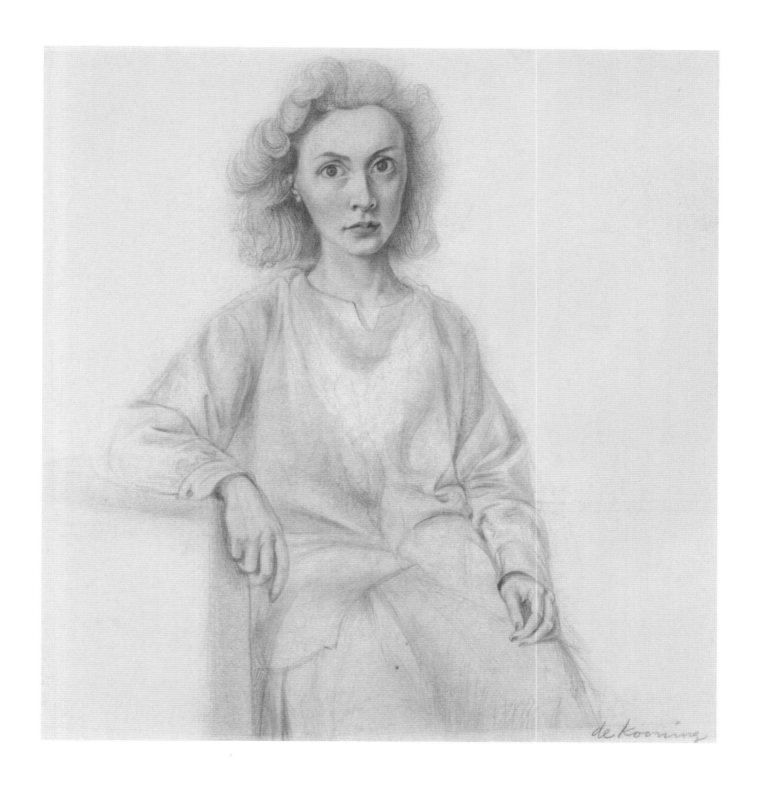

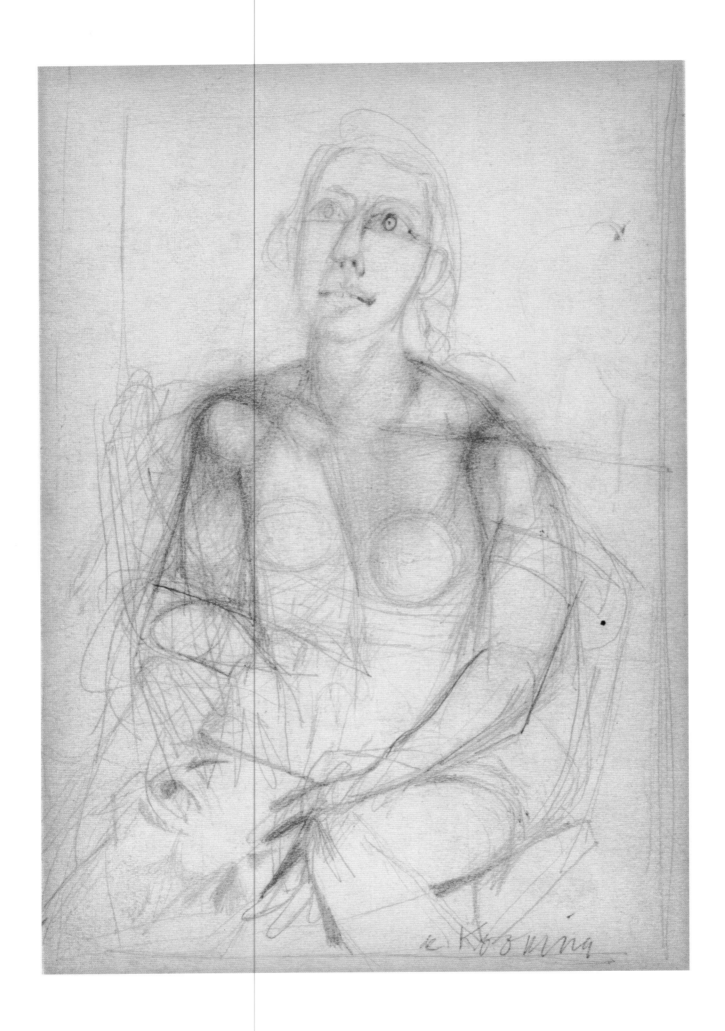

plate *woman*, 1941

5

plate *seated woman*, c. 1941

6

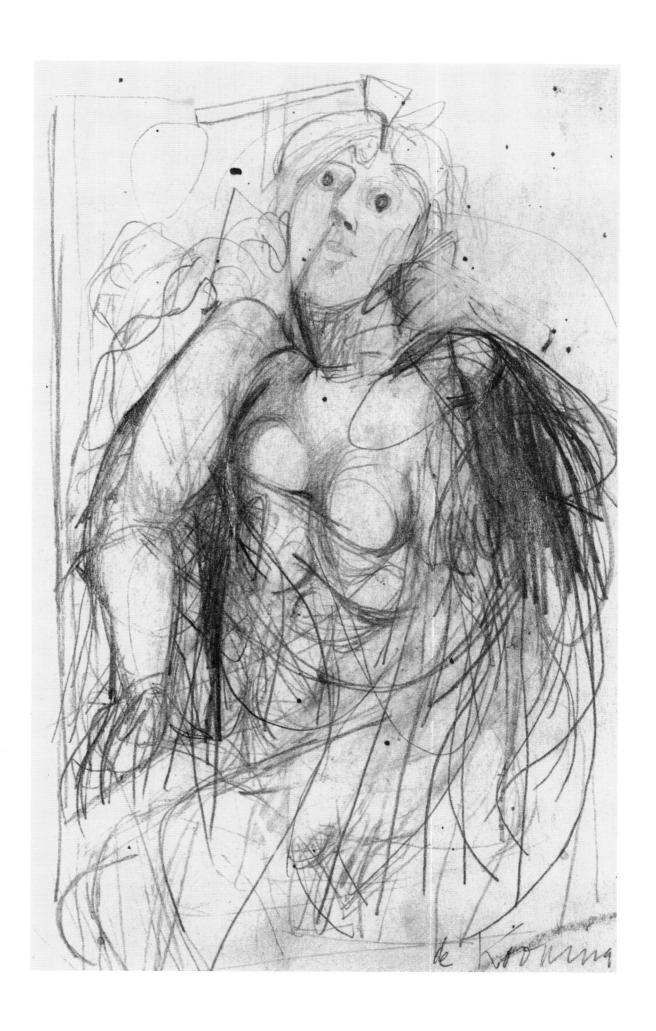

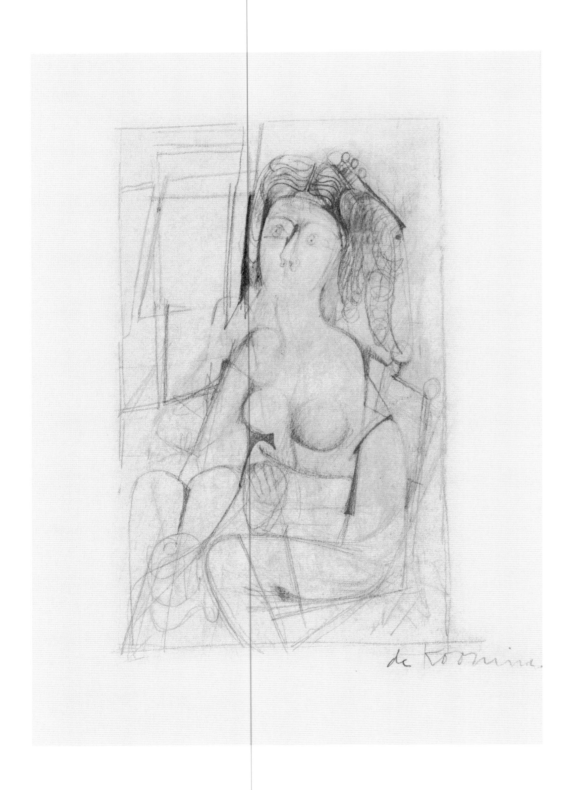

plate *seated woman*, c. 1943

7

plate *woman*, c. 1942

8

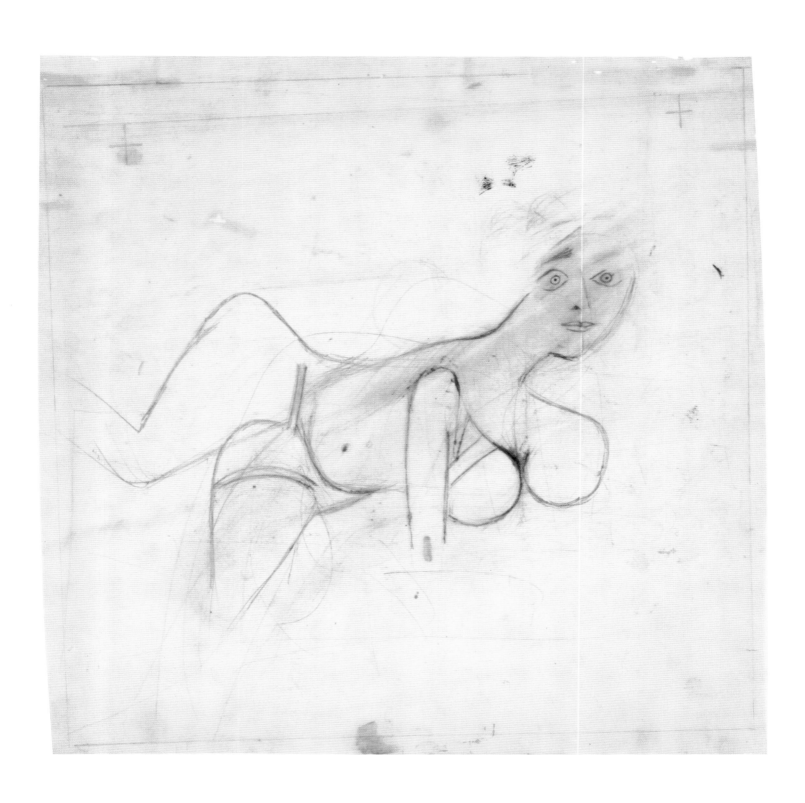

plate

9

study for "pink angels," 1945

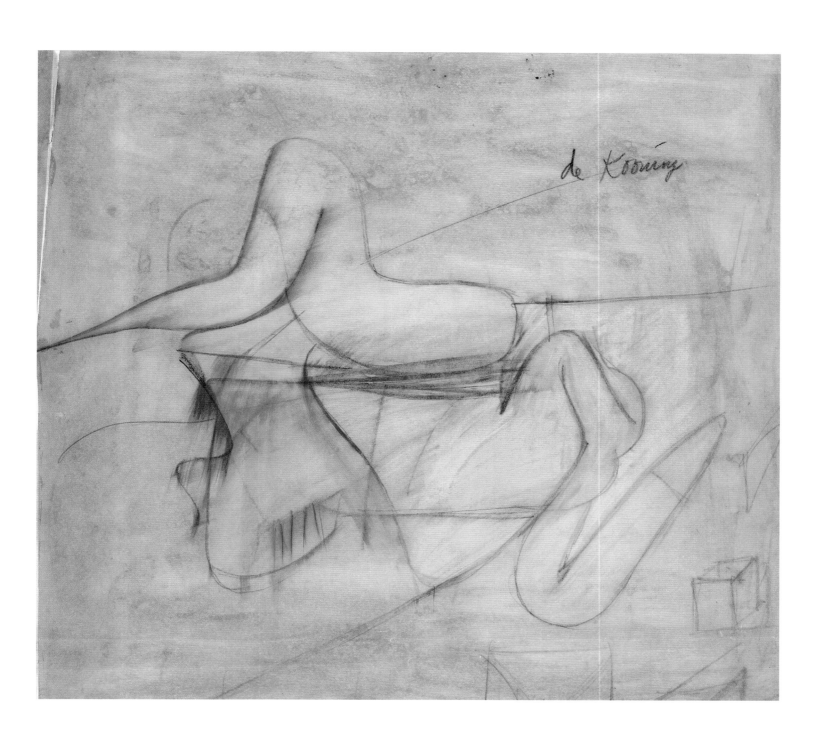

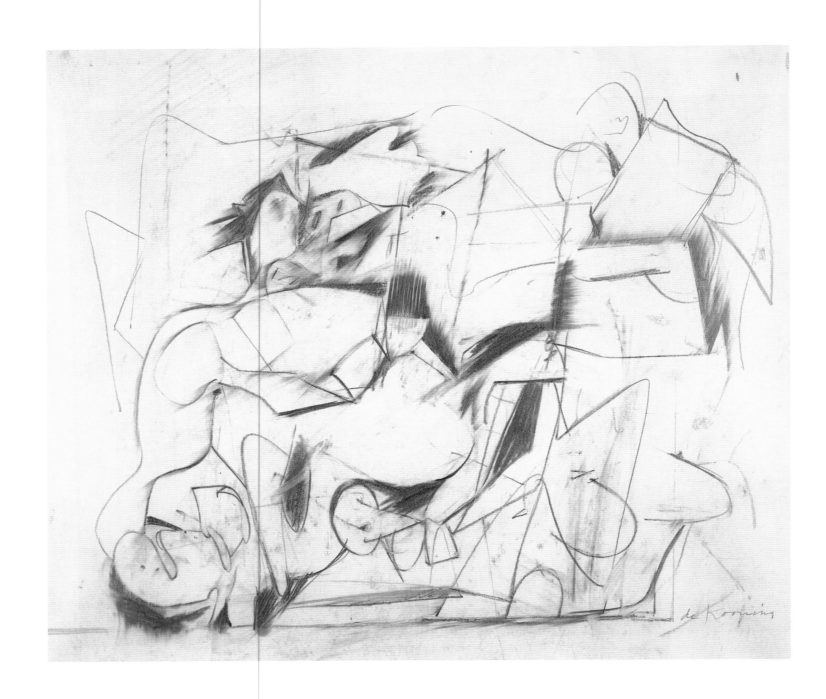

plate *untitled*, c. 1945

10

plate *study for backdrop*, 1945

11

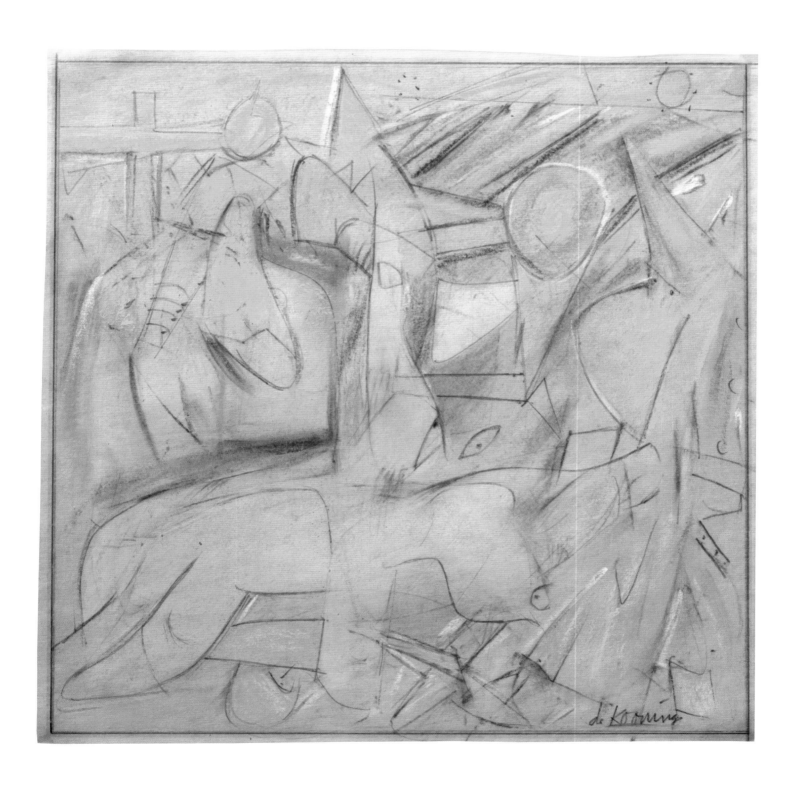

plate
12

still life, c. 1945

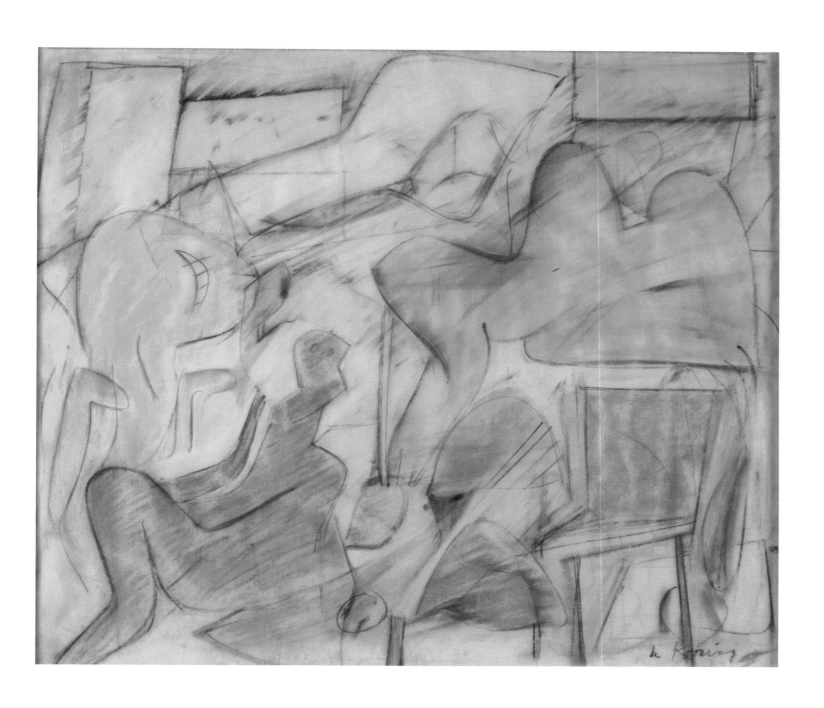

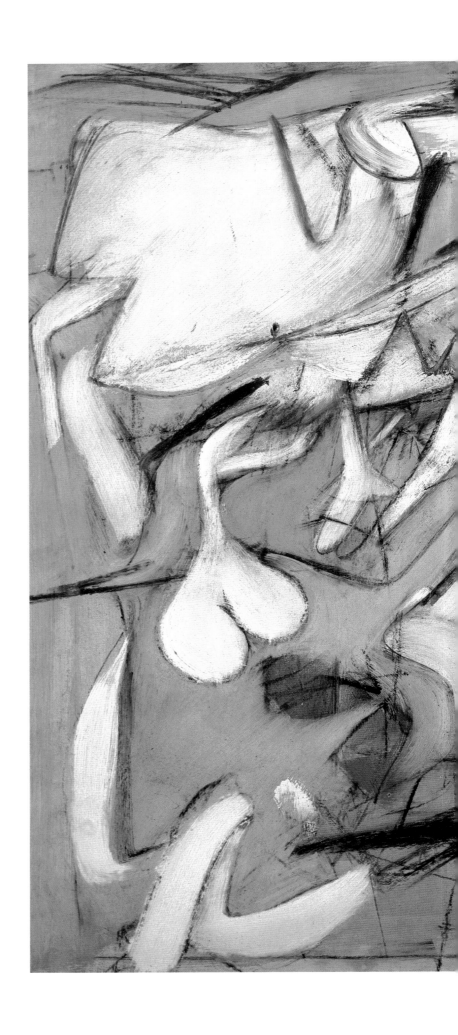

plate *fire island*, 1946

13

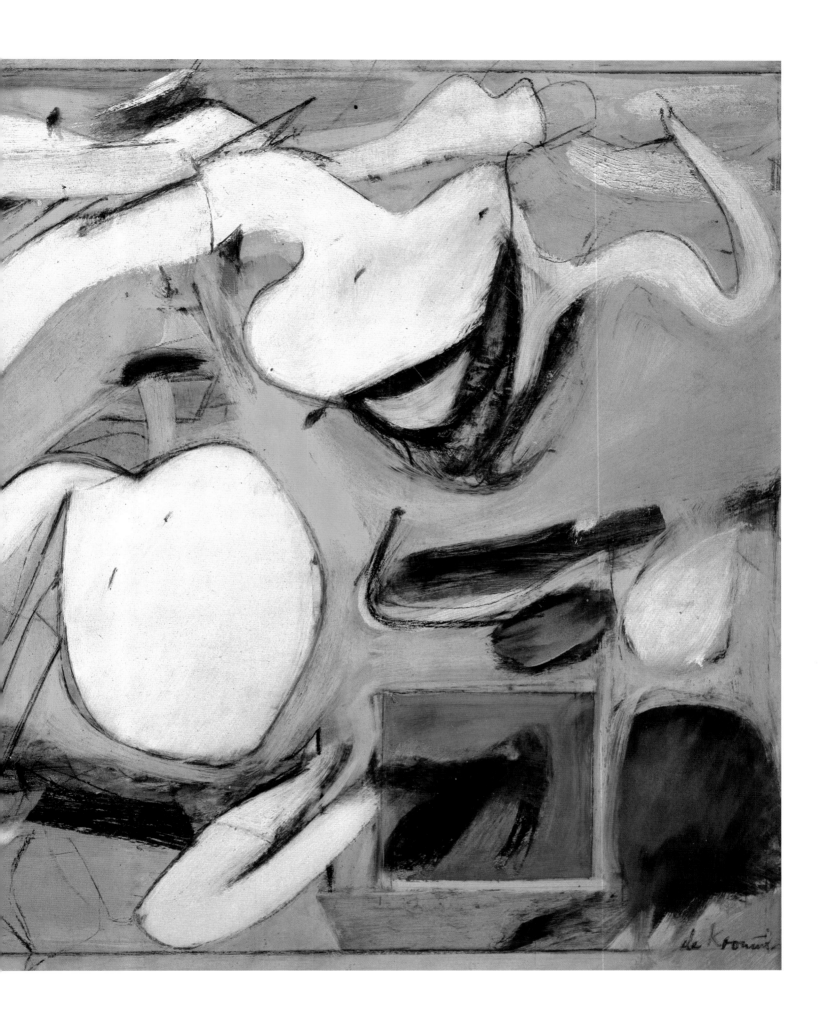

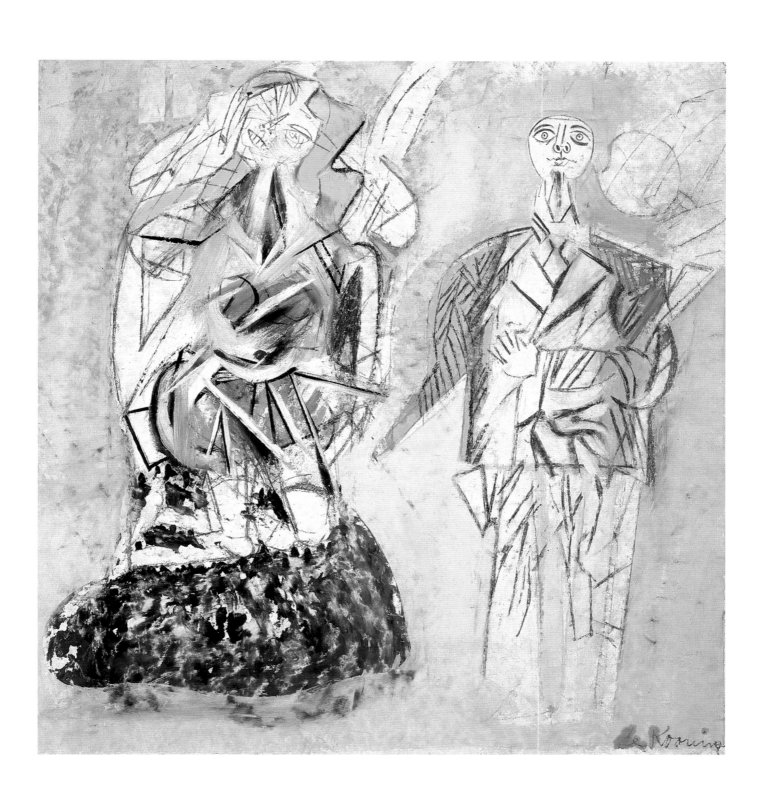

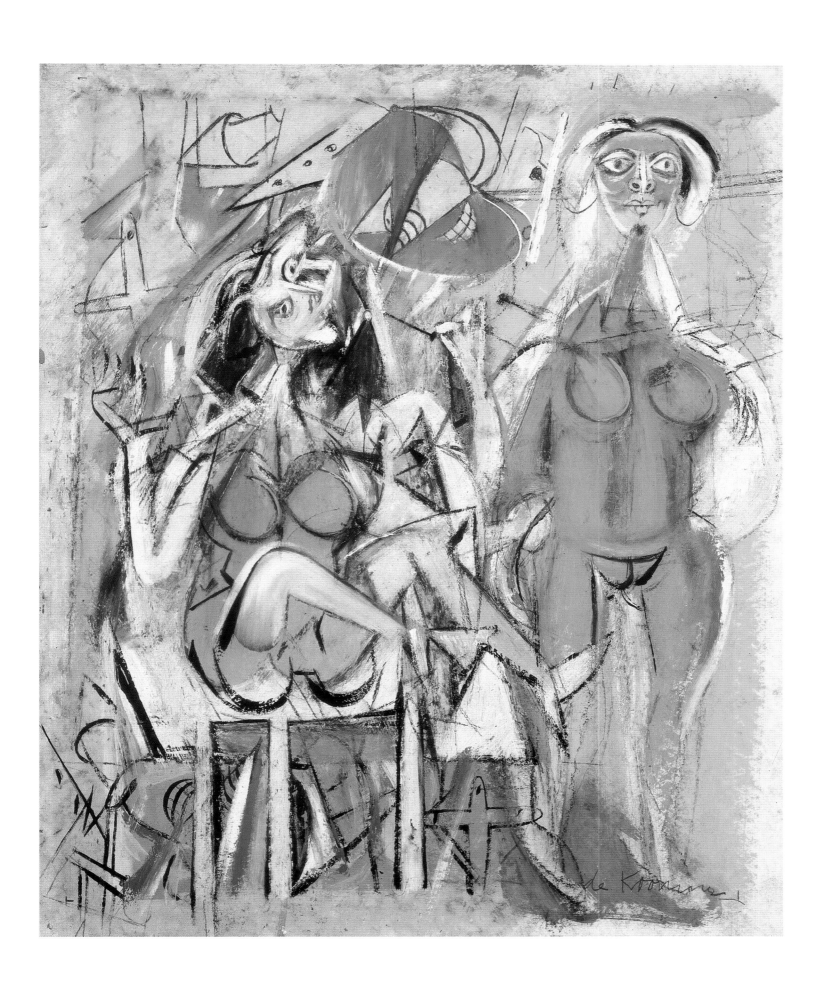

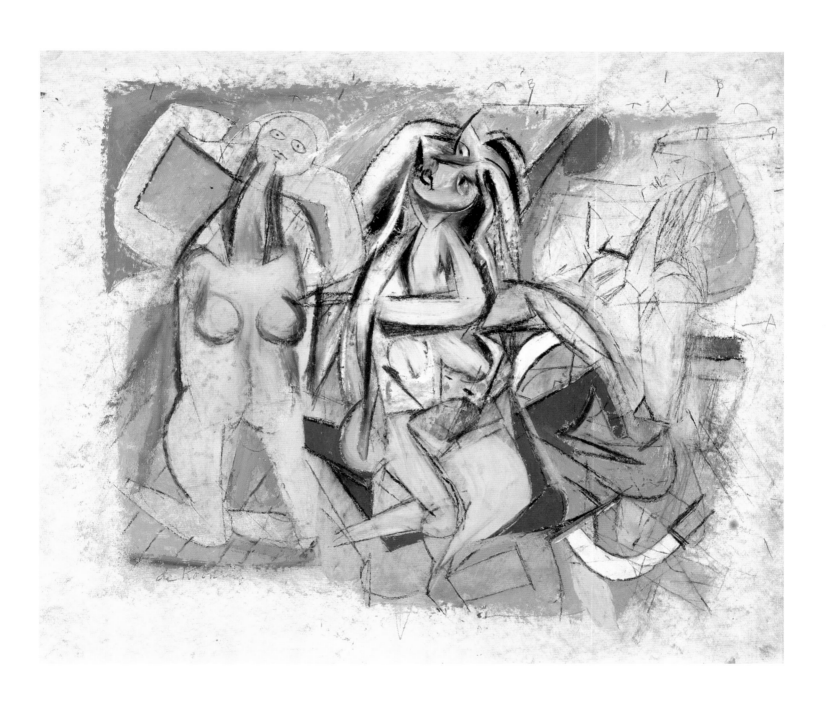

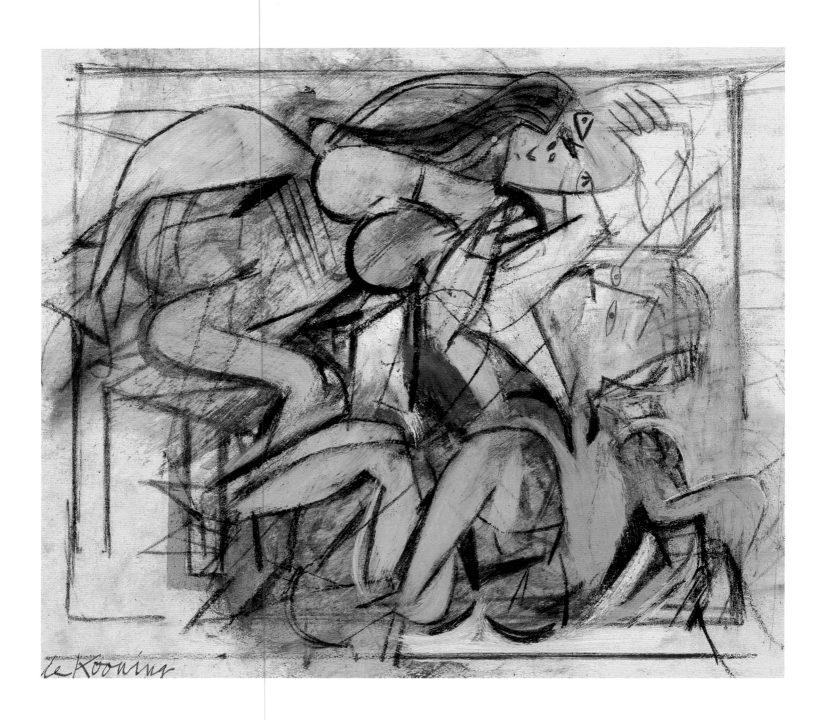

plate *two figures, c. 1946–47*

18

plate *pink angel, 1947*

19

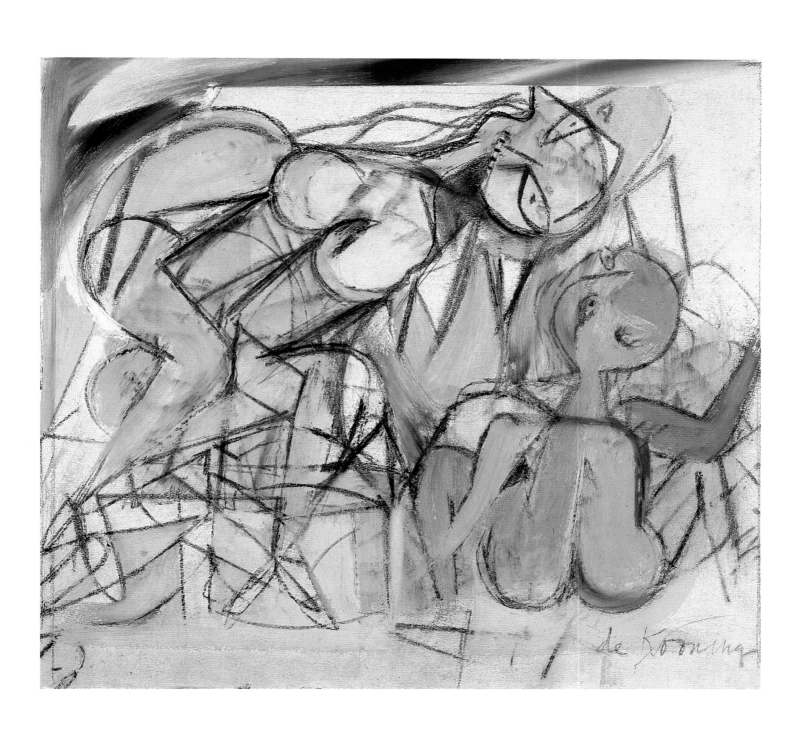

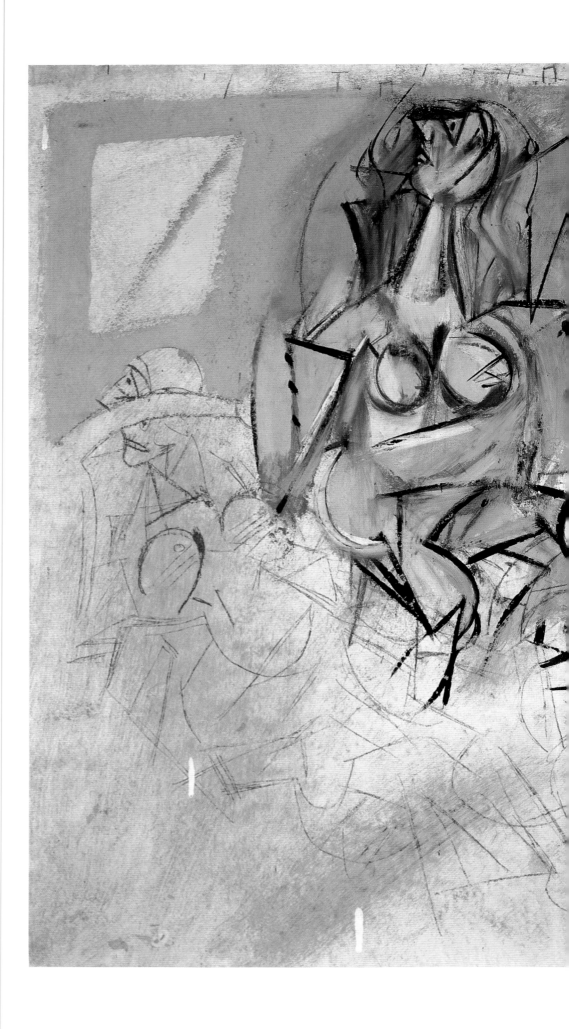

plate *untitled study (women)*, c. 1948

20

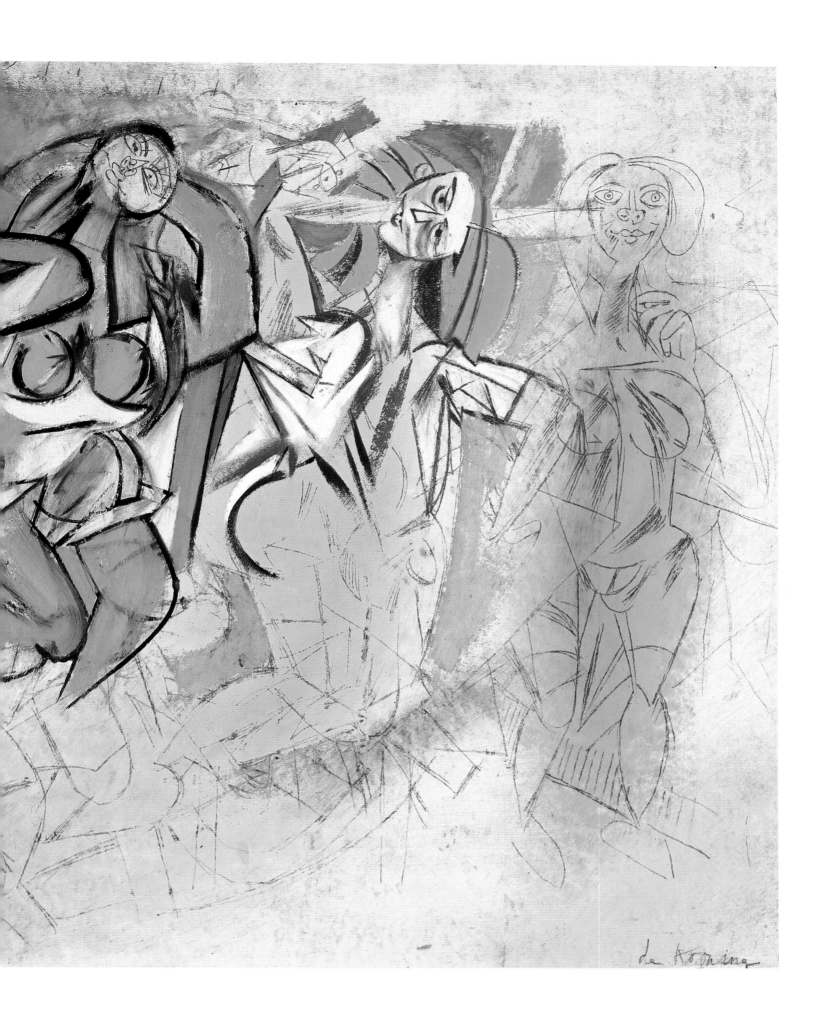

pink lady (study), c. 1948

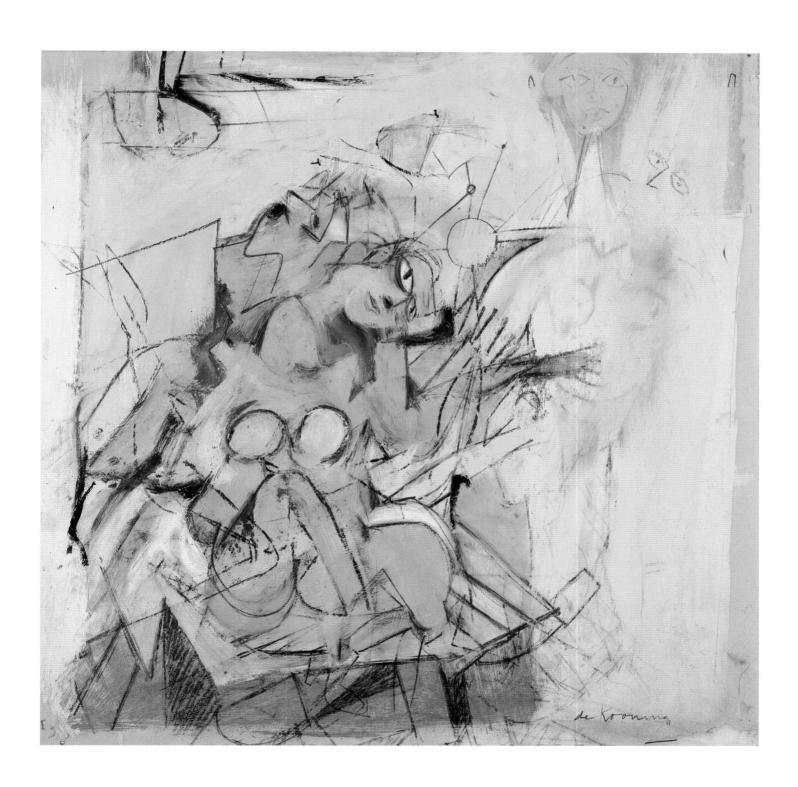

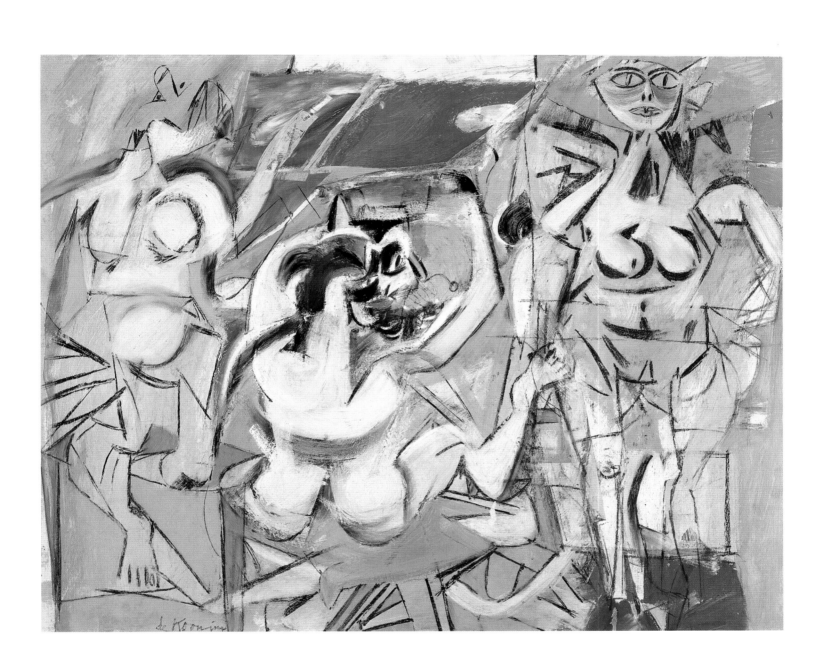

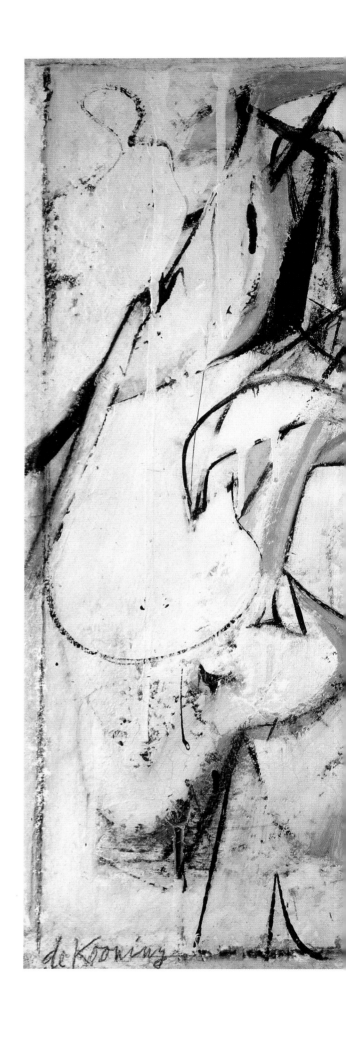

plate *mailbox*, 1948

23

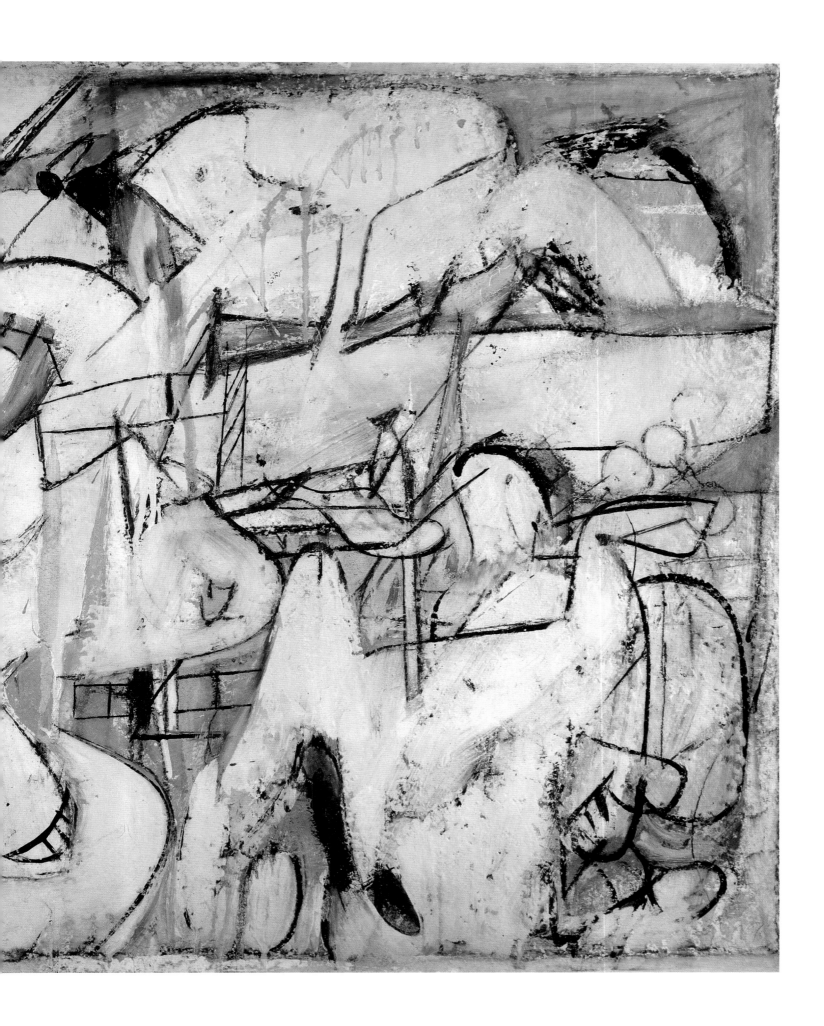

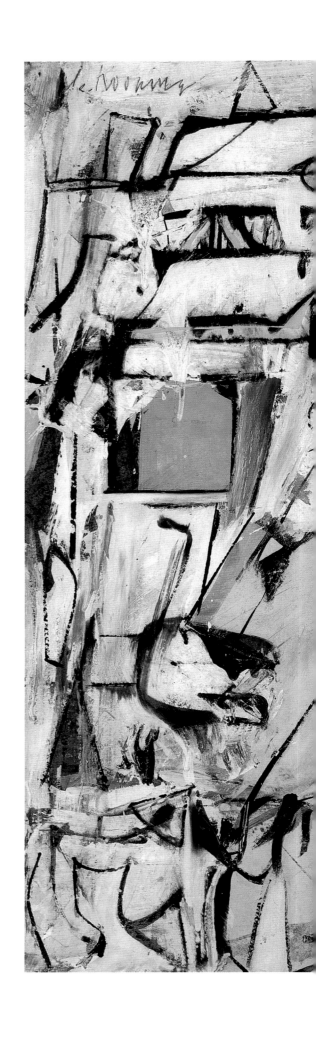

plate *asheville*, 1948

24

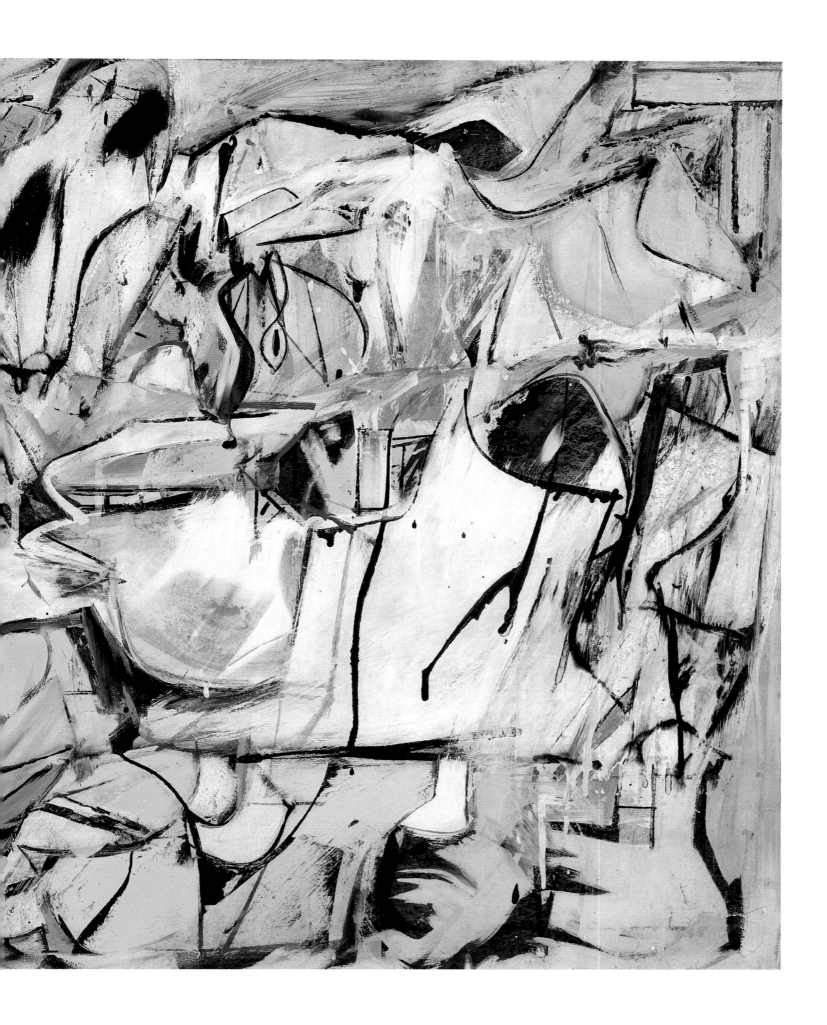

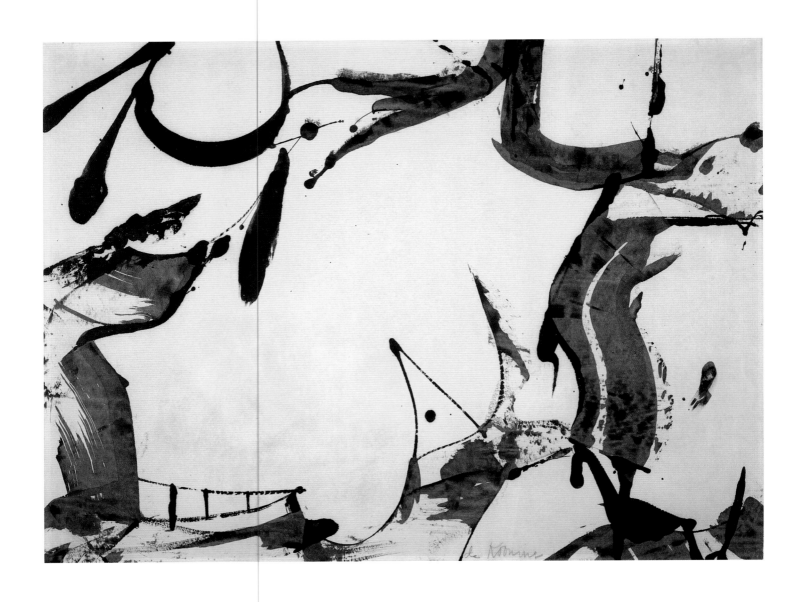

plate *untitled*, 1949
25

plate *warehouse manikins*, 1949
26

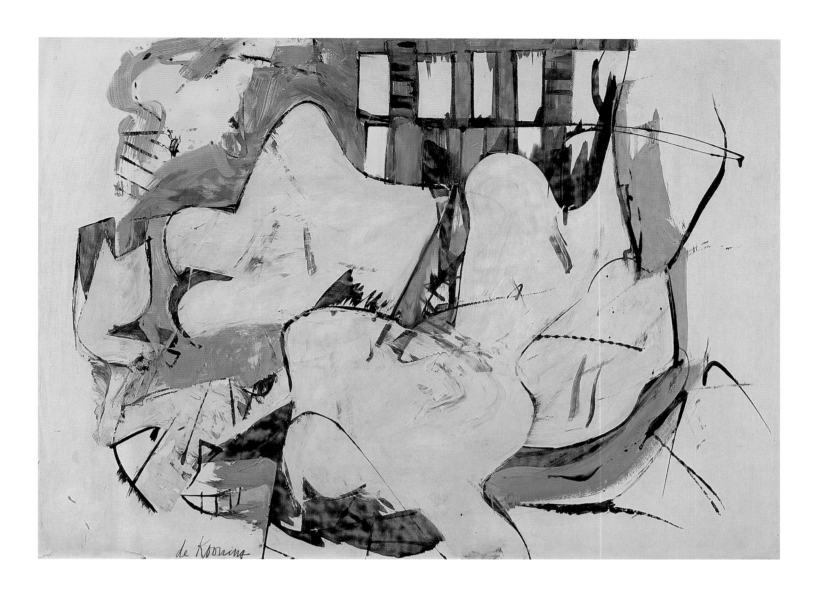

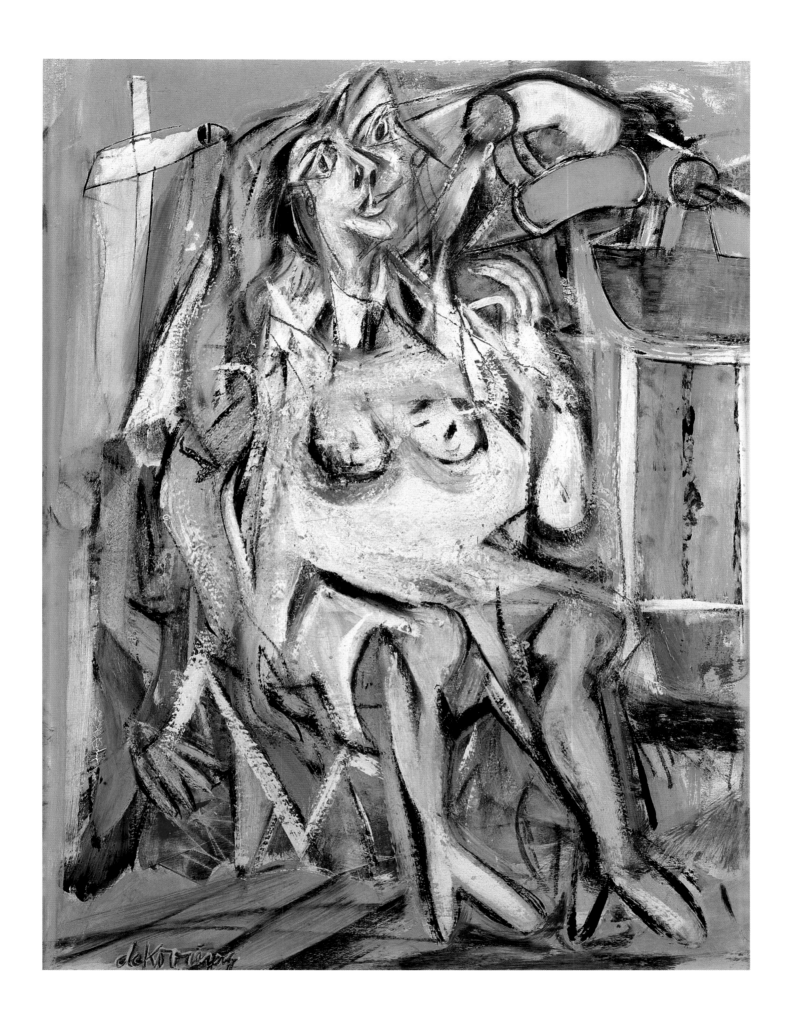

plate *woman, c. 1949–53*

28

plate *seated nude (portrait of elaine), c. 1947–49*

29

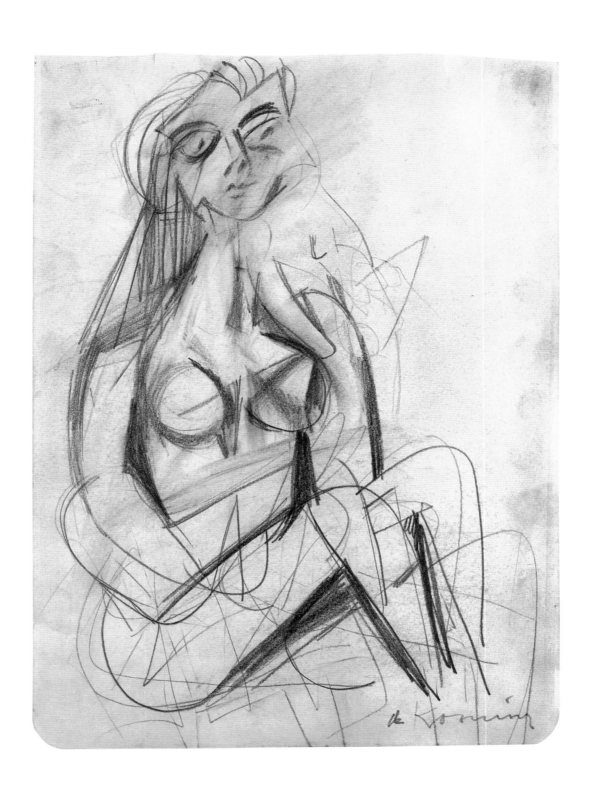

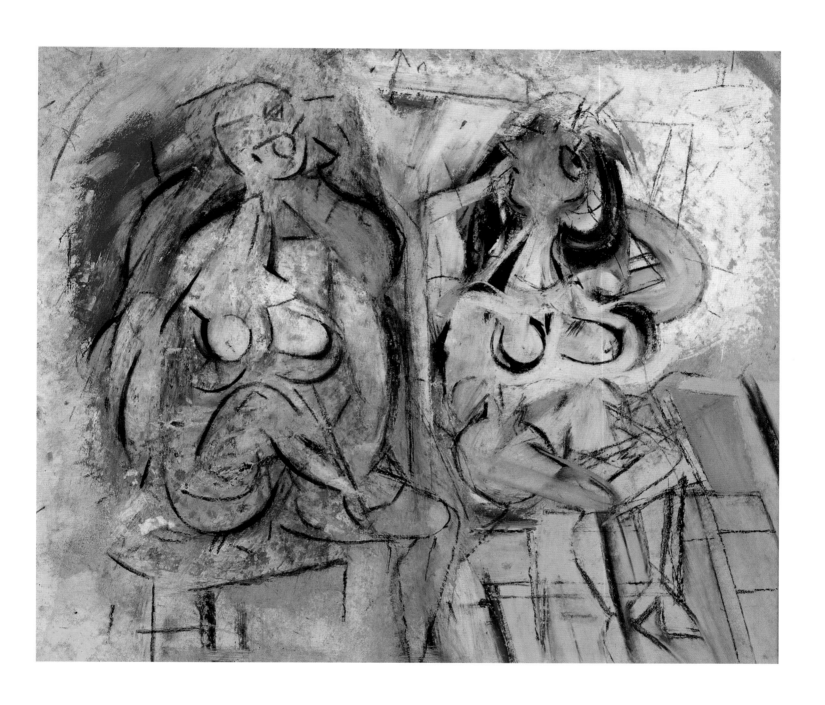

two women on a wharf, 1949

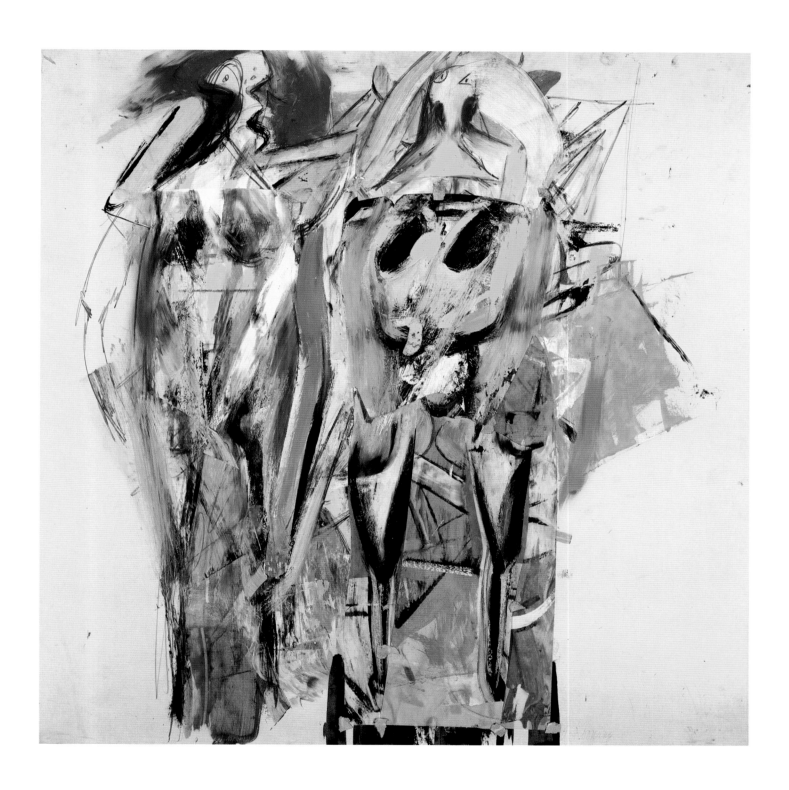

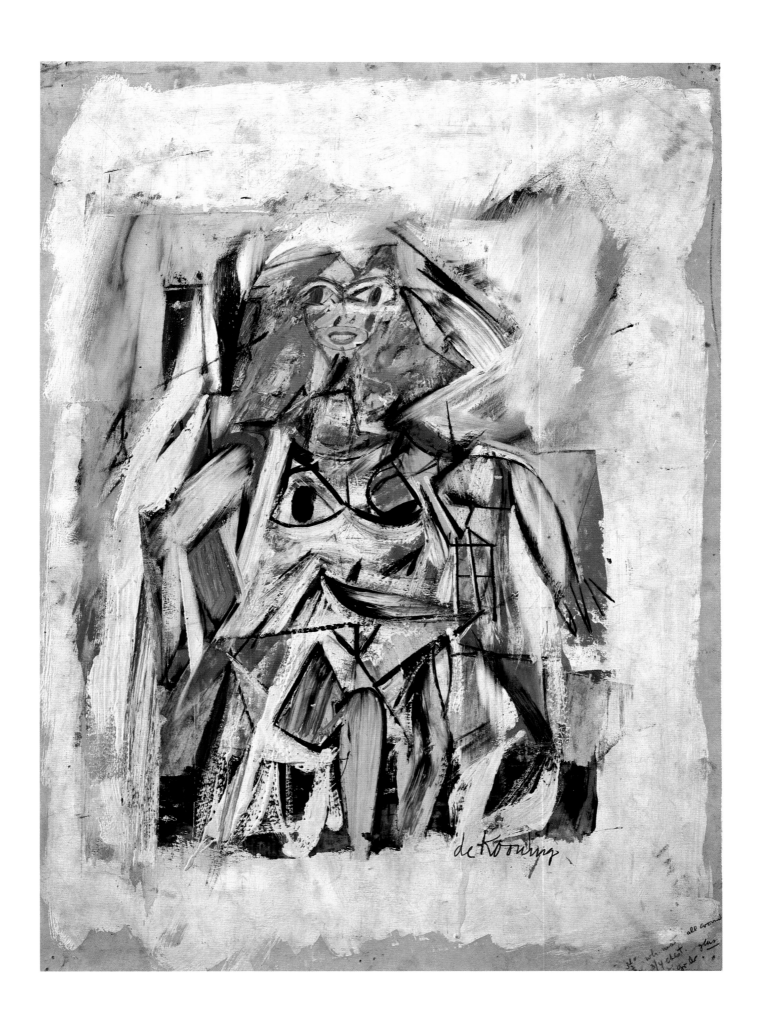

plate
33
 two women, 1950

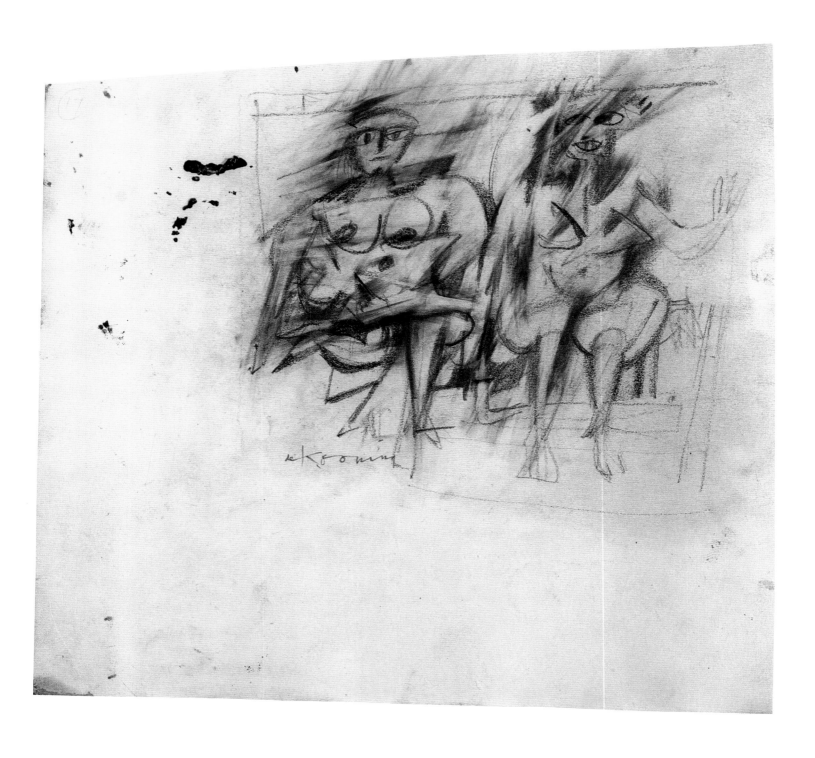

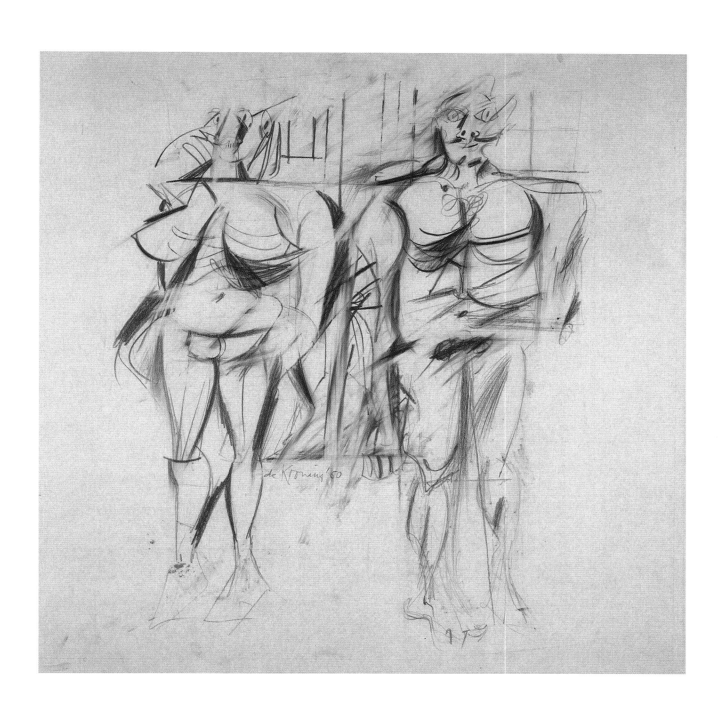

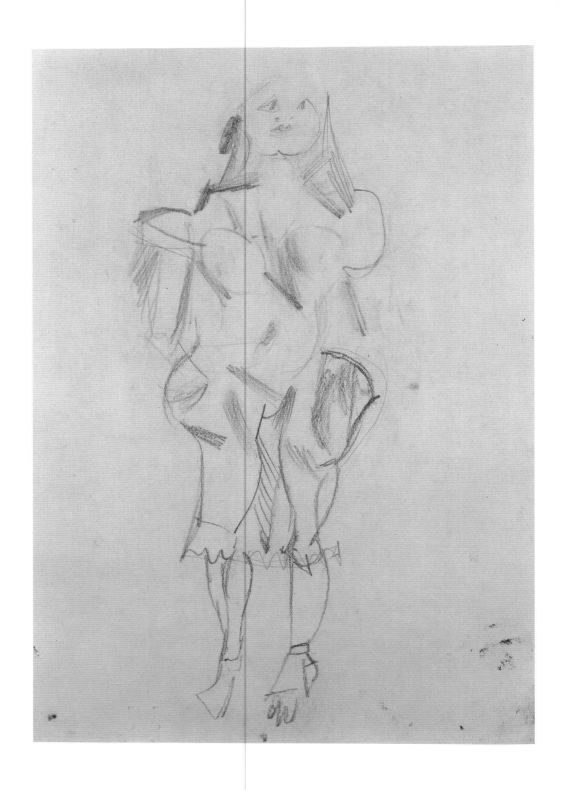

plate *woman*, 1950 (verso) *woman*, 1950 (recto)
35

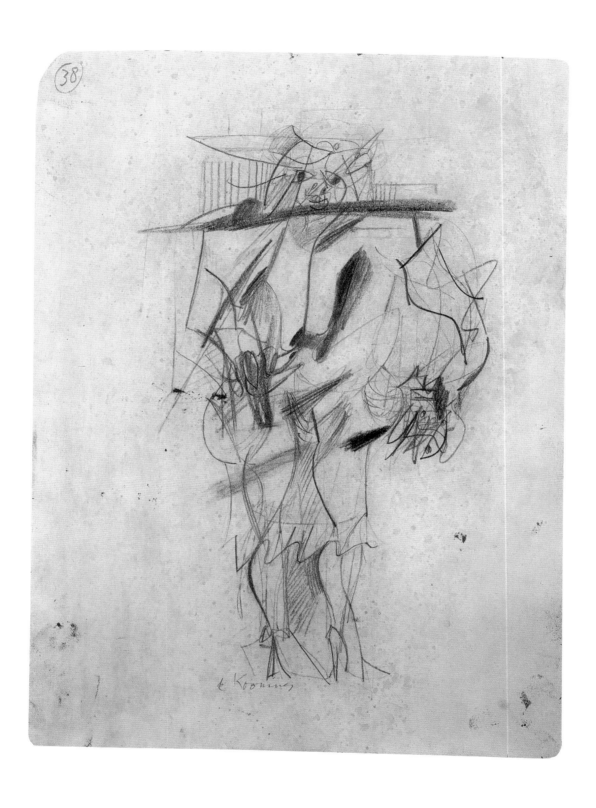

de Kooning

plate *woman, wind, and window II,* 1950

36

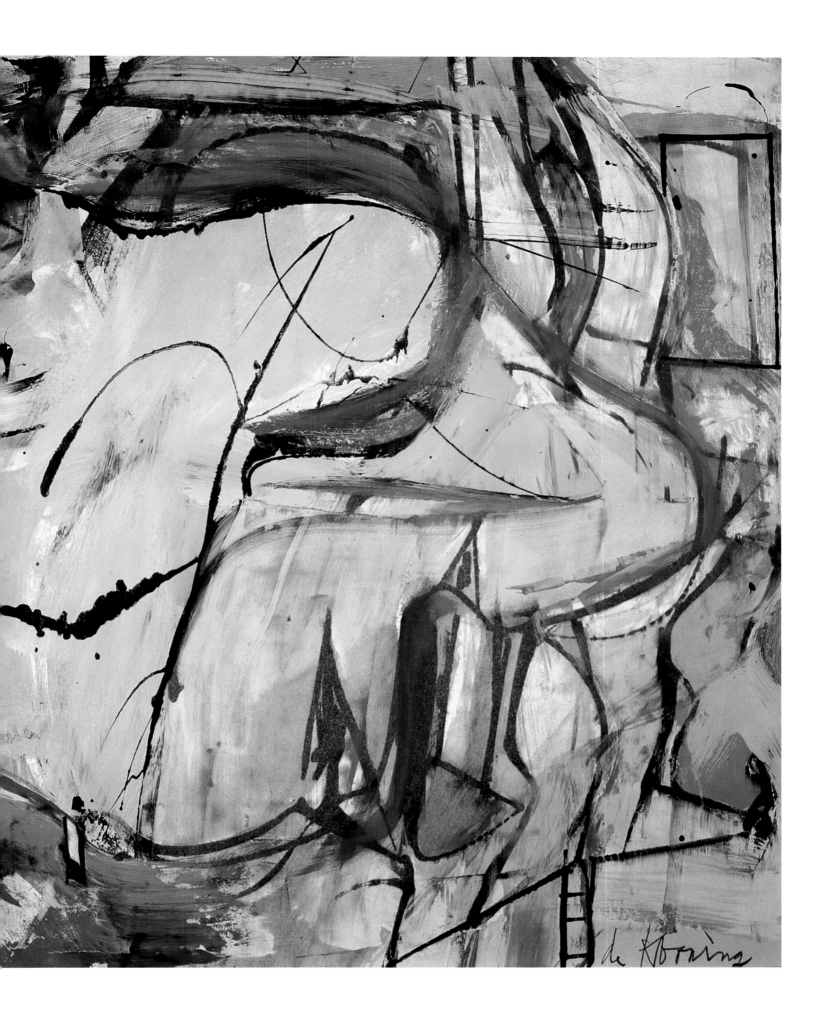

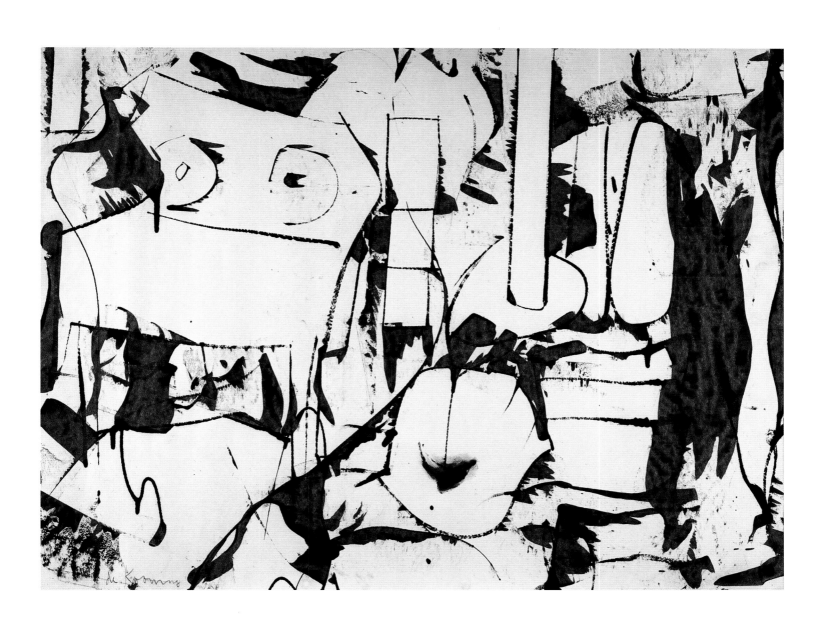

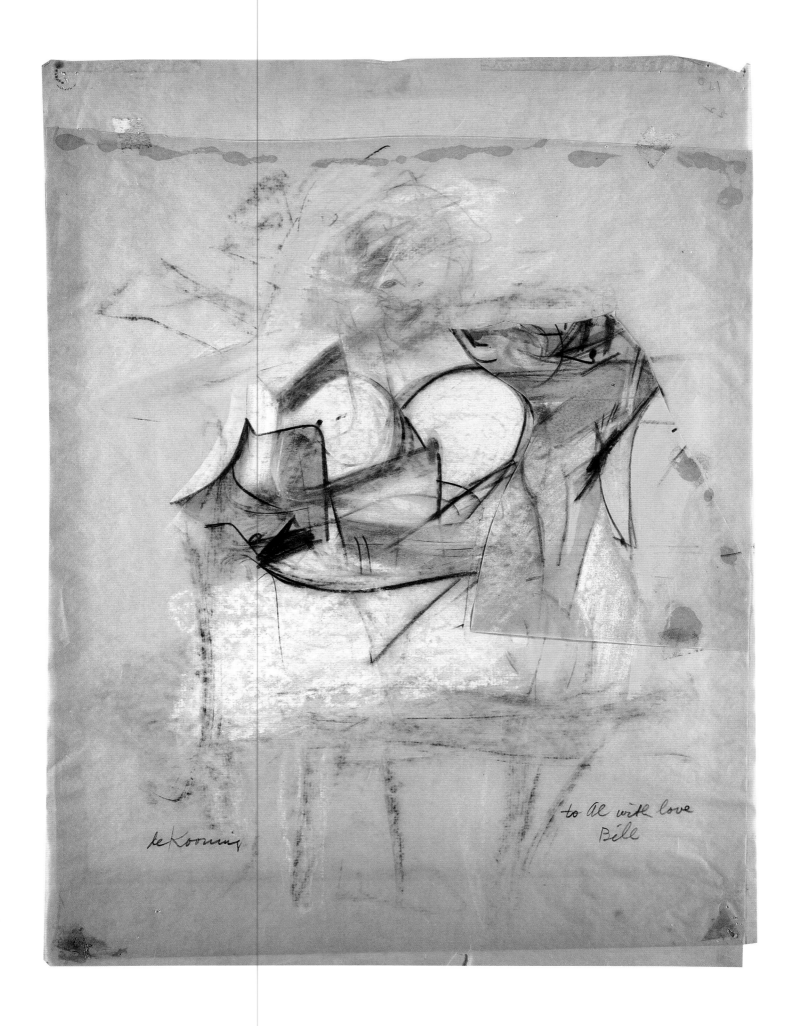

plate **woman, c. 1950**

38

plate **study for "marilyn monroe," 1951**

39

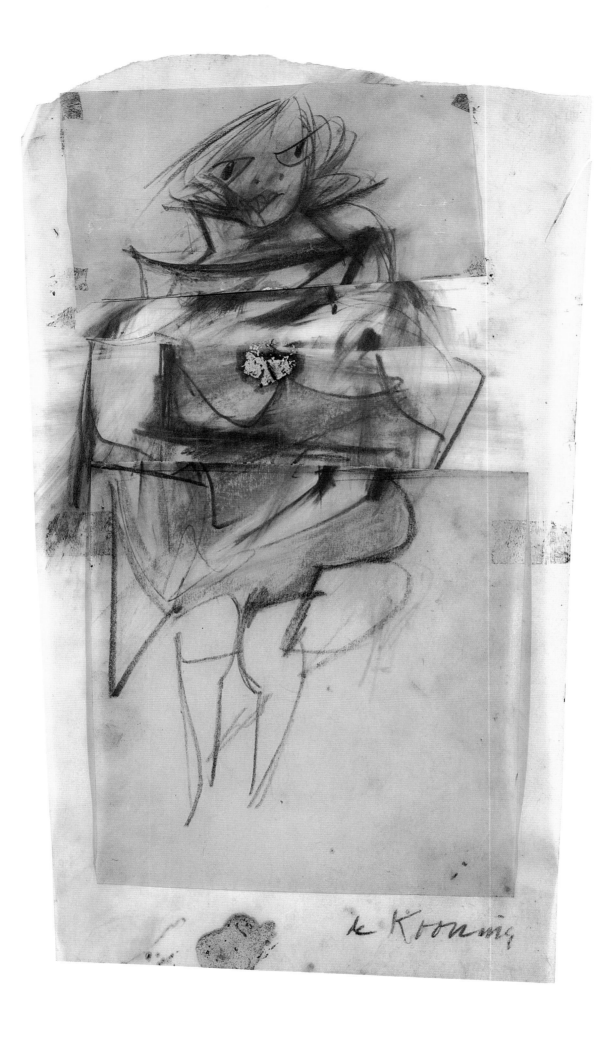

de Kooning

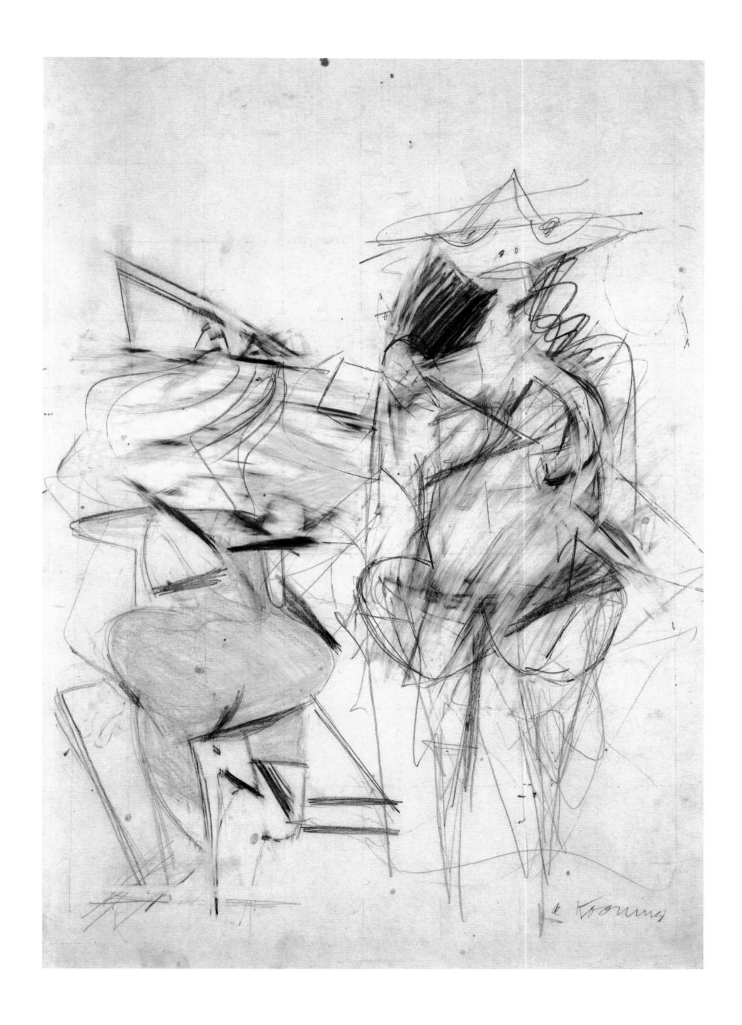

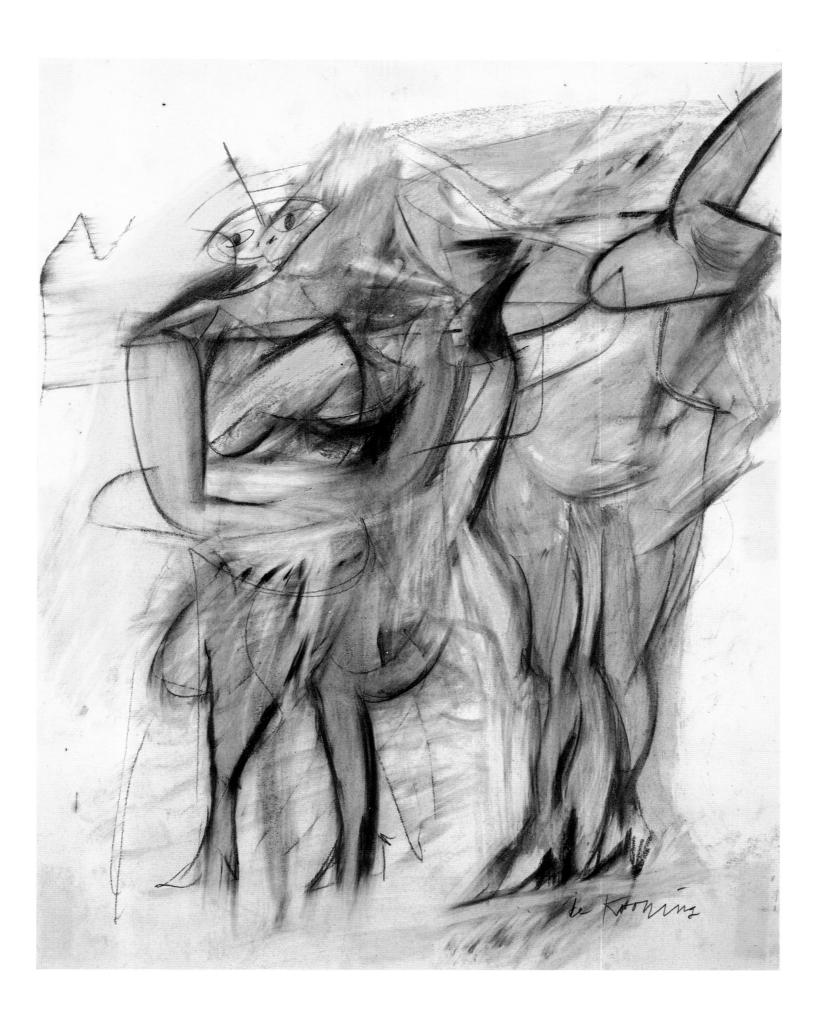

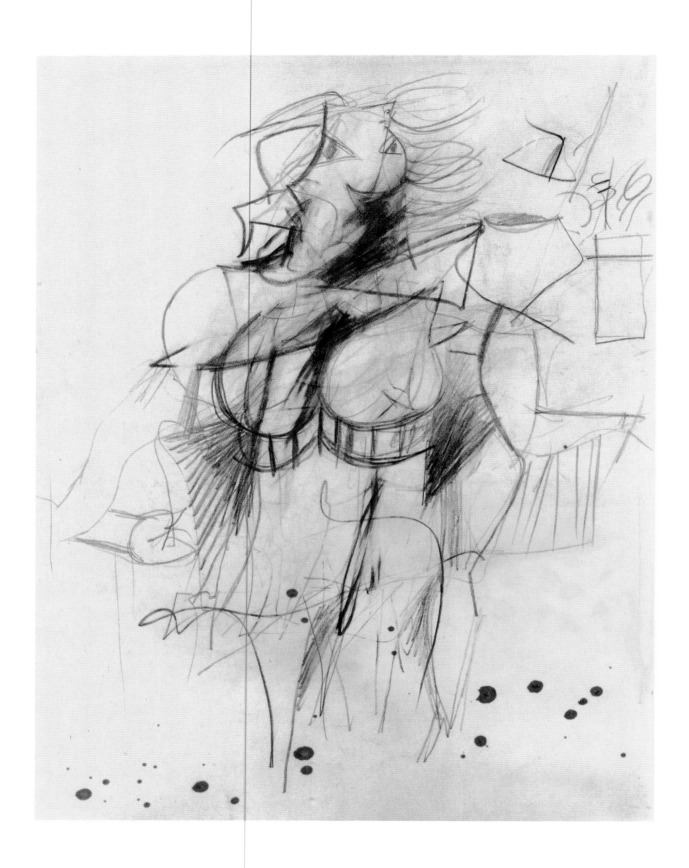

plate **woman,** 1951

42

plate **reclining woman,** 1951

43

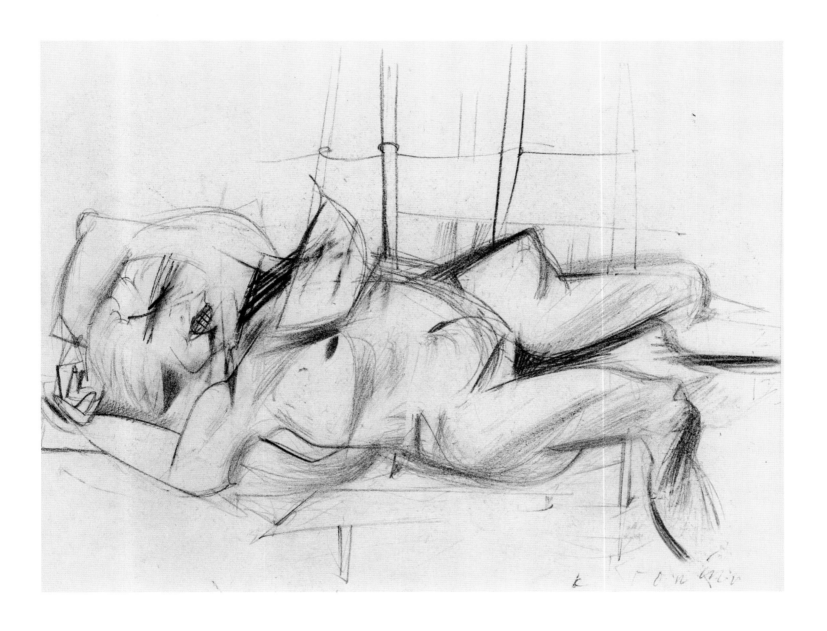

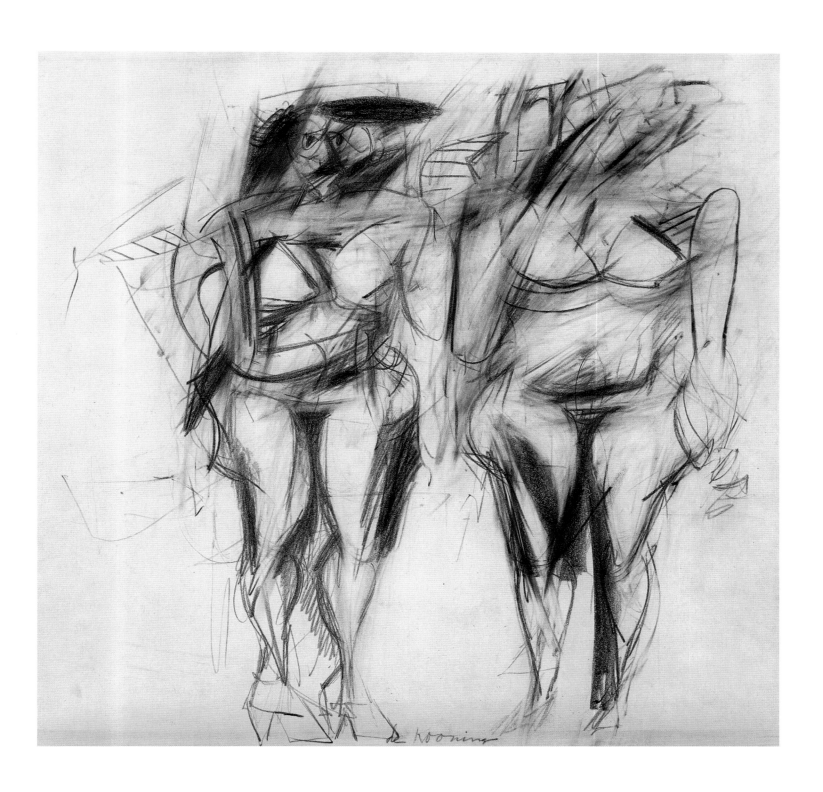

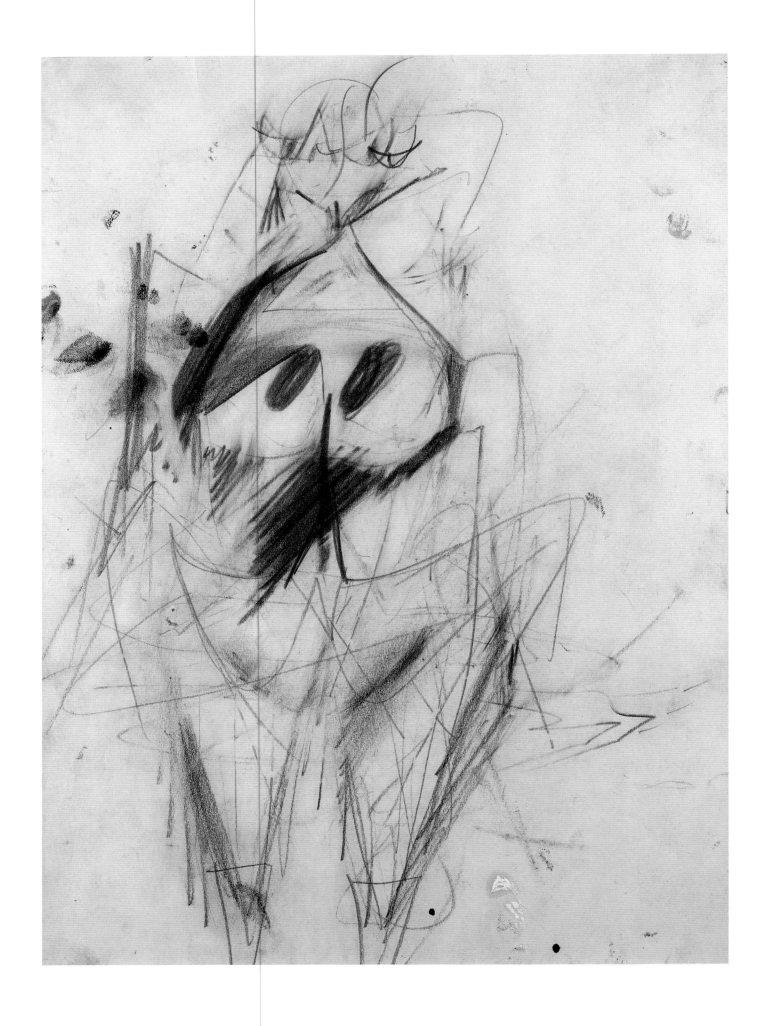

plate **woman, c. 1951**

45

plate **woman, c. 1951**

46

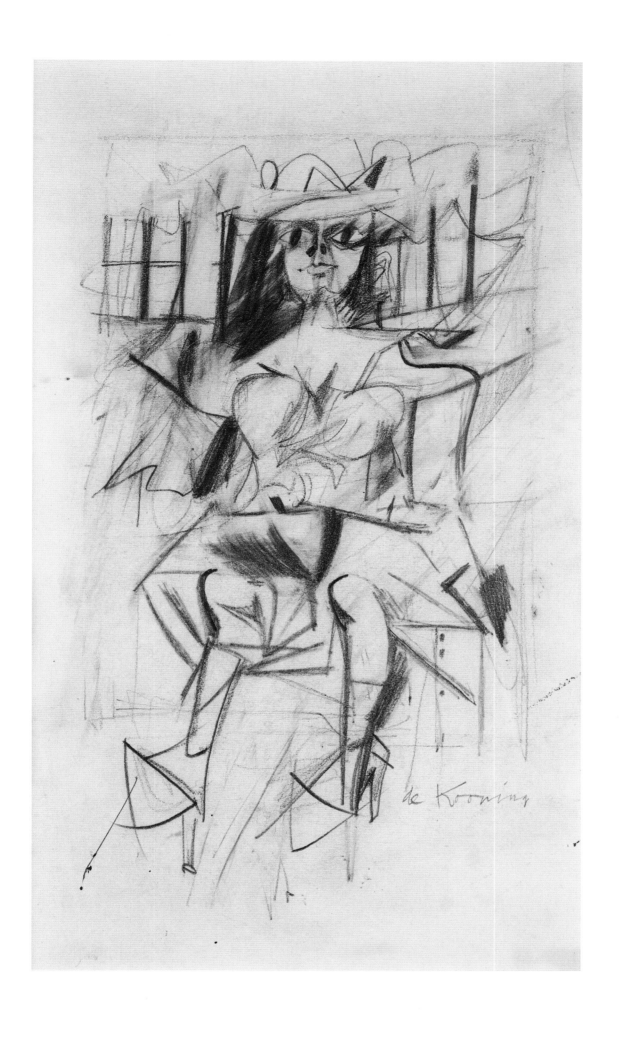

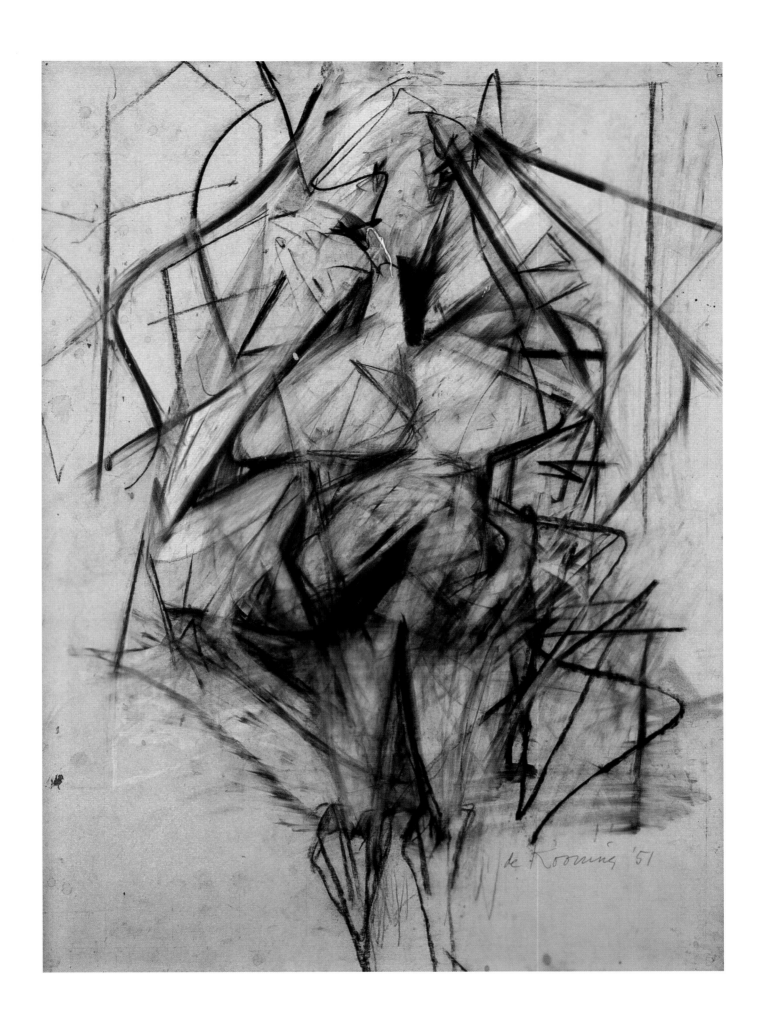

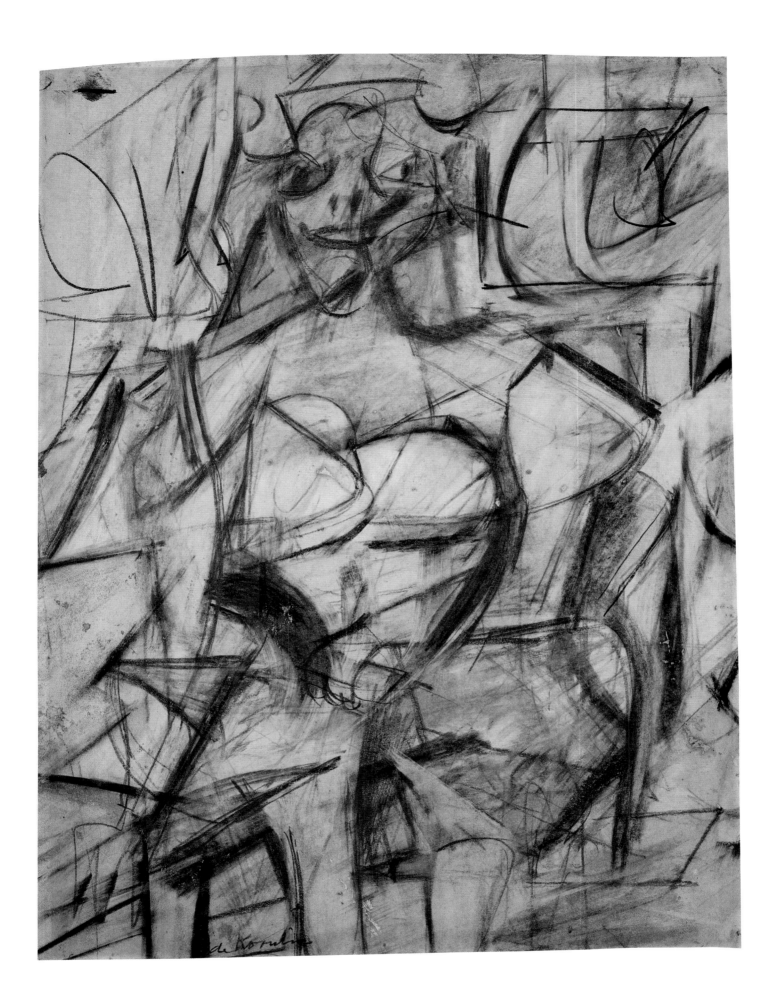

plate
49

study for "woman VI," 1952

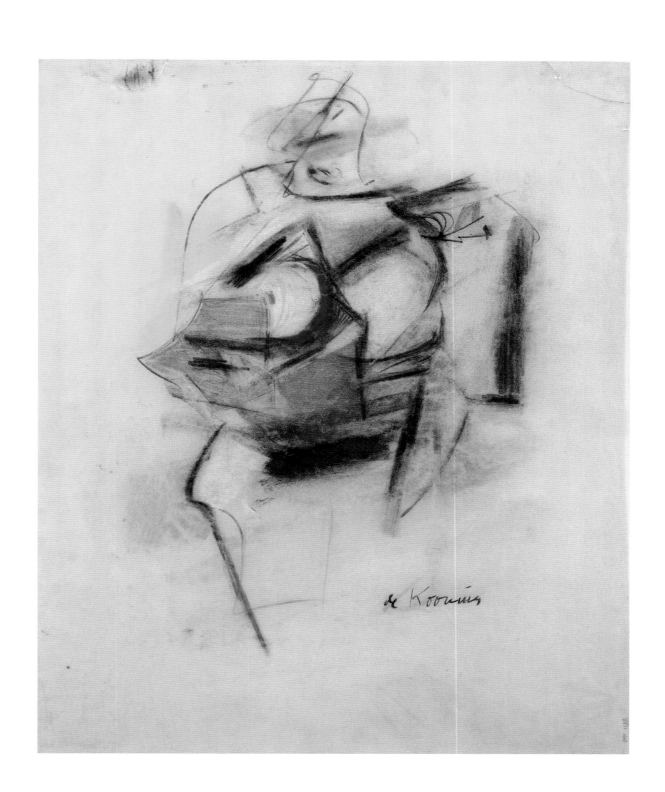

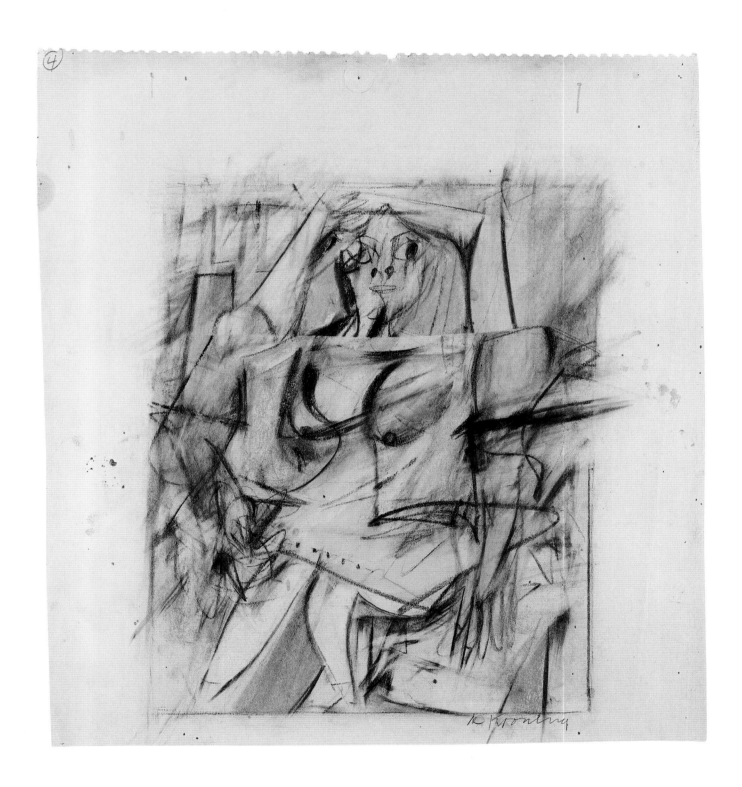

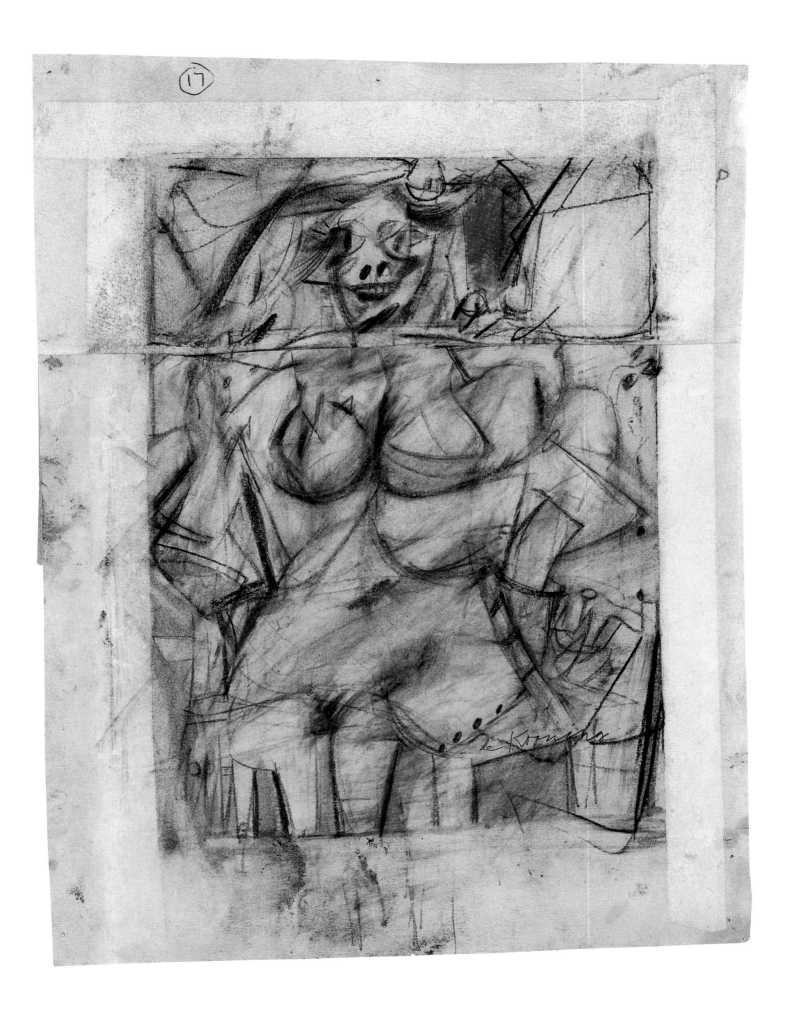

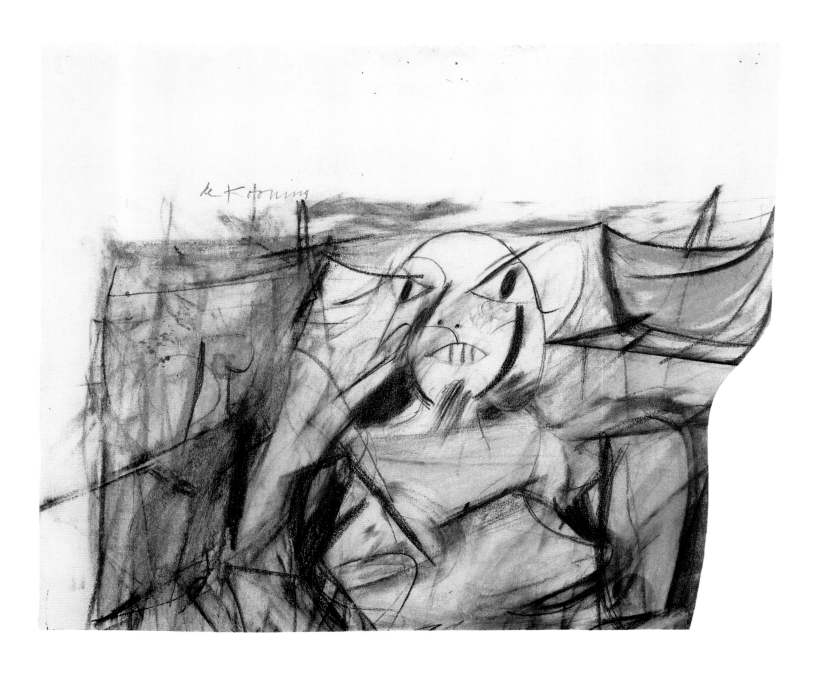

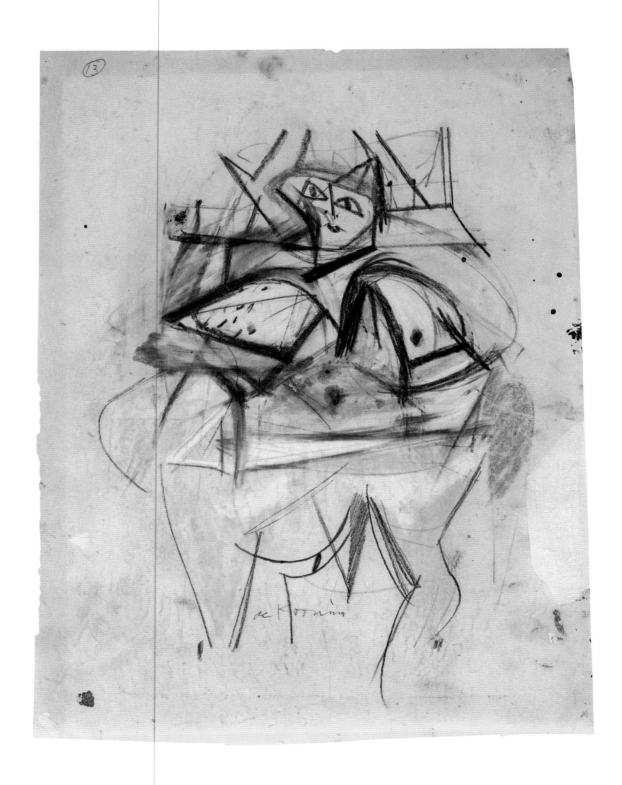

plate **woman, c. 1952**

53

plate **woman, c. 1952**

54

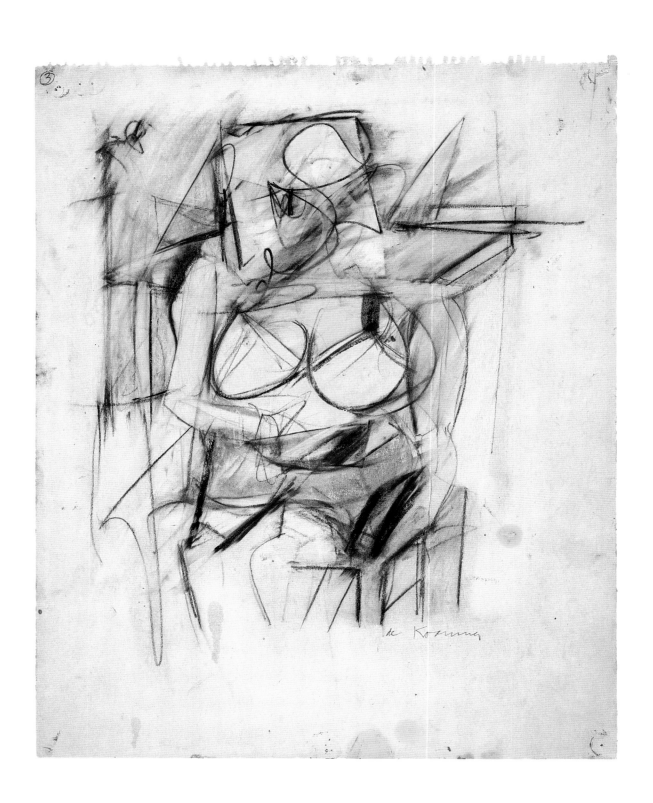

plate
55

study for "woman," 1952

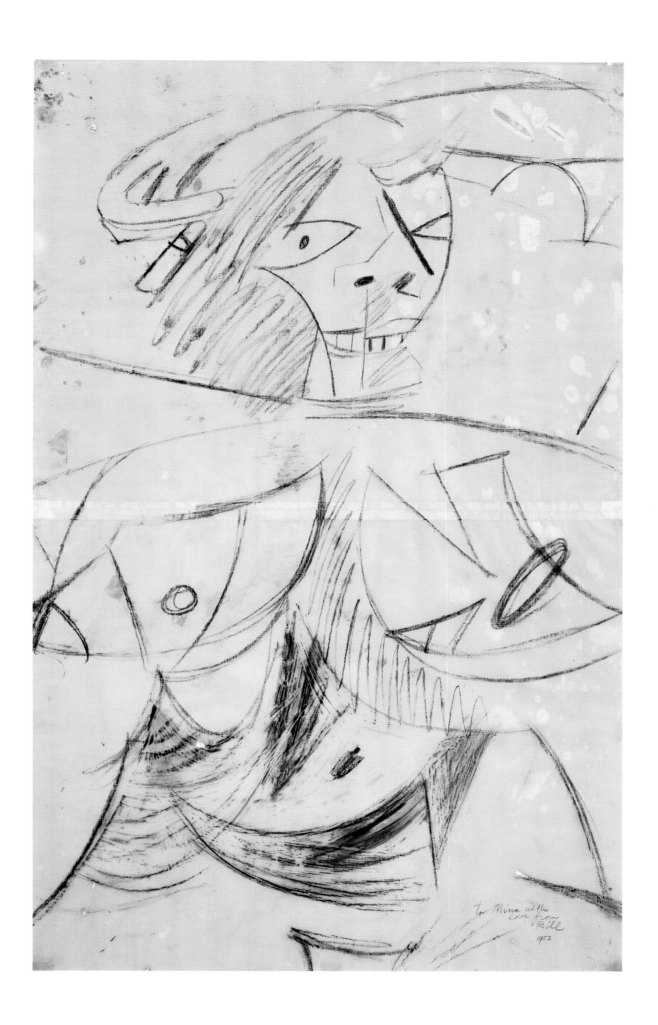

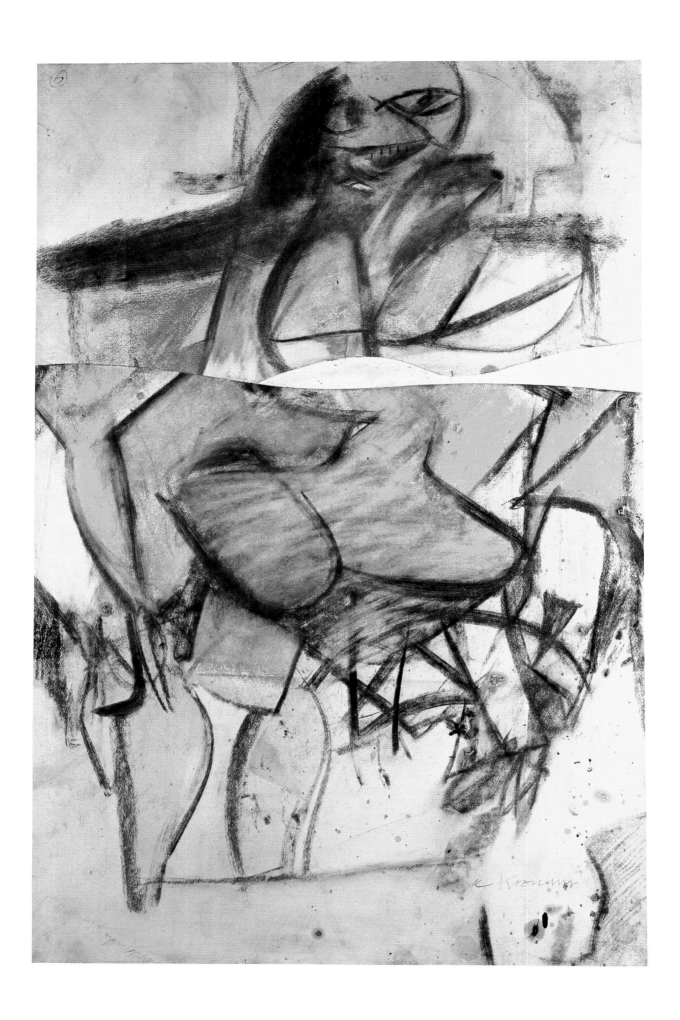

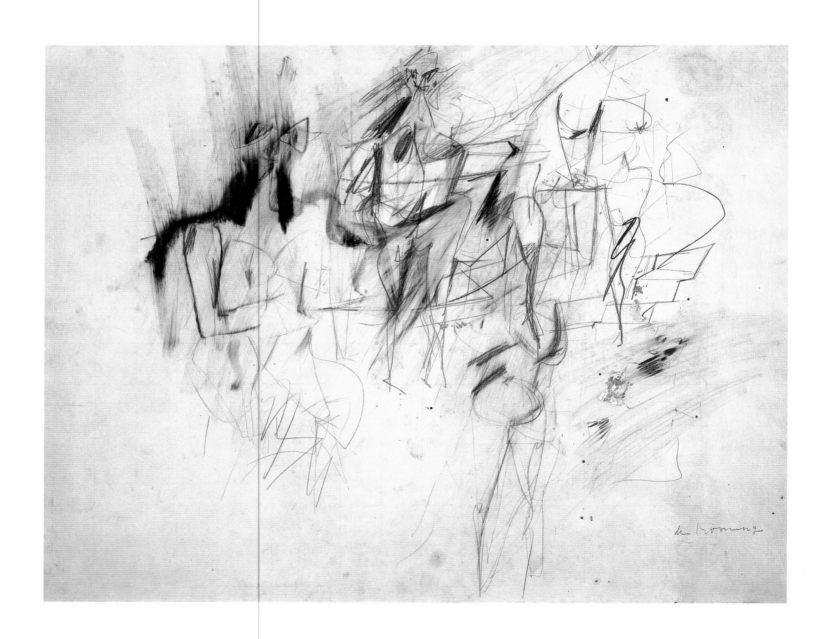

plate **two women, 1952**
57

plate **three women, 1952**
58

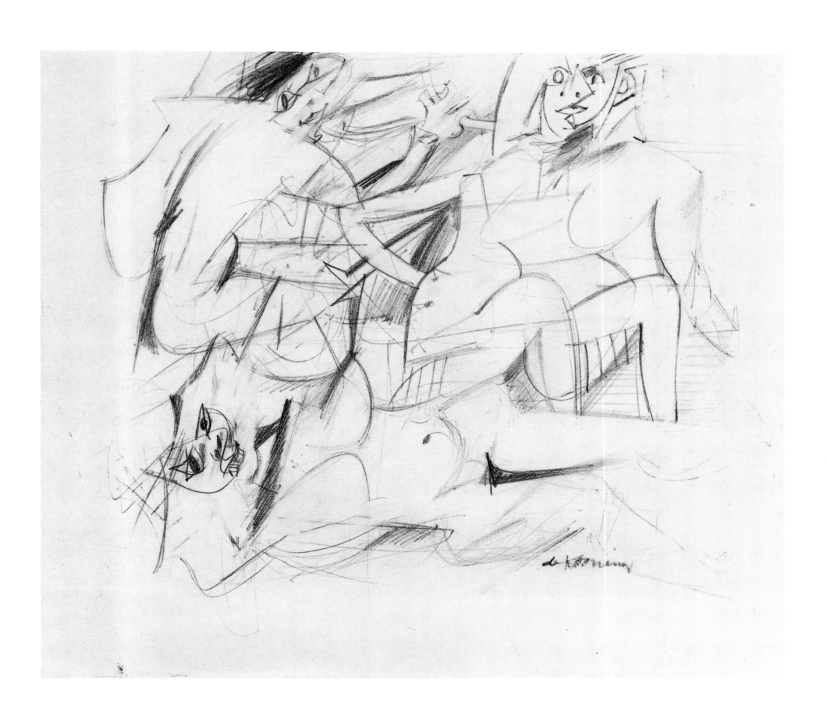

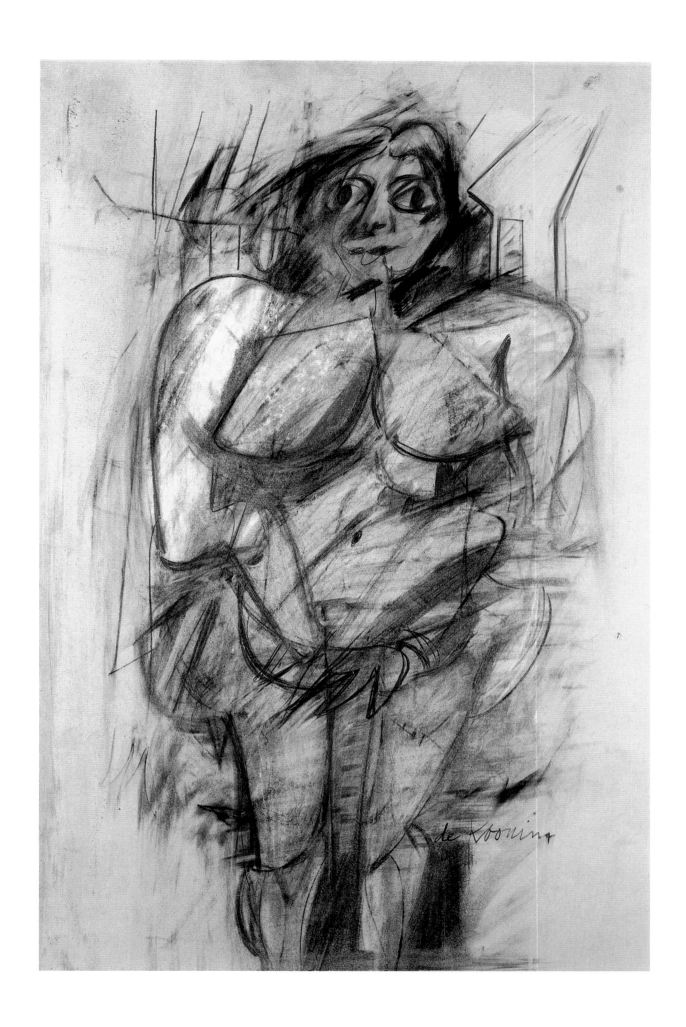

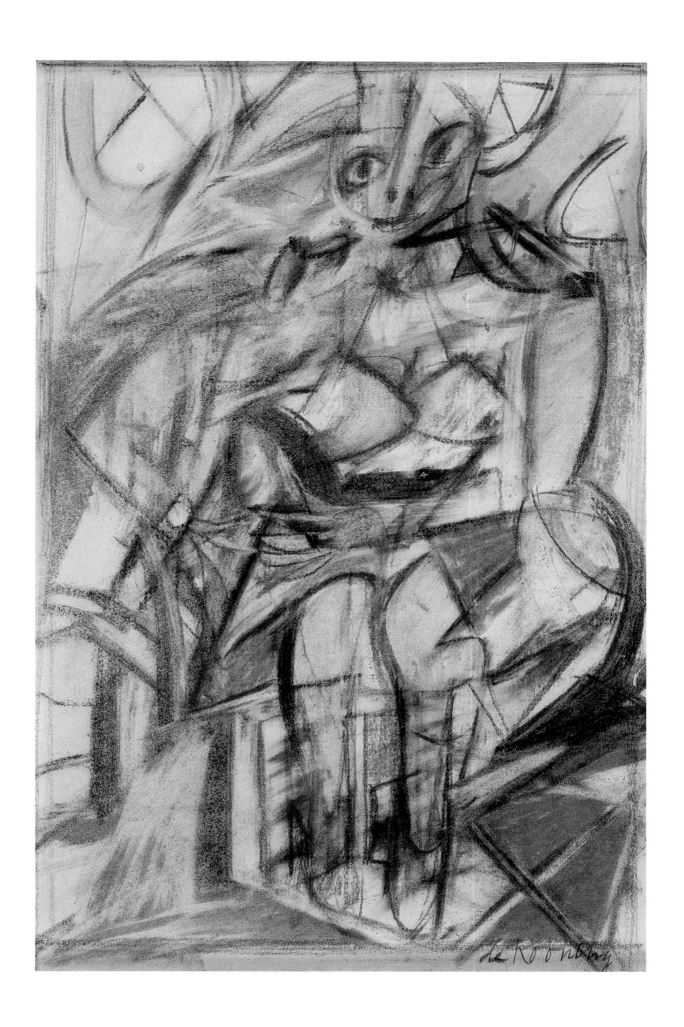

plate
61

woman, c. 1952

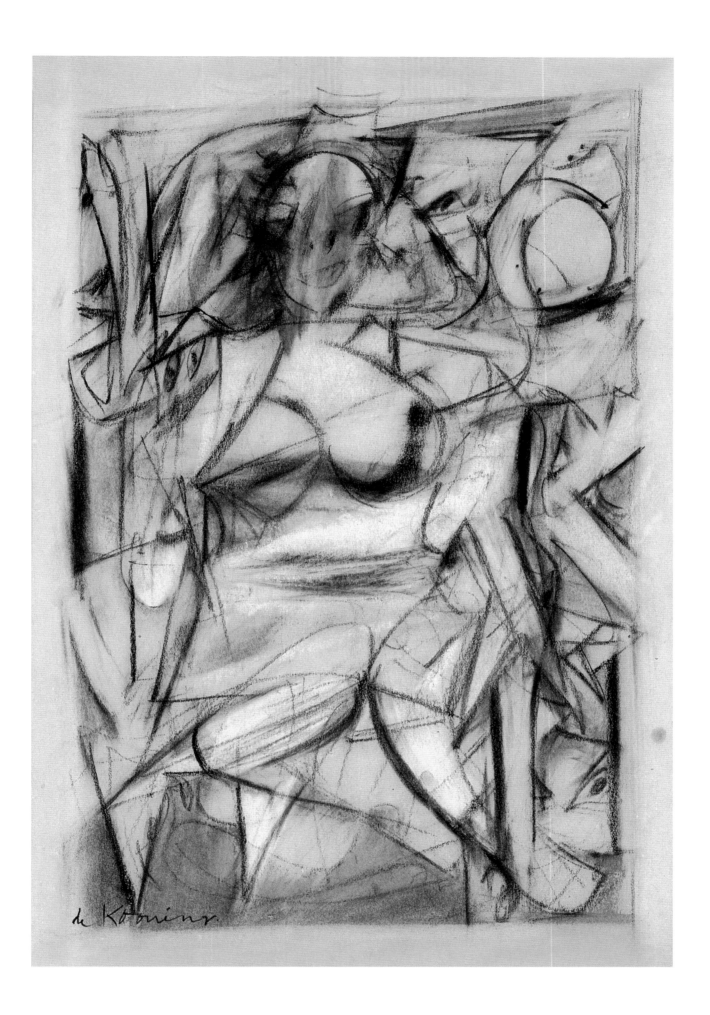

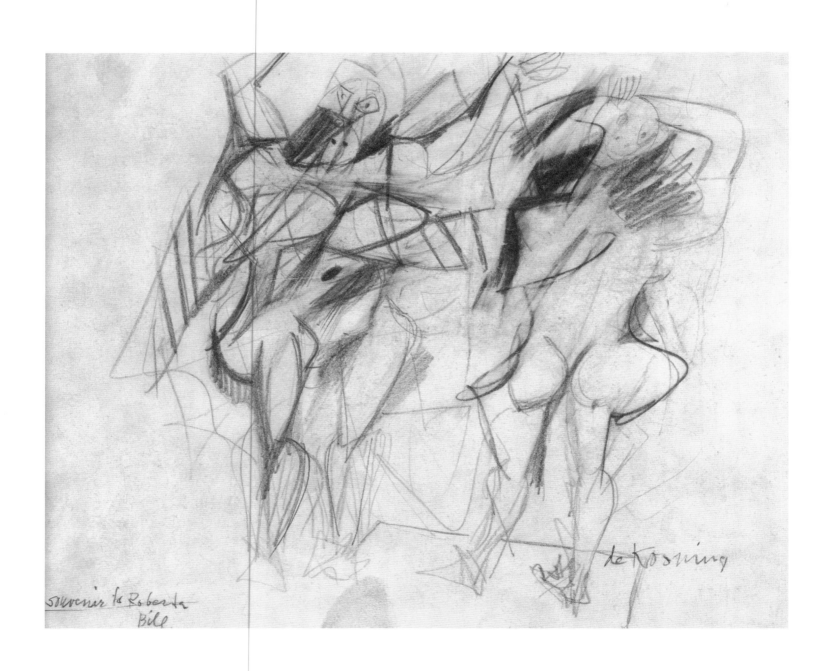

plate *untitled (two figures)*, 1952

62

plate *two women*, 1952

63

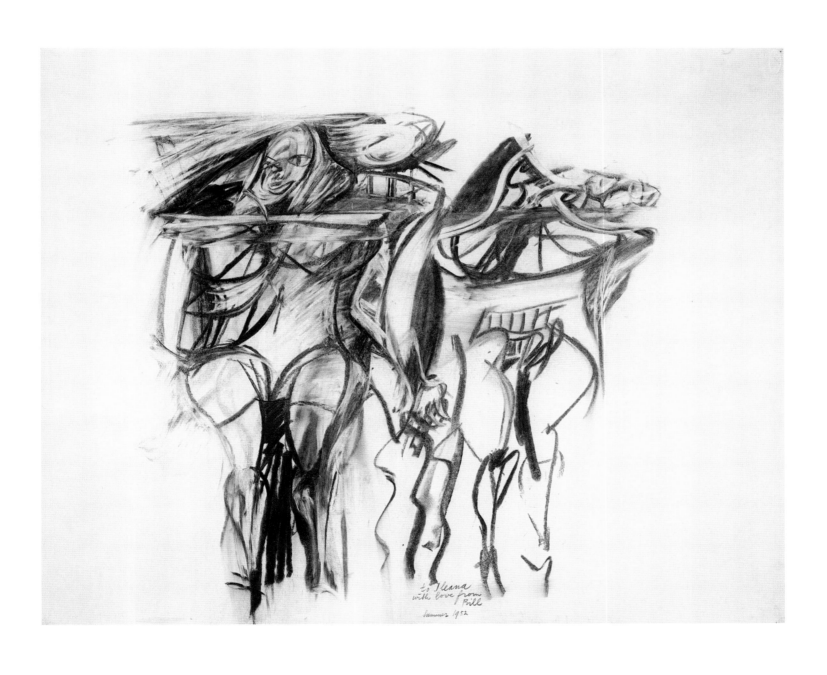

to Ileana
with love from
Bill
summer 1952

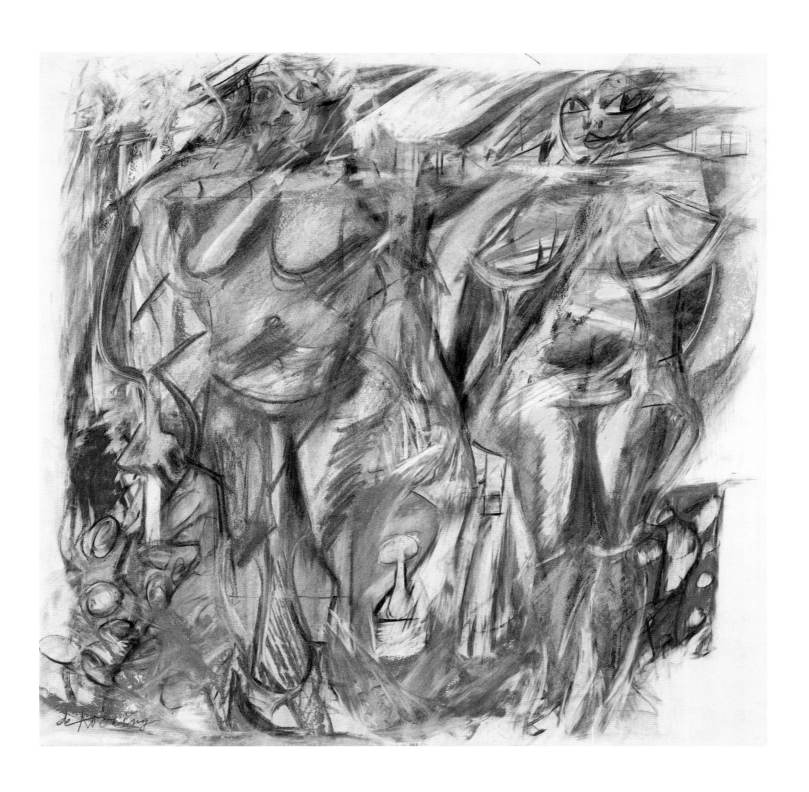

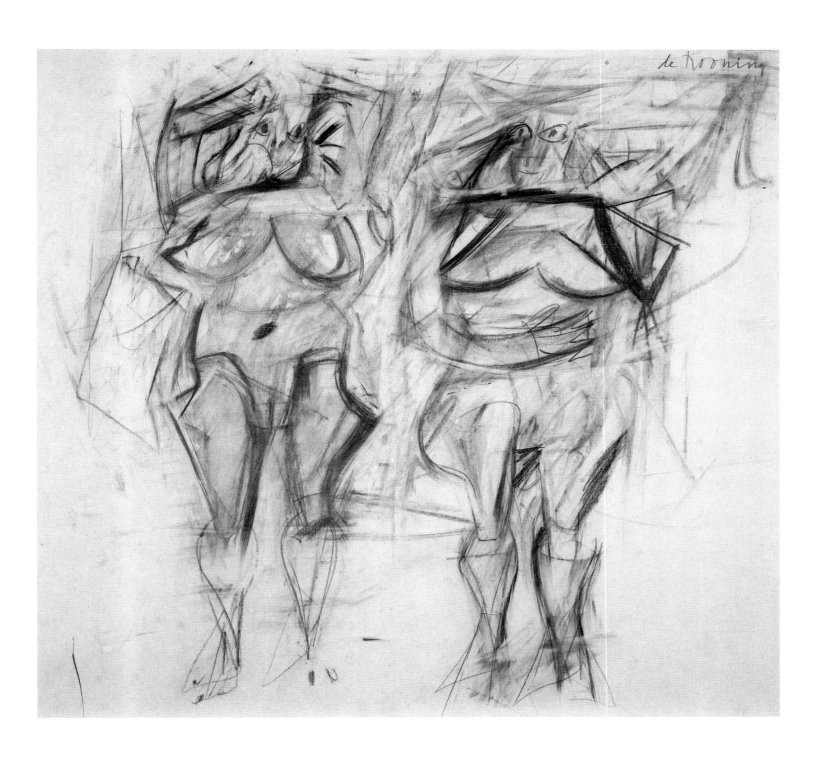

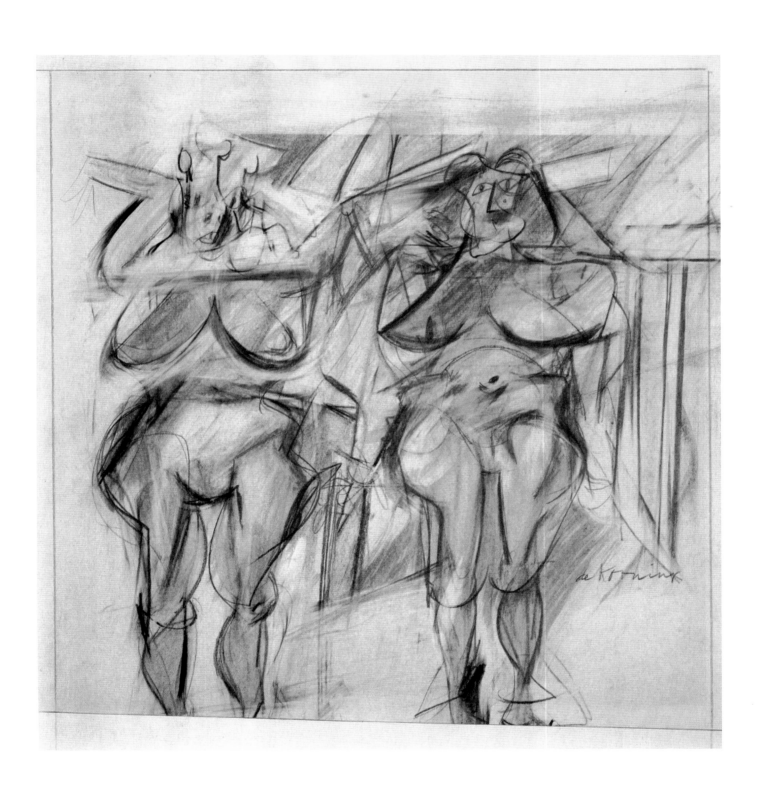

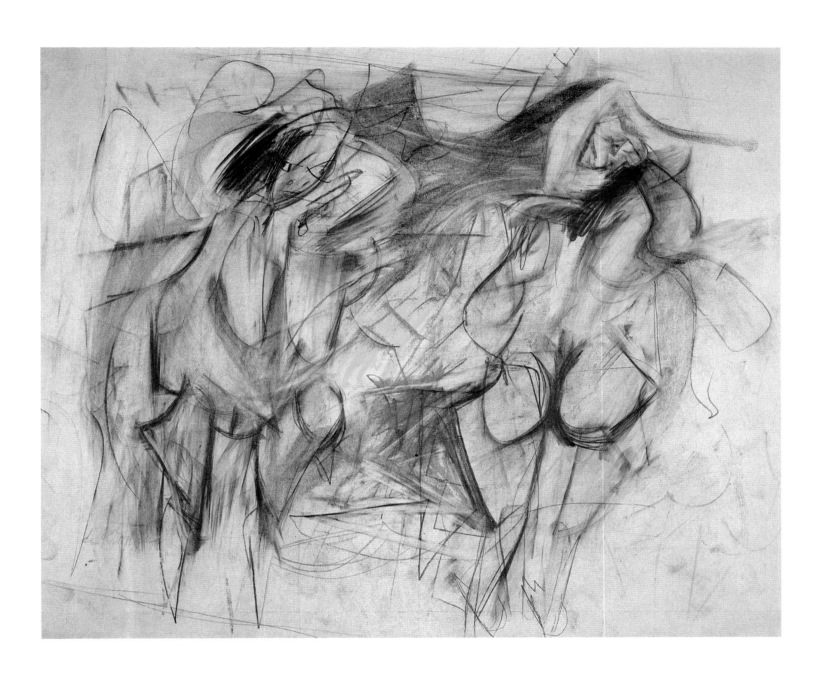

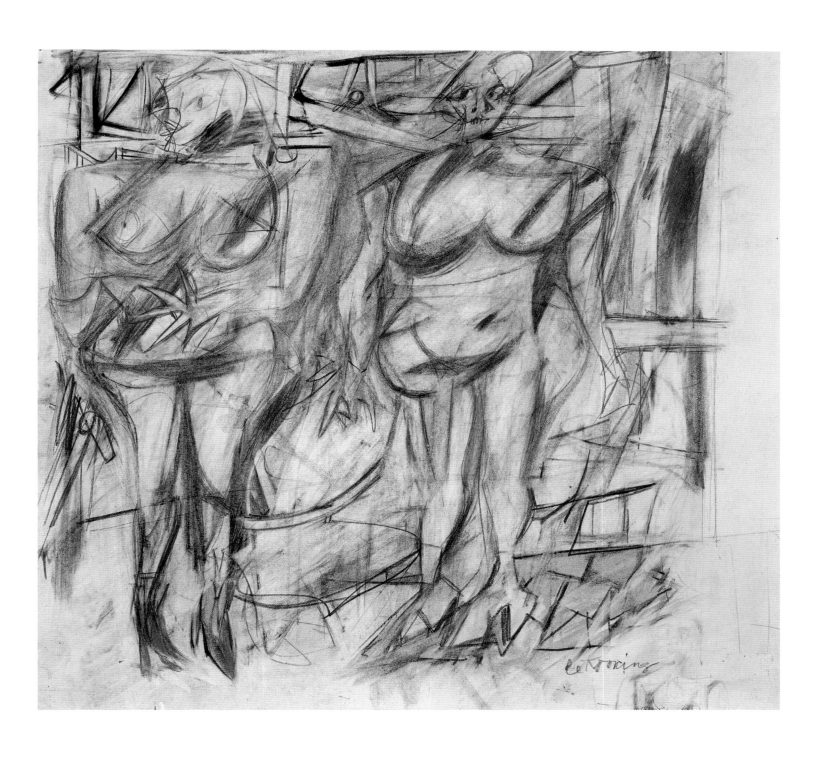

plate *women seated and standing,* 1952

69

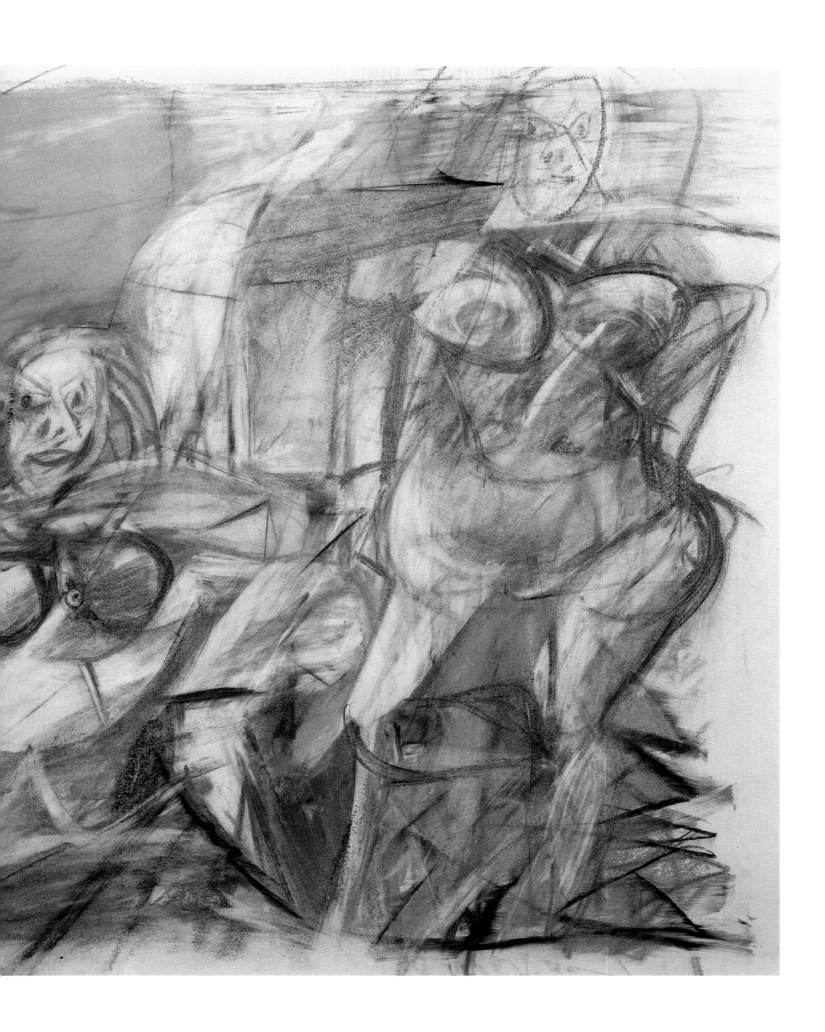

plate
70

torsos, two women, c. 1952–53

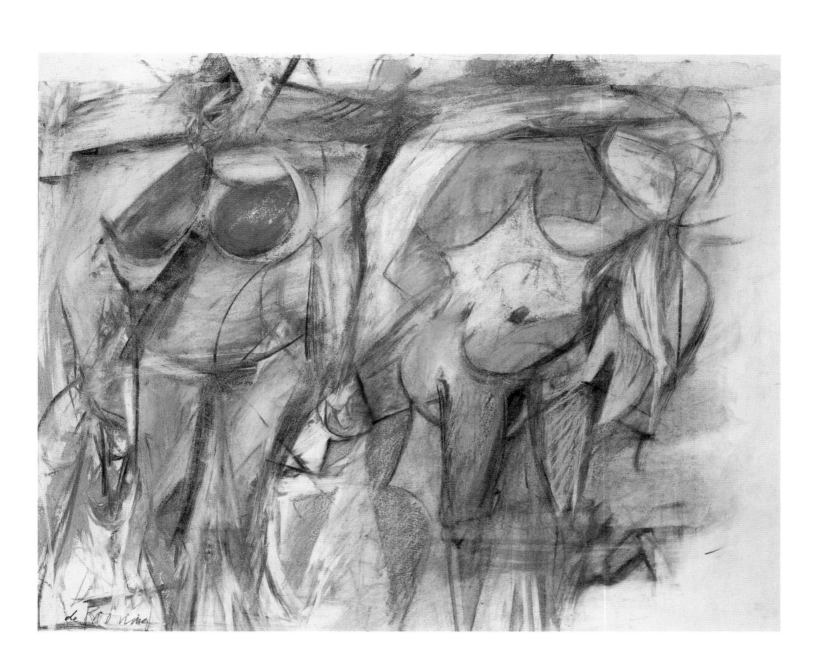

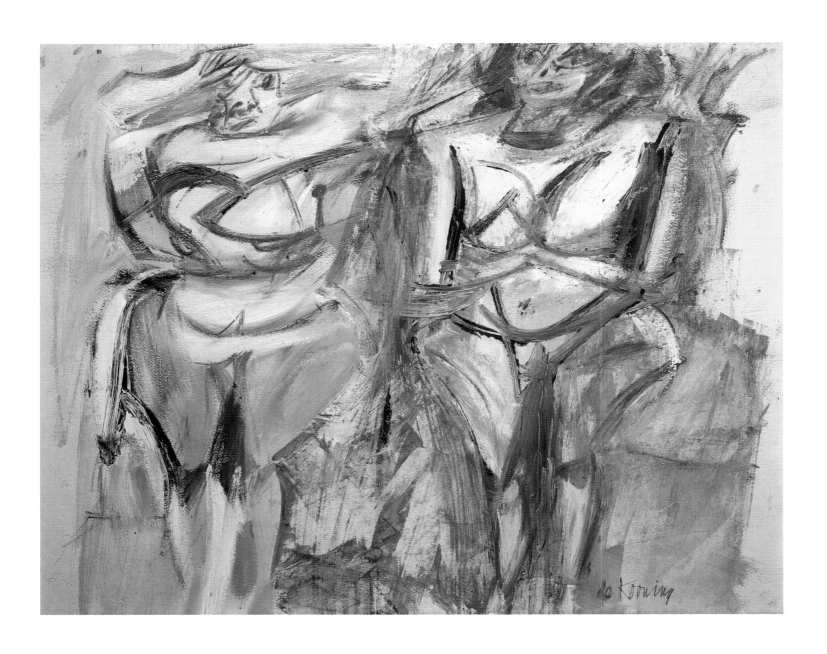

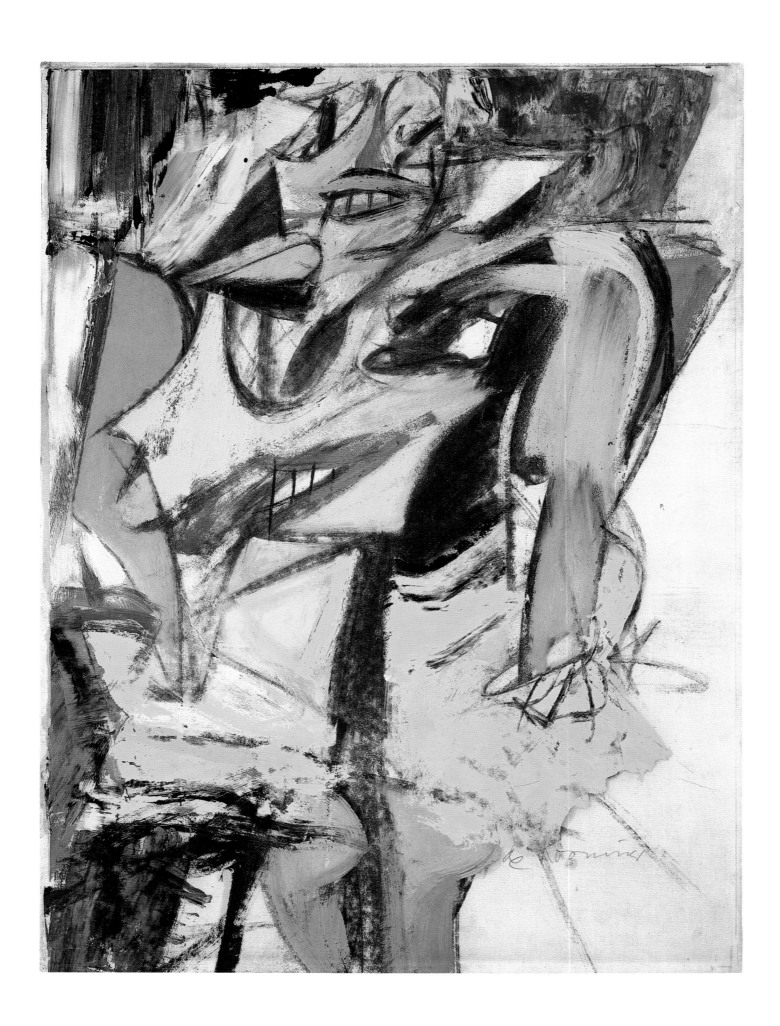

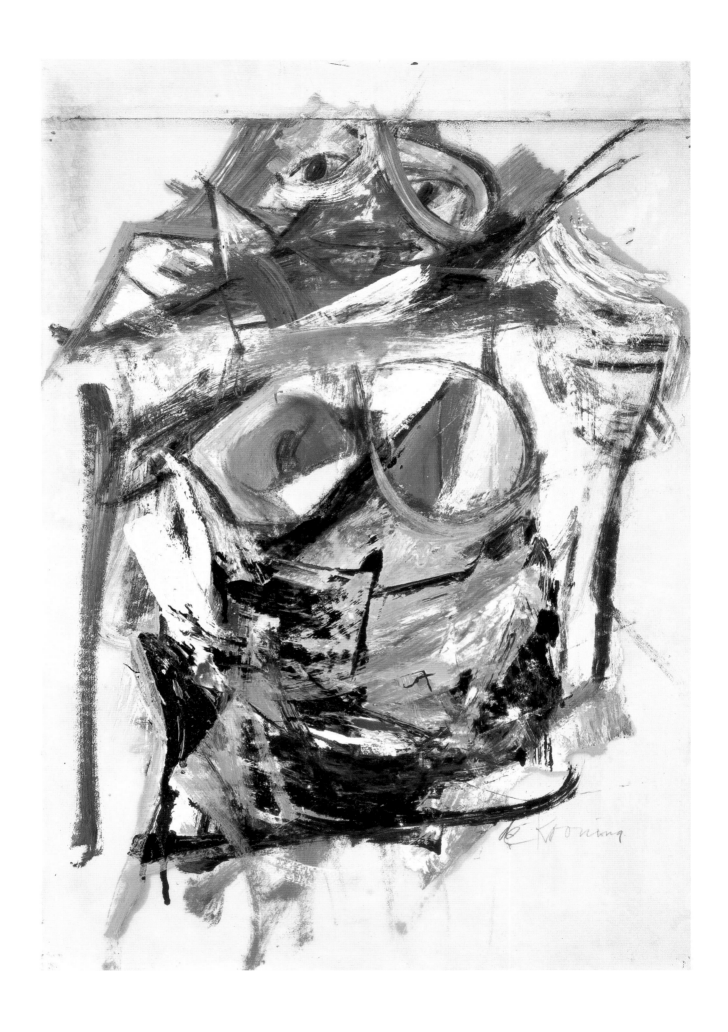

plate

74

monumental woman, 1954

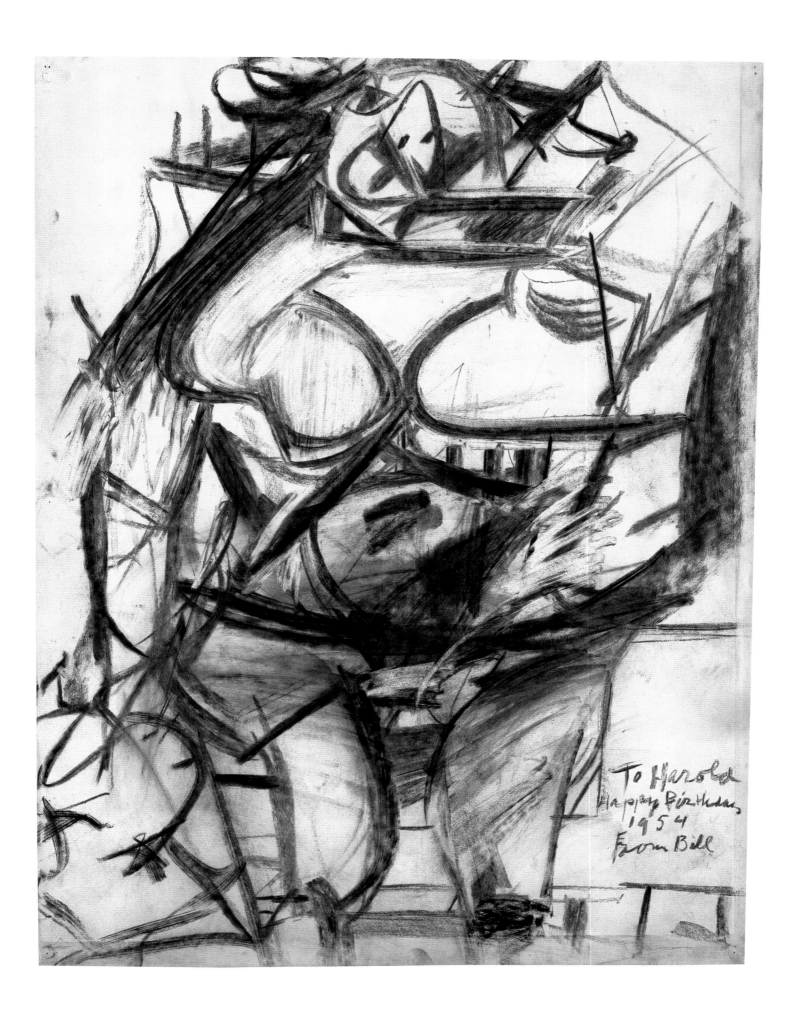

To Harold
Happy Birthday
1954
From Bill

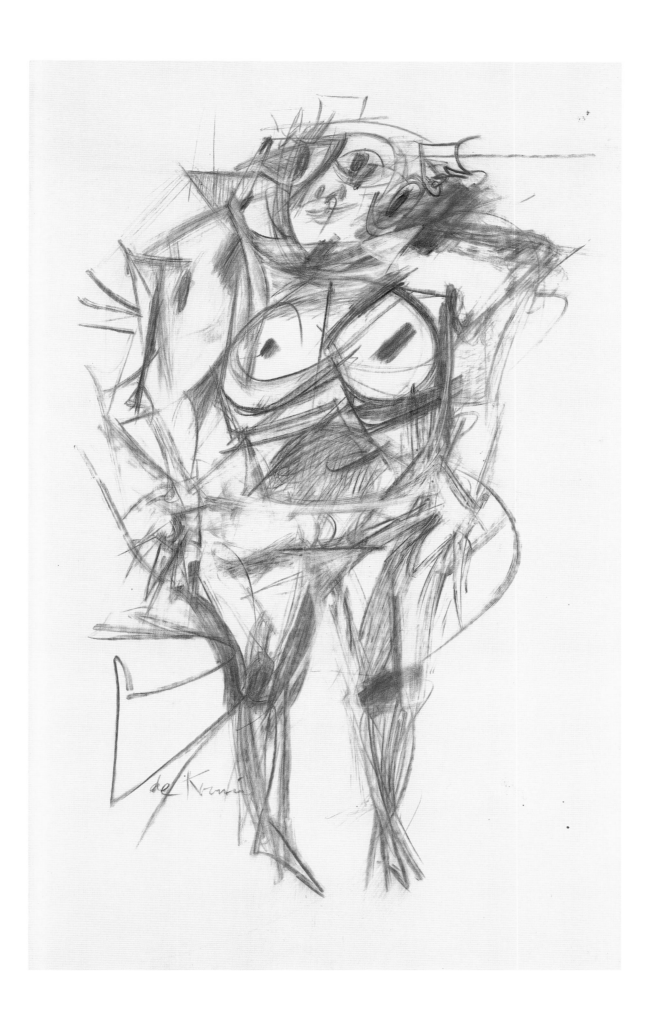

plate *two women,* 1954

76

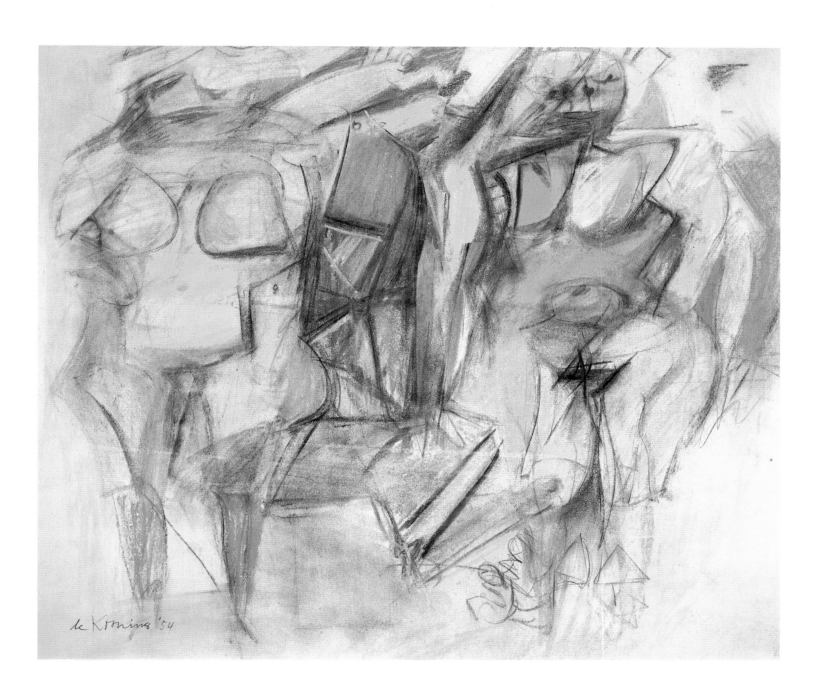

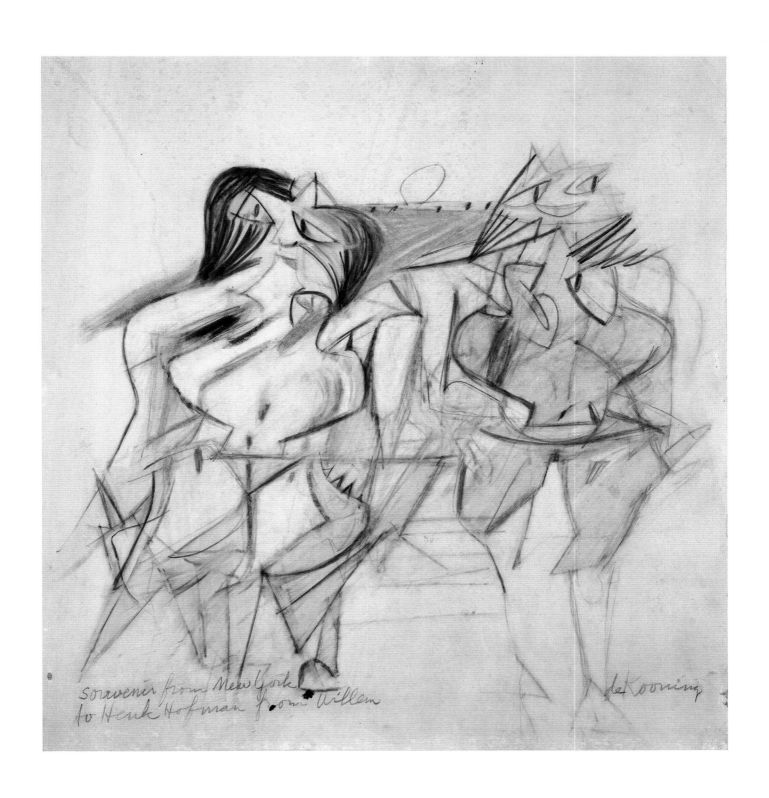

souvenir from New York
to Henk Hofman from Willem

de Kooning

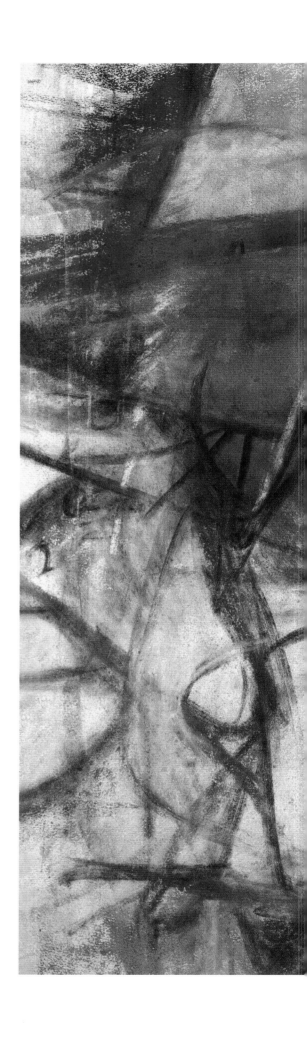

plate *figure in interior*, 1955

78

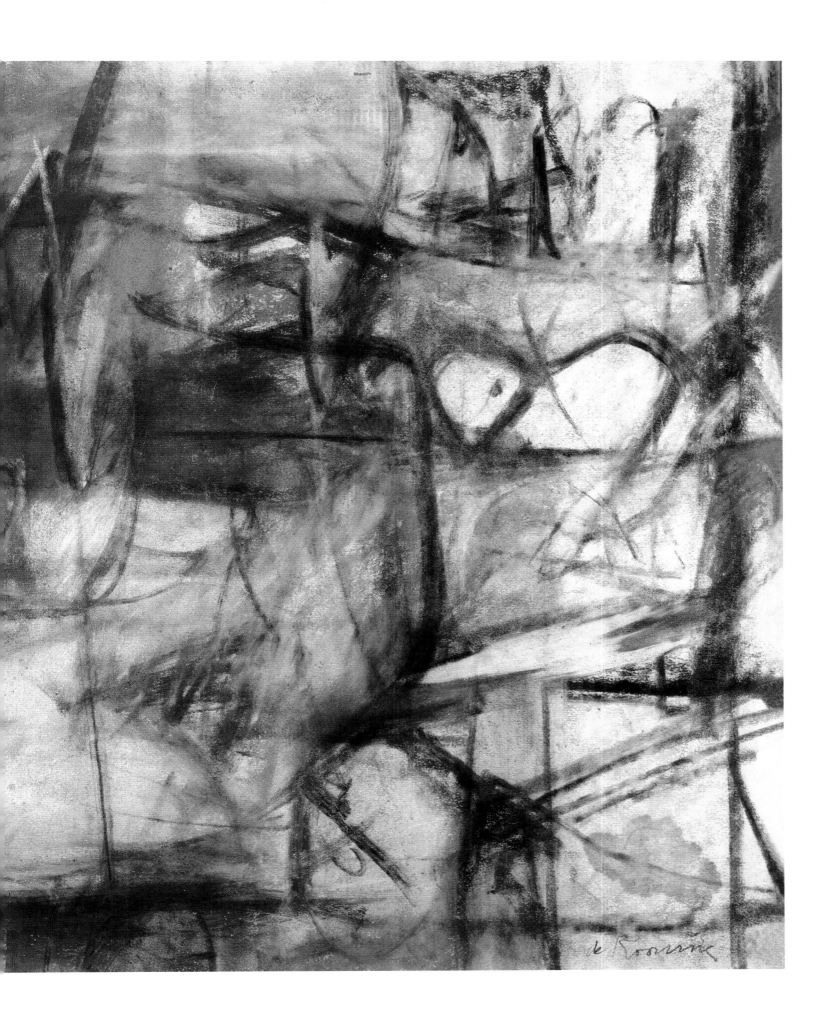

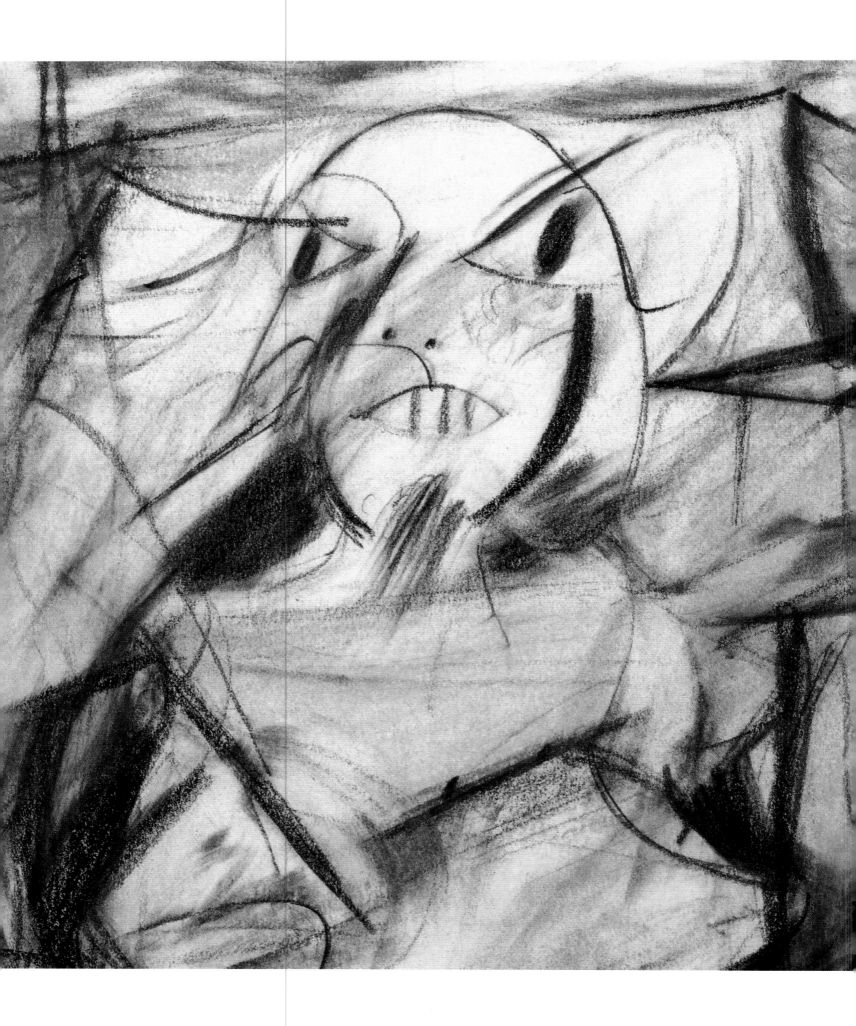

summer of '52

In June 1952, Willem de Kooning left his New York studio for Southampton, Long Island, with the paintings *Woman I* (1950–52) almost completed and *Woman II* (1952) and *Woman III* (1952) in different states of execution. He was preparing these works for a keenly anticipated solo exhibition planned for the spring of the following year at Sidney Janis Gallery. In leaving his studio for the summer, as he had done the year before, de Kooning was not only taking a break from the city and its active social scene, he was taking a break from painting. He had begun *Woman I* in June 1950 and it had preoccupied him for the better part of two years. It was a work that, in his own estimation, would define his mature career. To this day the development of this singular composition informs our understanding of de Kooning's struggle with painting.

Although there had been many precedents for this struggle in the artists de Kooning admired including Paul Cézanne, John Graham, and Arshile Gorky—as well as in his own work, de Kooning had never before been consumed with a composition that stood so squarely in the spotlight of New York's burgeoning art world. At the age of forty-four, with two solo exhibitions under his belt, he no longer had the luxury of creating works while sitting on the sidelines—works that, for the most part, were known only to a small circle of other painters. Even though "Jackson Pollock broke the ice,"[1] de Kooning had become the center of an emerging generation of artists in May 1951 when he was featured in Leo Castelli's first Ninth Street exhibition, along with Mike Goldberg, Grace Hartigan, Alfred Leslie, and Joan Mitchell. With this exhibition de Kooning was recognized, especially among younger artists, as the most influential force in the New York art world. In contrast to Pollock, whose methodology was so distinct that to emulate him was to be derivative, de Kooning's open-ended approach suggested new possibilities for painting. His March 1953 exhibition at Sidney Janis would be the public affirmation of the preeminent place he held among New York artists.

By comparison with Charles Egan's gallery, the site of de Kooning's previous solo show that took place in April 1951, Sidney Janis occupied a completely different position in the New York art world. Of all the city's galleries, Janis was the most important

141

opposite: *Study for "Woman I,"* 1952 (detail)

Woman I, 1950–52
Oil on canvas
75⅞ x 58 inches
The Museum of Modern Art, New York. Purchase

Installation of "Willem de Kooning: Painting on the Theme of Woman," Sidney Janis Gallery, New York, 1953

bridge between European and American culture; it had established the reputation of many European masters in the United States, including Piet Mondrian, the most influential Dutch painter of the twentieth century. Like Mondrian, de Kooning had also emigrated from the Netherlands to New York and suddenly found himself having an impact on other artists he could not have imagined.

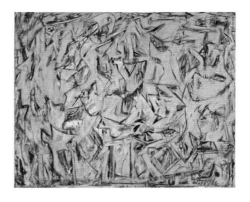

According to Thomas B. Hess, then editor of *Art News*, in January 1952 de Kooning cast aside *Woman I* in frustration.[2] It was not until March, after a visit from the art historian Meyer Shapiro, that he resumed work on the painting. In June, when he decided to take a break from the studio and the art world, he and his wife Elaine moved to a house in Southampton that they shared with Castelli and Ileana Sonnabend. He did not, however, take a break from his chosen subject. During that summer, de Kooning produced arguably the most lush, assured, exquisite, powerful, and challenging works on paper of his career. Working on the porch of Castelli and Sonnabend's home, he continued the practice of drawing, which had been so integral to the development of the Woman series and his work in general. At least one hundred of the drawings that he made between 1950 and 1955 may be associated with this series. Yet, unlike drawings he made as studies for the paintings, the ones de Kooning made during that summer attained such an impressive level of finish that they constitute a body of work that stands independent of the paintings. Though he made the studies simply for himself, these drawings were evidently made for presentation.

When de Kooning commenced work on *Woman I*, Hess began to spend time with him to research the painting's creation for an article planned for the March 1953 issue of *Art News*. The article was to be titled "De Kooning Paints a Picture," and the photographer Rudolph Burkhardt, a friend of the artist, was commissioned to photograph every stage of the painting's development for Hess's story of near-mythological proportions. *Art News* had previously published similar articles on the creation of works by important artists, and the stakes were high in publicizing de Kooning's return to the figure from the abstraction of *Excavation* (1950) in such a visible forum.

Focusing the public's attention on *Woman I*, Hess's article captured the sense of urgency and drama surrounding the work's creation, destruction, and re-creation. Published just prior to the opening of the Janis exhibition, the article began by drawing the viewer into the intensive struggle that characterized the artist's creative process as he and the author chose to represent it. As Hess wrote:

> In the first days of June, 1950, Willem de Kooning tacked a 7-foot-high canvas to his painting frame and began intensive work on *Woman*…He decided to concentrate on this single major effort until it was finished to his satisfaction…. The picture nearly complied to his requirements several times in the months that followed, but never wholly. Finally, after a year and a half of continuous struggle, it was almost completed; then followed a few hours of violent disaffection; the canvas was pulled off the frame and discarded…. A few weeks later, the art historian Meyer Shapiro visited de Kooning's Greenwich Village studio and asked to see the abandoned painting. It was

142

Excavation, 1950
Oil on canvas
81 1/8 x 101 1/4 inches
Collection of the Art Institute of Chicago
Mr. and Mrs. Frank G. Logan Purchase Prize; gift of
Mr. and Mrs. Noah Goldowsky and Edgar Kaufmann, Jr., 1952.1

brought out and re-examined. Later it was put back on the frame, and after some additional changes was declared finished—i.e., not to be destroyed.[3]

Hess further explained that the painting escaped further alteration by being given a rest for the summer.

It was no doubt with some sense of completion as well as an awareness of the expectations of him as he prepared for the Janis exhibition that de Kooning took a break from painting to return to the comfort, ease, and more instantaneous satisfaction that working on a diminutive scale allowed. His state of mind had evolved from one that, months earlier, had led him temporarily to abandon *Woman I*; yet he was still not over the hump of completing it. The drawings that de Kooning made during that summer are unusual, although not unique in his career. As Hess observed, the vast majority "are in the literal sense 'working' drawings. Almost none of them are independent works and very few are studies or sketches as these terms conventionally are applied to drawings made at various stages in the systematic development of a composition or in the analysis or refinement of a form.... When he is at work on a painting, drawings of all shapes and sizes lie scattered around him on tables, benches, the floor—like leaves falling from some huge tree."[4]

The quiet, private, study-like quality of many of de Kooning's drawings, however, is not descriptive of the works he made for the Janis exhibition. With this exhibition in mind, he produced a series of gloriously rich, confidently executed drawings, mostly pastels, which brought to completion ideas he had previously explored on paper in a far more cursory fashion. Using pastel, graphite, and charcoal, he achieved a state of finish much more characteristic of his paintings. These drawings, in contrast to the dozens he had executed for *Woman I* as he was working out ideas—fighting to keep a line fresh, or pondering how to transfer a shape, mark, or gesture from paper to canvas—were the result of a more confident hand. Rather than surveying the struggle of the preceding months, he searched for a sense of completion and posed questions. Whether he intended at the time to feature the drawings as a discrete group within the exhibition is not known; nonetheless, the works exhibited in the two rooms of Sidney Janis Gallery in March 1953 were ultimately separated by medium. When visitors entered the gallery, they encountered a room with sixteen drawings double hung, which offered a process-oriented introduction to the six Woman paintings in the adjacent room. Given the polished qualities of these drawings, distinguished by the preponderance of double-figure compositions and the expressive use of color, one may assume that de Kooning did, in fact, have their inclusion in the exhibition in mind as he was making them.

The Woman paintings have been the subject of dozens of publications. Thus it is remarkable that, although critics have recognized their exceptional character, relatively few have focused specifically on the works on paper. This is especially so considering they represent a break between the simultaneous creation and destruction that characterized de Kooning's paintings from June 1950 to June 1952 and the ultimate resolution that ensued the following autumn. In reviews of the Janis show and subsequent exhibitions, several critics called attention to the drawings, though virtually none focused on them at length. In a review of de Kooning's 1955 exhibition at the Martha Jackson Gallery, Fairfield Porter observed that the artist "demonstrate[s] Ingres's dictum that 'what is well drawn is well enough painted.'" He went on to remark that in works such as *Woman as Landscape* (1955) or *Two Women in the Country* (1954), the artist's "spaces are most substantial and fullest when he is able to use bare canvas, or flatness:

Dark Pond, 1948
Enamel on composition board
$46^{3}/_{4}$ x $55^{3}/_{4}$ inches
Frederick R. Weisman Art Foundation,
Los Angeles, California

it is in the most 'painterly' pictures that areas of thick paint and strong brush strokes look as though he were unsure of how to bring the painting to the frame, as if the painting had stopped before he could let it go."[5] This inability to "bring the painting to the frame" and to focus the activity of the composition on the center of the canvas—in contrast to the allover quality of Pollock's drip paintings—is consistent with many of the works on paper.

Reviews of the Janis exhibition gave short shrift to the drawings, referring to them as a "group of sketches" for paintings described as "monuments of confusion" about the success of failure.[6] Henry McBride's review featured a reproduction not of one of the paintings, but of a pastel, *Two Women with Still Life* (1952, plate 64). ("She reminds me of a lady of my acquaintance," the author observed.) In this review, McBride suggested that de Kooning produced the drawings in the service of the paintings and that they demonstrated the latter were products of a long and arduous process: "The pictures had not been dashed off hurriedly as one might think. On the contrary, the artist had struggled with them intensely for at least two years, making endless studies and changes."[7] Finally, James Fitzsimmons wrote in his review, "The exhibition also includes a number of pastel drawings in which the problems of anatomy and posing are explored. I found several of these quite exquisite and perhaps a little more coherently organized than the oils."[8]

But Hess's article was the first and the most extensive examination of the Woman series. Describing the creation of *Woman I* in great detail, Hess advanced the mythology of "heroic" struggle that characterized a generation of artists, asserting this struggle as central to de Kooning's working process. In this regard, he acknowledged the supportive role of the drawings. He carefully noted, for example, that de Kooning began a painting by generating

large-scale preliminary charcoal drawings and that the painting was further informed by several pencil drawings. Regarding the interplay between drawing and painting that typified its development, he wrote:

Before making changes, de Kooning frequently interrupted the process of painting to trace with charcoal on transparent paper large sections of, or the whole composition. These would be cut apart and taped on the canvas in varying positions. Thus in stage 1, the position of the skirt and knees have been shifted by the overlay.... Technically the method permits the artist to study possibilities of change before taking irrevocable steps. It also keeps a continuous if fragmentary record of where the picture has been. De Kooning often paints on the paper overlays, testing differences of color and drawing. Furthermore, when he goes back to the canvas it can be in relation to an area in two different stages of development—the overlay and the state beneath it. Off-balance is heightened; probabilities increase; the painter makes ambiguity into actuality. And ambiguity, as we shall see, is a crucial element in this (and almost all important) art.[9]

Fifteen years later Hess reiterated the supportive role of the drawings: "in two years of work on one rectangle of canvas, *Woman, I* was completed and then painted out literally hundreds of times. De Kooning paints fast and could cover the whole surface in a matter of hours. But then would follow weeks of analysis, dissection, drawing sections of the figure, moving the drawing to overlay another area."[10] He claimed, perhaps excessively, that there were "hundreds of studies, drawings, small oils, a magnificent series of pastels executed in East Hampton, Long Island, in the summer of 1952," and that, "In the studies de Kooning often expressed

144

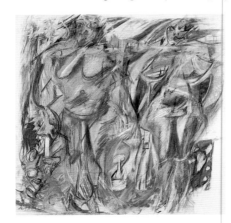

Two Women with Still Life, 1952

his enchantment with American girls: they are beautiful, bright, charming; some of these figures closely resemble his wife Elaine. But on the big canvas, Woman remained regal, ferocious."[11] It was not until 1972, however, that Hess analyzed the drawings not only in relationship to the paintings, but as independent works.[12]

Of the sixteen drawings included in the Janis exhibition, thirteen were pastels; one was graphite; the other two were oils on paper. Although the exact chronological sequence in which de Kooning made the pastels is unknown, stylistic analysis suggests that they probably progressed from single standing and seated figures to the predominant motif of the summer: two figures in architectural, landscape, or still-life environments. In addition, although de Kooning had used pastels in the past, he had never indulged in the medium to such a degree in such a concentrated period of time. His decision to work in pastels was perhaps motivated by a desire to take these works to a much further degree of refinement than the sketches he had made in support of the paintings.

The compositions of many of the pastels differ significantly from the paintings. The paintings focus on single monolithic figures that, for the most part, fill the pictorial field. Greens suggest landscape and blues ocean, while shapes resembling windows imply architectural elements. By contrast, nine of the pastels are double-figure compositions. All include specific references to elements drawn from landscape, architecture, and still life. As the paintings referred increasingly to the act of painting itself, the pastels remained truer to the reality from which de Kooning drew. He must have been aware of this difference as he planned the layout of the Janis exhibition, since the drawings not only informed the viewer about the process of making the paintings but also provided glimpses of specific details that were obscured in the paintings. Or so he would lead us to believe.

145

The pastels can be divided roughly into three groups: studies for Woman I, single-figure compositions, and double-figure compositions. The first group consists of color sketches that apparently inform or at least directly relate to the creation of Woman I. Given the notational character of these works, it is likely that they offered de Kooning opportunities to explore certain problems. Both Hess and E. A. Carmine observed that the breasts of the figure in Woman (c.1952, plate 54), for example, specifically resemble those of the figure in the painting. In addition, the figure in Study for "Woman I" (1952, plate 52) also resembles Woman I, especially in the eyes and mouth. Three of the pastels in this group—Woman (Seated Woman I) (1952, plate 60), Woman (1951–52), and

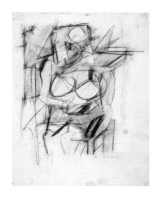

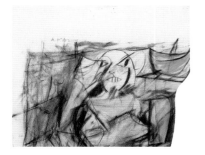

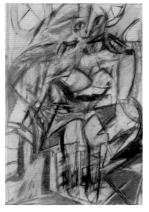

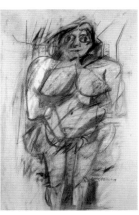

Woman, c.1952
Study for "Woman I," 1952
Woman (Seated Woman I), 1952
Woman, 1952

Woman (1952, plate 59) possess a higher degree of finish than the other pastels, and it is clear why de Kooning chose them to be among the few single-figure drawings in the Janis exhibition. Woman (Seated Woman I) is the most complex of these works. Not unlike the figure in Woman I, the figure here is a seated woman, visible frontally but fractured in a pinwheel-like landscape. She is rendered in a cubo-futurist fashion as if she were rotating, amplified by disk-like forms behind her head that are similarly distorted in circular twists. The palette of orange, green, yellow, red, ochre, and brown further amplifies the drawing's kaleidoscopic effect, which differs from the more settled monumentality of Woman I. Nevertheless, in certain details, such as the way in which the hands touch, the shape of the eyes, and the orientation of the left and right leg, the parallels to the painting become apparent.

In Woman (1951–52, plate 48), a particularly confident drawing, de Kooning relied more heavily on charcoal to create a series of repeated forms and shapes that are echoed in both the figure and the architecture. In an exuberantly baroque fashion, figure and ground intermingle, and color is used in a limited manner only to highlight the composition. Torso, breasts, knees, and architecture are all realized as expansive cones. Only the hair, a garish orange that appears in many of the pastels, is specifically descriptive.

The largest of the single-figure pastels included in the Janis exhibition is Woman [plate 59]. This composition is the most coherent and monumental of these works and demonstrates Kooning's debt to Pollock and Gorky, as well as the influence of Graham. The eyes that lend de Kooning's figure its perplexed and troubled expression seem to reference Graham's other-worldly, occult-inspired eyes. The face is exceptionally descriptive, while the architectural elements in the background—which may be read both as

windows and interior forms—are not as developed as in many other works with less emphasis on the figure and face.

The second group of pastels consists of single-figure compositions. Study for "Woman I" (1952, plate 50) evokes Woman I in general terms, but diverges from the painting in its specific composition and details. For example, the hands hang at the side instead of coming together in the figure's lap, and the rendering of the breasts and torso indicates that it is related to Woman I more in feeling than in fact. The repeated window-like architectural forms of the background pick up the orange of the figure's hair, which also evokes the orange hair of the Woman (Seated Woman I) and Woman [plate 48] figures.

The positive and negative space of the frieze-like form in the lower part of the composition is clearly evident in the more lyrical Seated Woman (1952, plate 51). Similar in scale and composition to Study for "Woman I," this work is rendered primarily in blues, with highlights of orange in the figure's hair, as well as violet—a color that appears in both drawings but is present in many of the other pastels. Whether she is seated or standing is not as clear as the jubilance of her expression. With long eyelashes and a toothy smile, she is among de Kooning's most Pop-looking figures; the artist pushes her almost kitsch-like quality further than he does in any of the other pastels. The face also shares similarities in color, form, and emphasis with the figure in Woman [plate 48].

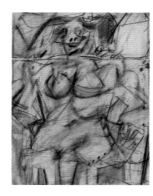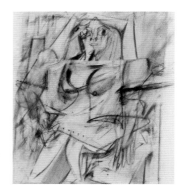

146

Seated Woman, 1952 (detail)
Study for "Woman I," 1952 (detail)

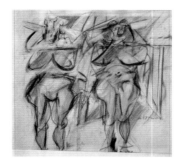

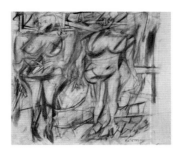

The third group of pastels consists of double-figure compositions in more referential spaces. These pastels must have had a special significance for de Kooning, for though he produced more single-figure compositions than double-figure ones, he made the latter the centerpiece of the works-on-paper room in the Janis exhibition. The complexity and finish of these compositions suggest that de Kooning took special interest in them during the summer of 1952, perhaps because they offered him the opportunity to echo forms between two figures. In addition, the horizontal format he adopted for this motif enabled him to introduce more specific references to architecture, landscape, and still life. At the same time, while giving him the opportunity to make more specific references to place, these compositions encouraged his development of shapes and forms that were referential, yet could stand alone as abstractions.

The architectural elements that form the background of *Two Women* (1952, plate 66) and *Two Women IV* (1952, plate 68) suggest the interior-exterior environment of the Castelli-Sonnabend summerhouse porch. In contrast to his New York studio, where a window offered a small view to the outside, the screened-in porch, used for both work and sleep, opened onto a more expansive view of the landscape. This view is evoked in the pastels, where complex vertical, horizontal, and diagonal struts resemble an agitated grid two standing figures occupy, as if on stage. These works, and their relatively complex architecture, lead one to imagine that de Kooning was representing the room where he spent most of his time working.

In *Two Women*, de Kooning created a sharply linear composition in which the angularity of the architecture is echoed in figurative elements, such as the breasts and hips. The figures seem to be floating in and out of the background while the architecture superimposes itself onto the figures and vice versa.

By contrast, in *Two Women IV*, the figures, seen from head to toe, are distinct from the background. Unlike the single-figure compositions, both *Two Women* and *Two Women IV* are characterized by a greater emphasis on the figure and its relation to the environment than on the specific nuances of the face. De Kooning no doubt found it liberating to make the background as important as the figure, thus obviating the conventional emphasis on the emotional content of the facial expression.

Two Women II (c.1952, plate 65) and *Two Women III* (1952, plate 67) are more expressionistic, gestural, and organic in composition. In *Two Women III*, the most expressionistic of the pair, the two figures seem to be lost in an agitated sea of blue and orange, as the kaleidoscopic effect of *Woman (Seated Woman I)* is taken to a much more fluid and organic extreme. Lost in a web of exquisitely intricate lines, the figures are drawn back into focus by the application of a

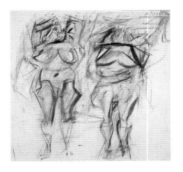

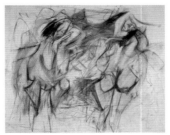

Two Women, 1952
Two Women IV, 1952

Two Women II, c.1952
Two Women III, 1952

peachy flesh color that distinguishes them from a background articulated in blue, purple, orange, and yellow. The figure on the right, meanwhile, is wonderfully ambiguous; her breasts and buttocks seem to mesh, bringing the multiple perspectives of Cubism into an almost liquid biomorphic composition.

In *Two Women II*, the architecture, which had previously tended to form the ground of the composition, infiltrates the bodies of the figures themselves. Arms raised behind the head form an architectural frame for the figure on the left, while a highly articulated horizontal line all but decapitates the head of the figure on the right. In addition, the legs and torsos of both exhibit an unnatural mechanical quality. This work, with its delicate application of color—especially orange and violet—is notable for the independence of line from its descriptive function, especially with regard to the figure. And all four of these standing-women compositions exemplify the extraordinary range and virtuosity that de Kooning brought to this motif. Each work is independent from the others; yet when seen together, the range—from the rigid geometrical and architectural articulation of *I* and *IV* to the fluid expressionistic qualities of *II* and *III*—is striking and demonstrates his deliberate command of the subject. He repeated this subject to a point where that apparently allowed him to navigate in many directions from a single origin.

In another group of three double-figure pastels, de Kooning's use of the medium began to take on a truly painterly and gestural independence. He probably completed *Women Seated and Standing* (1952, plate 69), *Two Women with Still Life*, and *Torsos, Two Women* (c.1952–53, plate 70) after his summer in Southampton.[13] In the Woman drawings, Philip Larson noted, he dispensed with conventional technique and opted for a more immediate handling of pastel, chalk, and charcoal.[14] Traditional pastel application often calls for a layer-by-layer application, beginning with

the darkest and working toward the lightest hues, with periodic fixings of color. De Kooning instead preferred to blur his colors into each other; preliminary outlines in charcoal fused with the surface of the paper and the tonality of the colored chalks. Rubbing and erasing, he dematerialized his figures and gave their bodies a luminous sheen. While he used gash-like strokes to build corporeal forms in the oils, the same gesture in the pastels yielded unexpected charm and delicacy. As Paul Cummings observed, "de Kooning introduced pastel to augment the pencil and charcoal, thereby changing the spatial and tonal aspects of the page. The pastel is often ground deeply into the paper's texture, resulting in delicate luminous tints rather than its usual grainy or velvety textures. His line in these few years underwent its greatest changes. This is recognized in the increasing velocity of application, the varying graphic weights achieved by the reiteration of the gesture in building a reinforced line, and his innovative use of the eraser as a stylus of light."[15]

Women Seated and Standing is among the most gestural of these pastels. The liberal and physical application of color in large, nondescriptive fields provides a counterpart to the jagged, angular charcoal lines, which endow the figures with a raw, raucous quality. Arguably worked on at two different times, this pastel is unusual for its inclusion of women both seated and standing. The seated woman on the left, thrust into the foreground, is notable for her fierce and angular features, as well as for the explosive orange behind her. Almost naturalistic highlights in the carefully rendered hair seep into a field of orange that forms a backdrop for the figure as well as a counterpoint to the blue within which she is posed. With references both to the landscape and architecture behind her, the figure on the right is more subdued and more closely related to the other standing figures. This is consistent with de Kooning's

148

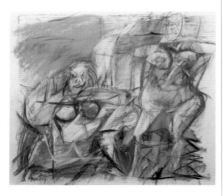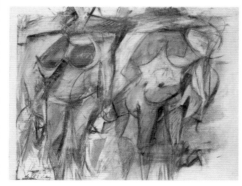

Women Seated and Standing, 1952
Torsos, Two Women, c.1952–53

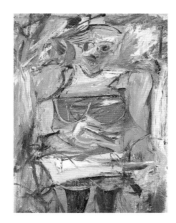

tendency to borrow something from one yet-to-be-finished composition and explore it in another. Finally by applying high-keyed color directly, in broad strokes, *Women Seated and Standing* anticipates the more colorful and abstracted quality of *Woman V* (1952–53) and *Woman and Bicycle* (1952–53).

Combining figures, landscape, and still life in a modestly scaled composition, *Two Women with Still Life* is one of the most complex, sensual, polished, and extravagantly rich pastels that de Kooning completed that summer. Two full-length standing figures, richly colored in fleshy peach, yellow, red, orange, and green, emerge from a background whose blues refer to the ocean and the sky and whose greens, which surround and even creep onto the figures themselves, suggest the landscape. Although the drawing was dated 1953 for the Janis exhibition, de Kooning clearly made it before January 1953. Compositionally similar to *Two Women I, II, III,* and *IV*, its use of still

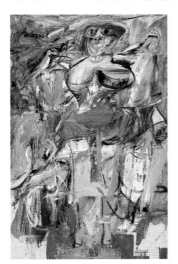

life and architecture is nevertheless more developed than in the other pastels; in addition, it displays a far wider range of colors. Working layer upon layer, de Kooning built up the surface by applying pastel over graphite and then by drawing the figures back out from the abstraction with charcoal applied in linear and descriptive strokes. Through the addition of layers and lines, one atop the other, as well as through the use of erasures and multiple alterations, he disguised his extraordinary virtuosity with the fierceness of his application of pigment—a virtuosity equaled by the fierceness of the figures themselves. In this dense and compact work, de Kooning struggled against beauty by creating a surface tension of color and line.

Two Women with Still Life reveals in particular the influence of the exuberant pastels made by Gorky in the Virginia landscape some ten years earlier. Like Graham, Gorky's treatment of eyes left an indelible mark on de Kooning. Where we might expect the wide-open, staring eyes of his figures to reveal something of psychological depth, they are in fact almost blank. Traces of Gorky can also be found in the biomorphic mushroom shapes and in the directness with which de Kooning applied color that was simultaneously descriptive and abstract. Hess described the array of still-life elements in the lower third of the composition as oysters, hamburgers, and a table brought out to a beachside setting. Even though those specific objects may have inspired the images, it is more clearly Gorky's biomorphic forms that inform their abstraction. Along these lines, the nebulous forms in *Torsos, Two Women* may reflect the more specific inspiration of one of Gorky's most important works: *The Artist and His Mother* (c. 1926–36). The form between the two figures—a form that is neither figure nor background and is heightened by the application of charcoal and orange—suggests that at one point de Kooning may have attempted to include three figures

Woman V, 1952–53
Oil and charcoal on canvas
60³/₄ x 45 inches
Collection National Gallery of Australia, Canberra

Woman and Bicycle, 1952–53
Oil on canvas
76¹/₂ x 49 inches
Collection of Whitney Museum of American Art. Purchase

in this drawing. Even if Gorky's legendary painting did not specifically influence *Torsos, Two Women*, it must have prompted his continuing interest, especially during the summer of 1952, in the motif of two standing figures.

Unlike the faces of many of the double standing figures that exhibit more painterly and abstracted qualities, the faces of the figures in *Two Women with Still Life* are distinguished by an unusual degree of specificity. With its large-eyed, confused smile, the figure on the left is remarkably similar to *Woman* [plate 59], while the one on the right is much closer to the pin-up girls from popular culture that de Kooning was also interested in. With her smiling red lips and glamorous eyes, she is more curvilinear, sensual, and feminine than the figure on the left, which is more broad-shouldered, straight-hipped, and masculine. Indeed, the broad chest and thick waist of the latter, though clearly female, hints at androgyny. The voluptuousness of the right figure contrasts strikingly with the muscularity of the one on the left.[16] Running behind the figures in the background is a frieze of architectural structures resembling windows. They divide the composition horizontally, in direct counterpoint to the strong verticality of the figures themselves. As he did in many of his other double-figure compositions, de Kooning took a strong linear element from the background and ran it across the figures, using it to connect one to the other.

One of de Kooning's most colorful and abstracted pastels is *Torsos, Two Women*. The horizontal line that connects the figures here has all but obliterated their heads, and the riotous colors anticipate the direction that the Woman paintings would take that fall. Of all the pastels, it is most suggestive of *Woman V* in its erotic palette. The figure on the left, for example, rendered in earth tones with patches of purple, violet, green, and fleshy peach, is distinguished by large orange-red breasts that foreshadow the palette and abstraction of the breasts of the figure in *Woman V*. With the same brutal confidence with which he would eventually apply oil to canvas, de Kooning worked the composition from light to dark and from dark to light, erasing and drawing over to such a degree that the paper begins to feel like flesh that has been scarred and healed.

During his summer-long reprieve from laboring on the Woman paintings, de Kooning found resolution to some of the problems of composition and palette through an exploration of drawing. Even the painterliness of painting, a thing that had obsessed him, was effectively addressed through the medium of pastel. He found in it a painterly quality antithetical to what might be expected from a drawing medium, yet it was somehow able to explain some of the most fundamental aspects of painting. Drawing allowed him to maintain the freshness so essential to his project. As Philip Pavia observed, "The drawings both were liberating and informational, and they provided him, at this most critical juncture in his development, an opportunity both to step back and consolidate that which he had learned in the process of painting while simultaneously forging ahead fearlessly, [knowing] that he would not be ruining an oil painting."[17] In addition, his double-figure compositions anticipated his next series of paintings, in which the figures disappear and the (formerly background) landscape becomes the subject. The drawings helped de Kooning break through a conceptual logjam, and it is understandable why he wished to give them such prominence in the Janis exhibition. Even though it was the paintings in the Janis show that ensured de Kooning's stellar place in the constellation of New York art, the real stars for de Kooning may have in fact been the drawings—because they showed him the way.

◆

150

schimmel

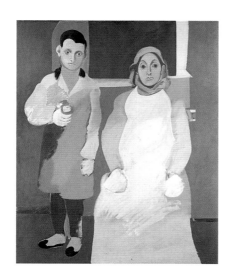

1 De Kooning, as quoted in Thomas B. Hess, *Willem de Kooning* (New York: Braziller, 1959), 11.

2 Thomas B. Hess, "De Kooning Paints a Picture," *Art News* 52, no. 1 (March 1953): 30–33, 64–67.

3 Ibid., 30.

4 Thomas B. Hess, *Willem de Kooning: Drawings* (Greenwich, Conn.: New York Graphic Society, 1972), 13.

5 Fairfield Porter, "Willem de Kooning at Martha Jackson," *Art News* 54, no. 7 (November 1955): 49.

6 Otis Gage, "The Reflective Eye," and Hubert Crehan, "See Change," *Art Digest* 27, no. 14 (15 April 1953): 4, 5.

7 Henry McBride, "Abstract Report for April," *Art News* 52, no. 2 (April 1953): 47.

8 James Fitzsimmons, "Art," *Art and Architecture* 70, no. 5 (May 1953): 6.

9 Hess, "De Kooning Paints a Picture," 32.

10 Hess, *Willem de Kooning*, exh. cat. (New York: The Museum of Modern Art, 1968), 75.

11 Ibid.

12 See Hess, *Willem de Kooning: Drawings*.

13 I am inclined to think that as the summer wore on, de Kooning moved from the monumental single-figure compositions to the double-figure ones, to the increasingly abstracted and gesturally charged pastels. To be sure, this neat ordering of his development probably does not reflect his tendency to move back and forth rather than to develop in a purely linear fashion.

14 Philip Larson, "De Kooning's Drawing," in *De Kooning: Drawings/Sculptures*, exh. cat. (Minneapolis: Walker Art Center, 1974), n.p.

15 Paul Cummings, "The Drawings of Willem de Kooning," in *Willem de Kooning: Drawings, Paintings, Sculpture*, exh. cat. (New York: Whitney Museum of American Art, 1983), 17.

16 In a 1956 interview, when pressed about the meaning of the Woman series, de Kooning said: "Maybe in that earlier phase I was painting the woman in *me*. Art isn't a wholly masculine occupation, you know. I'm aware that some critics would take this to be an admission of latent homosexuality. If I painted *beautiful* women, would that make me a nonhomosexual? I *like* beautiful women. In the flesh; even the models in magazines. Women irritate me sometimes. I painted that irritation in the 'Woman' series. That's all." See Selden Rodman, "Willem de Kooning," in *Conversations with Artists* (New York: Devin-Adair, 1957), 102.

17 Philip Pavia, conversation with the author, New York, June 2001.

Arshile Gorky
The Artist and His Mother, c. 1926–36
Oil on canvas
60 x 50 inches
Collection of Whitney Museum of American Art, New York
Gift of Julien Levy for Maro and Natasha Gorky in
memory of their father

de kooning controlling de kooning

skill

At Manhattan's Sidney Janis Gallery in May 1959, Willem de Kooning presented a group of broadly brushed abstractions in the style of *Montauk Highway* (1958).[1] These new works were consistent with the artist's longstanding interest in the gestural act of marking. We might just call it "drawing"—drawing in its most primitive form, involving bodily movement that traces out the line or mark. Granted, works like *Montauk Highway* hardly appear "drawn" or linear, certainly not at first; yet they clearly suggest the tracing or tracking movement of the painter's arm, with its brush (gesture as additive) or scraper (gesture as subtractive). By one means or another, de Kooning spread color across his picture surface, nearly always leaving the drawn or dragged aspect of his paint apparent.

As "drawing" in this sense, his new abstractions could be linked to his earlier, figurative images of Woman, both those classified as "painting" (those on canvas) and those classified as drawing (those on paper).[2] *Woman I* (1950–52, page 141), an oil on canvas, and *Two Women III* (1952, plate 67), a pastel on paper, both display fragments of line and contour along with passages of "painterly" color. They also contain numerous marks that seem to hover between contour and passage, such as the strips of green, yellow, white, and black that surround the legs, arms, shoulders, and head (or hair) of *Woman I*. Such marks or areas of color enclose the figure like a thickened contour, yet extend its material substance in all directions, as if identifying the physicality of the body with the materiality of the paint. Because the marks that clearly lie within the "body" of the represented figure are so similar to those that appear at its periphery, the distinction between figure and ground becomes indeterminate.[3] In *Two Women III* the areas of pinkish (flesh?) color to the left and right of the head of the left-hand figure might signify arms, but they might just as plausibly be a feature of the background. Cultivating this kind of ambiguity, de Kooning's technique made any firm distinction between enclosure and extension impossible to discern.[4] His ambiguity in marking was consistent with a formal or structural ambiguity that characterized his conversation; with inversion, reversal, contradiction, and ellipsis he avoided conclusion and certainty. Here, from 1959, is a timely sample of his talk: "Existentialism…has something to do with the essence or existence… I can take both at the same time…I could make the essence [exist]…or I could say that the existence is the essence."[5]

The abstractions de Kooning exhibited in 1959 may have shared both "drawing" and ambiguity with his previous work, but a certain difference was nevertheless striking. The organization of the marks in the new works was much looser than anything seen in the Woman series of the early 1950s, nor did it compare with the dense, concentrated structure of the abstractions of the mid-1950s, such as *Gotham*

opposite: *Study for Pink Angels*, 1945 (detail)

Montauk Highway, 1958
Oil and combined media on heavy-weight paper
mounted on canvas
59 x 48 inches
Los Angeles County Museum of Art
Gift of the Michael and Dorothy Blankfort Collection
in honor of the museum's twenty-fifth anniversary

News (1955). Even sympathetic viewers must have found de Kooning's new broadness and looseness surprising. After all, in a general statement of 1955 Clement Greenberg had identified this artist as the one Abstract Expressionist to maintain Cubist composition and even extend its pictorial investigation.[6] As a formal assessment of the earlier de Kooning style, Greenberg's was reasonable enough, although the artist always resented being typecast or categorized in this manner.[7]

De Kooning's "late Cubist" form, Greenberg suggested, would "reassure" the knowledgeable public that his "savage dissections" of the human figure still belonged to a tradition with a viable structural logic.[8] Today it may seem strange for a critic to refer to "savage dissections" without immediately appending commentary on psychoanalytic or gender factors. If a male artist appears to be "dissecting" a female body, we ask whether the motivation is fascination and desire or anxiety and hostility. And would the problem belong to the individual or to society? Many critics did tend to speak of de Kooning's *picture* of Woman as if it had come alive like a pagan idol. With their own projections, they fetishized the Woman even if the painter didn't. As an alternative path of interpretation, de Kooning's cartoonish Woman could be regarded as a parodic critique of American postwar conformity and its advertising image of the all-American girl—part pin-up, part cheerleader, part housewife and mother. This was essentially the view of Thomas Hess, a more intimately informed and more sympathetic critic of de Kooning than Greenberg.[9]

Such interpretation hardly interested Greenberg, who directed his language to the immediate materiality of the painting rather than its representational pop-culture references. De Kooning had "dissected" form and composition, not the imaginary (social) body with which most other viewers, whether male or female, were identifying. When Greenberg commented on "late Cubist" form in 1955, he was implicitly resisting opinions like that of James Fitzsimmons, who projected the "savage dissections" onto specific anatomical parts, regarding three prominent dabs of paint on *Woman II* (1952) as "three bloody stab wounds on the chest." "I have heard [de Kooning's Woman] described as the American woman of the future," Fitzsimmons wrote; "this female personification of all that is unacceptable, perverse and infantile in ourselves, also personifies all that is still undeveloped [in the American unconscious]." Then he added, in contradistinction to Greenberg: "it is exceedingly difficult to evaluate these paintings on a formal aesthetic basis." The difficulty for Fitzsimmons was twofold: de Kooning's compositions were quite incoherent to begin with (although this didn't invalidate them), and the confusion was compounded by the inherent "horror" of the image.[10] Perhaps Greenberg tacitly agreed. In 1953, when he himself introduced de Kooning's new Woman paintings for an exhibition, he spoke generously but with a hint of apology for the artist's turn from his late-1940s abstraction. "[De Kooning] wants in the end to recover a distinct image of the human figure, yet without sacrificing anything of abstract painting's decorative and physical force…[His line] is never a completely abstract element but harks back to…human form."[11]

When Greenberg committed himself in 1958 to revising a number of his essays for their republication, he chose to alter what he had said about de Kooning's "late Cubist" composition in 1955. He now identified the painter's "reassuring" traditionalism as little more than a sop for those "who still find Pollock incomprehensible."[12] Jackson Pollock, de Kooning's deceased rival, would be eternally known as an abstract artist. Despite the occasional representation, he didn't paint anything so obviously "reassuring"

154

as Woman. But in 1958, and certainly a year later with the 1959 exhibition on view, it might have seemed that de Kooning had become as challenging as Pollock. He had left his implicit traditionalism behind, at least temporarily. In fact, his new abstractions not only eliminated the figure but a lot of the old abstraction, too. Each work of the *Montauk Highway* type seemed to have been reduced to five or six sweeping strokes of the brush. Were these paintings as "fast" as they looked?

Perhaps de Kooning was dodging social and psychological issues by slipping into pure spontaneity—hence, the appearance of speed and reductiveness. He often insisted that a painter's concentration on the act of painting blocked all other considerations (as here, in a statement of 1951): "If you paint your whole life, you take that for granted, and after a while all kinds of painting become just painting for you—abstract or otherwise."[13] Refusing any fundamental distinction between abstraction and figuration, de Kooning implicitly rejected one of the prime reasons to make an abstraction; according to Alfred Barr, an abstract work "confines the attention to its immediate, sensuous, physical surface far more than does [representation]."[14] For Barr, as for many others around mid-century, what counted most was "the primary reality of paint on canvas," however it became evident.[15] Even though Hess offered a cultural reading specific to de Kooning's Woman and, beyond that, enjoyed speculating on the political and social causes of general aesthetic trends, he claimed that the merit of any great painting—Titian was his example—would be discovered "independent of references to anything except to its physical existence."[16] This, in 1951, was a commonplace notion.[17] American art and social critics alike linked material presence to the value of direct experience, the means to liberated expressiveness in an era felt to be one of social conformity and subtle political repression.[18]

Even if the value of de Kooning's art were confined to the immediacy of his mark, anyone who knew him would suspect that something more must lie behind the superficial reductiveness of paintings like *Montauk Highway*. He wasn't one to finish an image quickly and easily. "Finish" itself raised difficult questions for artists concerned with spontaneity. To understand a work as finished would seem to require a standard for artistic resolution, which amounts to a precondition; and preconditions defeat spontaneity. In April 1950, when a group of New York School artists met at "Studio 35" to discuss this issue, de Kooning made one of his typical dead-end contributions: "I refrain from 'finishing.'" In other words, resolution wasn't his problem; he had no desire to finish. The refined technique of School of Paris painters, de Kooning believed, automatically brought a sense of finish along with it: "They have a touch which I am glad not to have," he quipped.[19]

Along with the "fast" touch that was his, de Kooning also had delaying tactics. He would scrape down a painting whenever he felt dissatisfied with its progress; but, even when things were proceeding well, he might scrape down at the end of a working day to insure a fresh start for the next session.[20] A canvas that looked "fast" might have been labored over for months. This is true of paintings of the *Montauk Highway* type; their outermost skin, seemingly "fast" and assured, records only a single day's work. Yet every "erasure" becomes part of an integrated template, either remaining visible (see the bottom right corner of *Montauk Highway*) or guiding the forms above it, so that the formal benefits of a day's labor won't be lost. The scrapings or erasures create a permanent gritty stain in either canvas or paper, like the stains on New York pavement that de Kooning enjoyed observing.[21] The stain, a kind of magical memory trace—both material and immaterial—was familiar to de Kooning from the commercial

work he undertook during the 1940s, where he tested out images by drawing with inks that could be removed without violating the underlying pencil study.[22]

Especially when de Kooning used pencil or pastel on paper, his acts of erasure—smearing, smudging, rubbing—assumed the character of a positive gesture, a decisive move as "fast" as any of his others. *Two Women* (1951, plate 41) and *Two Women* (1952, plate 66) are typical works, constructed as much from the removals as from the additions. Every element of de Kooning's technical practice, from the most positive to the most negative, can become its opposite: the marks are both direct and indirect, spontaneous and controlled. They changed their character as de Kooning twisted and turned them from concave to convex and back. In his view, to finish was merely to reach a satisfying state of ambiguity.

Time gave its review of de Kooning's 1959 work an appropriately clever title: "Big Splash." The phrase captured both the look of the paintings and their effect on the market; for despite the exaggerated scale of these new gestures, they quickly sold out. "There's no way of astonishing anyone any more," de Kooning told *Time*'s reporter, as if there were an element of disappointment in his success; "I'm selling my own image now."[23] At this point in his career, aged fifty-five, the contrarian artist had to accept his public acceptance. Critics were acknowledging him as the most influential member of his generation: "Today young painters blow-up enormous pictures after a glimpse of small de Kooning sketches." This was Hess's observation, as he concluded the first monograph written on the artist. It happened to use *Montauk Highway* as one of its illustrations and was published shortly after the 1959 show.[24]

De Kooning's high rate of approval affected his most immediate public of fellow painters and also affected himself. On the part of the other artists, there was concern—evident already in Hess's phrasing—

that such a clear paradigm would exert undue influence. It would inhibit the younger artists' capacity to invent images and methods according to their own expressive needs. De Kooning, like any fashionable model, was supplying the others' needs and desires for them. His own concern was similar: he worried that success would induce him to repeat himself. He would become his own imitation, hardly better than the art school graduates making their "blow-ups."

Around 1959 resistance to the de Kooning paradigm congealed. Younger artists decided that derivations from his manner were generating a new kind of academicism, a "slickness of the unslick," to quote Helen Frankenthaler.[25] As much as de Kooning was a hero, he had become the figure to be resisted or circumvented. His gestural strokes tempted imitators, but the imitations lacked the original intensity (as Hess implied in his monograph). De Kooning's own concerns didn't derive from groundless paranoia, for it was sometimes suggested that he, too, lacked the original intensity. If I interpret Barnett Newman's anonymous references correctly, he shared this opinion, believing that de Kooning fell into the trap of plotting out "spontaneous" effects. Most likely, Newman was describing de Kooning and his ally Franz Kline when he complained to an interviewer, probably late in 1961: "There is such a thing, you know, as contrived spontaneity. There are those who work with great deliberation and calculation from sketches that they enlarge or from a variety of sketches that they swing together…correcting and correcting."[26] Enlargement was Kline's device; the phrase "swing together" probably referred to de Kooning's practice of tracing elements of one of his images onto the surface of another, to create an unforeseen configuration alien to both sources. Newman distinguished his utter directness from the practices of these collegial rivals. He was the one who "never worked from sketches, never

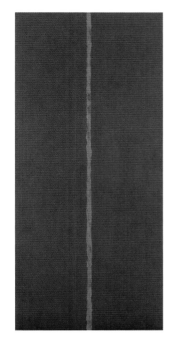

planned a painting, never 'thought out' a painting."[27]

Let's assume that de Kooning was striving for creative and emotional spontaneity as much as anyone else and was aware of this kind of carping about his tricks. We then have a context for remarks he made in 1959 within the space of about two months, thoughts that would apply not only to works like *Montauk Highway* but also to the famous figure paintings, such as *Woman I*. To the *Time* reporter in May 1959, de Kooning said, "I'm not trying to be a virtuoso, but I have to [paint] fast."[28] And to an interviewer who was having him filmed during the summer of that year, he addressed the same issue but in a more complicated way: "When I am falling, I am doing all right: when I am slipping, I say, 'Hey, this is very interesting.' It is when I am standing upright that bothers me. I'm not doing so good. I'm stiff, you know."[29] On the one hand, he strives for speed—painting "fast." On the other hand, he strives for a self-induced lack of balance— "falling," "slipping." Both features of de Kooning's technique insure that his painting remains spontaneous, inventive, and, for him, a true adventure. What he wants to avoid is virtuosity: "I'm not trying to be a virtuoso."

Yet de Kooning *was* a virtuoso. He possessed remarkable motor skills and an unsurpassed

knowledge of painter's materials. "The brush is handled…with great virtuosity, of course, for there is probably no one around who knows *more* about the techniques of painting," wrote Fitzsimmons, regardless of his misgivings about de Kooning's 1953 show of Woman paintings.[30] To escape virtuosity, de Kooning would have to suppress or disguise what was already there. The situation seems to have been grasped immediately with respect to the artist's 1948 exhibition of abstractions, his first one-person show. Included was *Painting* (1948), an elaborate construction of marks made by tools for both brushing and scraping. With the hand being used so many different ways in *Painting*, surface sensuality dominates

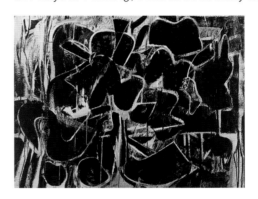

compositional logic. In a brief review, Renée Arb aptly wrote of "virtuosity disguised as voluptuousness," concluding that "the process of painting [itself] becomes the end."[31] I believe she meant that de Kooning directed his skill at manipulating the medium without the constraint of following an external model. De Kooning's skill, his virtuosity, was embodied knowledge, understood as if from the inside—habits of the hand and eye involving intense concentration and control.

Such skill could be demonstrated but not easily described. John McMahon, who became acquainted with the artist during the late 1950s and served as his studio assistant during the 1960s, recalls being

Barnett Newman
Onement III, 1949
Oil on canvas
71 7/8 x 33 1/2 inches
The Museum of Modern Art, New York
Gift of Mr. and Mrs. Joseph Slifka

Painting, 1948
Enamel and oil on canvas
42 5/8 x 56 1/8 inches
The Museum of Modern Art, New York. Purchase

instructed in how to sharpen a pencil to a perfect point with a knife; then, how to roll the pencil while drawing a straight line, to avoid allowing the line to become thicker as the pencil moved along.[32] Elaine de Kooning's brother, Conrad Fried, remembers that de Kooning would fabricate his own brushes with extra-long floppy hairs (Hess alluded to this in 1953).[33] These homemade tools were interchangeable with the commercial liner's brushes that de Kooning used to similar effect—designed to make "fast," whiplash lines and tapering spreads of ink or pigment, both with a single stroke. It was the nature of these devices to bump dexterity up to a higher level, provided the difficulties of the tool could be mastered.

Much of de Kooning's embodied skill derived from his early experience with commercial techniques while a teenager apprenticed to a decorating firm in Rotterdam; he also followed a rigorous program at the city's Academy of Fine Arts. Hess, in his first commentary on the painter (a section of his 1951 book on American abstraction), referred to the Rotterdam period as the time of "the perfect square made freehand."[34] I suspect that Hess never would have mentioned this near-obsessive element of training had it not remained evident in the painter's later work, no matter how loose it became—precise in the ambiguousness of its imprecisions. In his mature years, de Kooning sought looseness with the same concentrated effort that he had once learned to direct toward tightness.

In New York during the 1930s and 40s, de Kooning had often earned money by lettering advertisements on stiff paper known as signboard. This entailed defining an edge from its outside and painting inward from the background; he would then refine that same edge from its inside, painting outward from within the established figure or cipher (and back and forth, as need be). De Kooning applied variations of this commercial technique in both figural and abstract images throughout his career; it accounts for the visual snap and spatial ambiguity of so many of his sharply defined edges [see *Two Women* (1953, plate 71)]. Typically, his "figure" or "foreground" element doesn't acquire a shape any more aggressive than that of its adjacent "background" element, nor do the juxtaposed colors establish a clear spatial hierarchy. Hess referred to such effects as among de Kooning's abrupt, "impossible" passages of form and color, which often resulted from his use of masking—"placing paper over the surface adjacent to the one being painted and running the strokes over the paper, which is then removed, leaving a clean edge."[35] Such an effect is visible in a passage of red and green to the right of the head of *Woman* (1949). Here a technique of great precision produces a result far outside accepted orders of representational figuration.[36] To viewers of the time, it may have seemed that the hand was in control but not the eye. De Kooning's capacity for controlling his hand became a factor of validation, analogous to the critical cliché of pointing out that Picasso could draw conventionally when he wanted. Wary of virtuosity, de Kooning subjected his control to self-control.

It would be logical to assume that de Kooning's technical control was great enough for him to have achieved whatever aesthetic effects he desired. Yet his pattern of change might also be a sign of anxious indecision and doubt. Observing one of his own gestural abstractions from the 1959 exhibition, de Kooning remarked to Hess: "You know, I think I might want to do some Women now."[37] Was he just indulging a whim? Did he have any idea of where he was going?

doubt

De Kooning, of course, had already undergone a shift from abstraction to Woman at the beginning of the same decade. Fitfully at work on *Woman I* since June

1950, he exhibited a group of his abstractions in April 1951, while remarking: "I haven't felt ready for exhibitions, and I'm not particularly happy about this one. I'm still working out of doubt."[38]

When doubt becomes the issue, it isn't de Kooning we think of first, but Paul Cézanne, if only because of Maurice Merleau-Ponty's musing over art and life in his famous "Cézanne's Doubt." Its French publication dates to 1945, and a translation appeared only a year later in Partisan Review, the journal for which Greenberg wrote much of his early criticism.

Merleau-Ponty's essay begins: "[Cézanne] needed one hundred working sessions for a still life, one hundred and fifty sittings for a portrait. What we call his work was, for him, only an essay, an approach to painting."[39] Some parallels are quickly apparent. Both Cézanne and de Kooning kept laboring over particular images; both failed to bring their highly eccentric pictorial orders to any traditional resolution; both had trouble finishing. "Will I reach the goal I've sought so much and so long pursued," Cézanne wrote to Emile Bernard about a month before he died; "I'm working from nature as always, and I think I'm making some slow progress (de lents progrès)."[40] Here the analogies break down. De Kooning, too, might have referred to "slow progress," but not in such a general way; his slowness applied only to specific works, such as Asheville (1948, plate 24), an abstraction on which he spent an entire summer, and Woman I, which required at least two and a half years.[41] His aim was to change, not to progress, even if change meant reversal. He had no problem moving from abstraction to Woman, from Woman to abstraction. "I can change overnight," he once said, referring to his individual paintings, his general way of working, and his personal behavior.[42] Doubt arose as a feature of the artist's attitude.[43]

In his anachronistic meditation on Cézanne at work, philosopher Merleau-Ponty approached the position of de Kooning, his true contemporary.[44] Both believed that finality and certitude were false desires, dulling the sensation of life. Merleau-Ponty defined the successful picture as one that "makes movement [or life] visible by its internal discordance."[45] This sounds like a description of figure painting by either Cézanne or de Kooning. (I believe de Kooning would have accepted it; but for Cézanne, it would have raised still more doubt.) The philosopher wished to counter interpretations that derived the meaning of a work from a given ideology or an artist's programmed psychological state, from life regarded as if formed outside one's immersion in a flow of perception. Artistic form was never prefigured by a context, nor captured in some totalizing perspective.[46] If these conditions made life and art painful for Cézanne, he was notable in demonstrating the truth of the situation for others to see. Whether or not de Kooning acquired his attitude from Cézanne's example, he was his heir in instability: "When I am falling, I am doing all right." It was a thought that would have seemed very strange to the older painter.

"I think I'm making some slow progress," Cézanne said in 1906. Along with the pathos, there is irony. To us, a century later, it seems as if Cézanne had already accomplished amazing feats of painting. If he had died a decade or so earlier—having produced works like his curiously patterned view of forest undergrowth but not his final images of Mont Sainte-Victoire, dense yet airy—certainly we, like Merleau-Ponty, would still be honoring him. Perhaps the strength of his commitment should have allowed him to feel closer to his goal of imitating the appearance of nature, projecting himself into it.

Like de Kooning, the way Cézanne chose wasn't theoretical but material—through the medium of paint. Materiality interferes with representation, because it limits what an artist can do and sometimes even imagine doing. Two years after Cézanne's

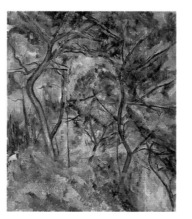

Paul Cézanne
Sous-Bois, c.1894
Oil on canvas
45^{13}/$_{16}$ x 32 inches
Los Angeles County Museum of Art
Wallis Foundation Fund in Memory of Hal B. Wallis

death, the Neo-Impressionist painter Henri-Edmond Cross, a master of structured technical procedure, recorded this note: "The materials allow a certain thought and not others…Consciousness is limited to what the material allows."[47] Here is the cause of Cézanne's doubt and insecurity: the technical limitations of his medium—the range of color he could use, the degree of refinement in his brushstrokes—kept him from reaching his straightforward goal, whether or not he ever realized that the paint, not some mental or visual failing, was his problem. Living in a different world, de Kooning insisted that "material complexity" negated all "doctrinal logic" (Hess's terms).[48] Greenberg put it another way: "What matters is not what one believes but what happens to one."[49] A frustrated Cézanne had anticipated their mid-twentieth-century position not as a point of principle, but as a last resort: "Time presses…No more theories! Paintings."[50]

As Cézanne attempted to bring his image "closer" to nature, he kept adding more strokes of color. Some were adjustments to existing passages; others were tantamount to erasures or maskings, which obliterated much that he had already done. The painter, while painting, needed to keep changing. Cézanne should have expected this for at least two reasons: first, he knew that he himself was sensitive to changes in his portrait models and in the light of the Provençal landscape he was observing; second, he must have understood that no method could be completely adequate to representation.[51] Indeed, to be familiar with painting is to realize that not every visual effect can be achieved with the available materials and tools. Nor will every effect created by a painter's techniques correspond to something seen, because representations readily assume features of their own. When painted, the image acquires a tactile sense as much as a visual one. Although Cézanne's hand worked to represent his eye's observations of evanescent light and color, it did so in a

particularly corporeal manner, as if eye and hand were operating through different mediums, each with its specific characteristics and capacities. This may account for the strange patterns in Cézanne's image of the forest. He indulged his hand in rhythms that seemed natural and comfortable to it—given painting's physicality, not nature's.

From our perspective, Cézanne was doing the proper thing. Perhaps he doubted his success because his material construction of nature, the result of his painting technique, didn't match the cultural construction that provided a context for his work, telling him what nature ought to look like as opposed to what it *felt* like. When younger artists appreciated and imitated him, he failed to return the admiration.[52] Merleau-Ponty—and de Kooning, too—would have provided him with a different context or construction to guide his assessments. Cézanne's fate was to accept a pictorial paradigm inappropriate to the practice he was developing through his felt experience— his "sensation," as he used to call it.[53]

Tension between the prevailing cultural forms and one's personal sensation surely generates anxiety. Famously, this is what Picasso perceived in Cézanne.[54] Making a stronger case, Merleau-Ponty referred to the painter's "schizoid temperament."[55] And this was Greenberg's view as well.

derangement

In 1948, when de Kooning had his inaugural one-person exhibition, Greenberg gave it a laudatory review. All works shown were abstractions as densely labored and as surprisingly elegant as Cézanne's late views of Mont Sainte-Victoire. Two years previously, Greenberg had written a brief essay on the phenomenon of Henri "Le Douanier" Rousseau, a project that gave him cause to link three modernist pioneers—Rousseau, Cézanne, and Vincent van Gogh—through what he perceived as their shared

160

derangement.[56] Greenberg identified a ready precedent for the three painters' alienation: "Just as Rimbaud had to give birth to modern poetry by deliberately cultivating the 'derangement' of his senses, so those who made the leap from impressionism to that which came after…[were] pushed by mental impulses so strong and so disconnected from the actual environment that they had to be those of psychotics."[57]

Greenberg may have chosen his terminology ("psychotic," "deranged") to pique his reader. In this, he was encouraged by a passage from Arthur Rimbaud's "Lettres du voyant" of 1871, concerning the "reasoned disordering [or disorientation] of all the senses."[58] The key word is "dérèglement." Etymologically, both the English "derangement" and the French "dérèglement" suggest the removal of a given, conventional order—indeed, a "disordering." But in Rimbaud's case, the lack of order or regularity was willed ("reasoned"), even though it threatened to lead the artist-poet into sensory situations he would no longer control. By featuring the word "derangement" as an alternative to "disordering," Greenberg indicated that the case of the three modernist painters was different from Rimbaud's. They arrived at their penetrating view of modern experience without being fully conscious of aiming to do so. The "deranged" Rousseau, Cézanne the "extreme eccentric" ("a little balmy," Greenberg adds), and poor Van Gogh, who suffers from "madness"—none could regulate his own deregulation. Whereas the poet "cultivated" his "derangement," the three painters became "psychotic." A psychotic fails to coordinate ends and means. Rousseau, for instance, wanted to be academic, yet painted like a "primitive."

Greenberg perceived a great advantage in the situation—not an advantage for the deranged painters, but for history. It didn't pertain to Rimbaud's poetry, which he calls "an evasion, not a solution,"

soon to become "in the profoundest sense, academic." Because Rimbaud's literary method constituted a device to achieve a transcendent art, it became formulaic, losing touch with its immediate social situation. Its "evasion" was to escape the materialist environment of a society being transformed, for better or worse, by the forces of industrialism. Greenberg insisted on linking the social and cultural conditions of recent modernity to a materialist or positivist mentality, arguing that "transcendent exceptions and aberrated states" amounted to pointless fantasy.[59] So in Greenberg's view, Rimbaud's self-consciously heightened sensory experience merely degenerates into escapism, whereas Rousseau's naive art is fated to meet and satisfy an unvoiced, but profoundly significant demand. "His flat, direct, almost crass colors, contours, and modelling," Greenberg concludes, "gave to many painters the first real impression they ever got of what life, reduced to solely empirical considerations and without the deception (but also protection) of faith in anything, looks like in art."[60] Rousseau's art had come to represent the empiricist mentality, flattened emotion, and coarsened sensation that modern social and material conditions were inducing. As an earlier writer aptly speculated, Rousseau seemed to have developed "from nowhere, unless out of the 'subconscious' of Art."[61]

Many of the terms of Greenberg's argument would reappear addressed to de Kooning less than two years later.[62] In 1946, while focused on Rousseau, the critic's analysis was unusually direct in linking the reception of modern art to its societal conditions:

> That which modern art asserts in principle—the superiority of the medium over whatever it figures: thus the inviolable flatness of the picture plane; the ineluctable shapedness of the canvas, panel, or paper; the palpability of oil pigment, the fluidity of water and ink—this expresses our society's

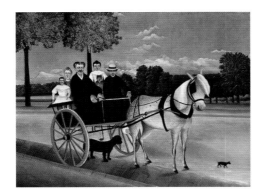

Henri Rousseau
The Carriage of Père Juniet, 1908
Oil on canvas
38 1/4 x 50 7/8 inches
Musée national de l'Orangerie, Paris
Collection Jean Walter et Paul Guillaume

growing impotence to organize experience in any other terms than those of the concrete sensation, immediate return, tangible datum…. such relatively cold, hard heads as Matisse and Picasso… needed mental cases [Rousseau, Cézanne, Van Gogh] to show them the way, to cut through to the ultimate truth of life as it is lived at present.[63]

Without intending it, Rousseau produced art for mid-century America—direct in its materialism and requiring no imaginative projection of moral, religious, or psychological values. Does Greenberg approve? Not necessarily; yet he doesn't expect conditions to be otherwise: "Modern art, like modern literature and modern life, has lost much…I cannot help regretting what has been lost. The regret is futile."[64]

Greenberg was no surrealist. For him, Rousseau's case was exemplary not because a "deranged" person turned out to be responsible for significant art (this was merely a historical accident), but because the public, both high and low, was accepting this art so enthusiastically (no accident at all). Rousseau offered them "concrete sensation, immediate return, tangible datum." I don't know whether Greenberg actually learned from observing this bit of cultural history or was merely using it to demonstrate what he already believed (probably the latter). At the very least, it indicates why, a decade later, he would regard de Kooning's "dissection" more as a cut in the paint than in the Woman.

will

There are relatively deep cuts and scrapes in *Painting*; de Kooning's Woman-of-the-1940s, if ever present on this particular canvas, was layered over or scraped out of visible existence. We might regard this as proof of de Kooning's ability to circumvent his skill, often by rejecting his own Ingres-like potential. Greenberg admired such willful practices. This would never have been an option for Cézanne, who possessed less facility to be resisted. Cézanne's internal conflict was between his personal view of nature and his struggle to devise a means of representing it, one that wouldn't go beyond his culture's dictates. De Kooning's internal conflict was between expression and skill. Reviewing the 1948 exhibition, Greenberg wrote:

Emotion that demands singular, original expression tends to be censored out by a really great facility, for facility has a stubbornness of its own and is loath to abandon easy satisfactions…. [De Kooning tries] to suppress his facility. There is a deliberate renunciation of will in so far as it makes itself felt as skill.

For expression's sake, de Kooning was denying his manual facility, or rather, the will to control it. Nevertheless, the painter had to follow by applying "a considerable exertion of the will" to *regulate* his efforts at spontaneity.[65]

No regulatory logic guarantees spontaneity. From a critical perspective, all conscious attempts at spontaneity seem disingenuous (hence, Newman's skepticism toward de Kooning). Yet the critique of spontaneity usually neglects the physicality of experience—how a gesture feels when it's actually being performed. Merleau-Ponty's writing on art addressed this lack. Greenberg, too, sometimes alluded to immediate feeling, as when he suggested that de Kooning was self-conscious enough to sense the difference between "being truly spontaneous" and "working only mechanically."[66] Could the painter have willed himself into spontaneity, gaining immediate experience in some new way?

Cézanne strove to "reach the goal," but with "slow progress." De Kooning simply left his art suspended in what appears to be a transient material state. During the 1940s, if not earlier, this had

162

become the "modern" thing to do, although few would ever do it as daringly as de Kooning. Art with a very physical, unfinished look challenged the public to apply its coarse empiricism to a new material object that wouldn't yield to any principle of order ("Order, to me, is to be ordered about and that is a limitation," de Kooning said in 1949[67]). The artist would beat conformist society at its own game, either by winning over its adherents, or by confusing them with an aesthetic attraction that couldn't be assimilated.

De Kooning developed various ways of accomplishing his material suspension, including uses of cutting, as in *Woman* (c. 1952, plate 56), and masking, as in *Study for "Woman I"* (1952, plate 50). His various techniques focused on the means, on his grappling with the medium, rather than on the image derived from the process.[68] His method—"psychotic," "schizoid," "deranged"—allowed him to immerse himself in drawing and painting without distinguishing between abstraction and figuration. He remained in unresolved, destabilized suspension, just like his images—"falling," "slipping." It was precisely where he wanted to be.

In one of his most radical gestures, de Kooning facilitated his figure drawing by closing his eyes, concentrating inwardly, centering and intensifying his sensation. Doing so, he exacerbated Cézanne's problem by removing the eye from the hand's production of an image intended for vision.[69] The two senses cease to operate in mutual support. Examples are a suite of twenty-four untitled drawings from 1966: one of them depicts two women dancing; another, a woman seated with crossed legs. Of the entire series, de Kooning yielded only the basic facts: "It is true that I made them with closed eyes ... I found that closing the eyes was very helpful to me."[70]

Working blindly allowed de Kooning to circumvent the more intellectual and regulative organ, the eye, lest it inhibit the more physical organ, the hand. His art originated within the fixed margins of the paper, the hand's domain, rather than in some indeterminate space inhabited by the model and then organized by the eye's traversal: "A model can take many different poses, but the only thing that counts is how the hand sets her on the paper. How she lives on the paper. I draw while she lives on the paper."[71] De Kooning discovered that drawings could be made, and perhaps better made, without visual attention being given to the model at the moment of drawing. As a controlled loss of control, the method caused skill and chance to become indistinguishable. Here was a grand case of de Kooning's ambiguity, generating doubt.

De Kooning sought to disconnect perception (what the hand could feel) from preconception (what the eye would automatically measure against as an existing standard, counteracting the effect of chance and the skill that produced it). His methods distanced him from proper proportion and conventional form. The direction of the distance—whether, for example, a particular feature might be stretched or compressed—appeared as an effect of willful chance. In the case of drawing with eyes closed, the effect would depend on how far the hand might travel as it traced out the salient forms of the model. These would be felt within the body of the artist, who would begin from the center, fitting the movement of his arm and hand to the margins of the sheet. Near the center, lines might flow rather freely; at the margins, physical features of the model might have to be compressed.

Of this "closed eyes" technique, de Kooning said: "I feel my hand slip across the paper. I have an image in mind but the results surprise me. I always learn something new from this experience."[72] The artist's hand slipped across. His image slipped to the margins. De Kooning was slipping—into a new experience, into the change he desired.

◆

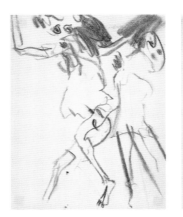
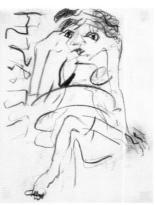

*For aid in preparing this
essay, I thank Roger Anthony
and Amy Schichtel of the
de Kooning Office, New York;
Kiki and Harold Rabinowitz,
New Haven; and Mette Gieskes,
doctoral candidate at The
University of Texas at Austin.*

1 Throughout this essay, I distinguish "abstraction" from "representational" or "figure" painting because de Kooning's critics did, and because the artist himself appears to have been more at ease with this categorical distinction than with most others. It also suits the nature of my discussion. I nevertheless believe that nearly all of de Kooning's "abstractions" either began with a reference to the human figure or incorporated figural elements along the way. When asked to speak about abstraction in 1951, de Kooning ridiculed the notion; see Willem de Kooning, "What Abstract Art Means to Me," *The Museum of Modern Art Bulletin* 18 (Spring 1951): 4–8.

2 This point was argued by Thomas Hess when he published a monograph on de Kooning's drawings; see Thomas B. Hess, *Willem de Kooning: Drawings* (Greenwich, Conn.: New York Graphic Society, 1972), 13: "[S]ome drawings could be considered paintings…The wonderful black enamel drawings of 1950 are made with exactly the same medium as the black and white paintings of 1948–50; they are all done with a housepaint enamel (called Sapolin) on paper, the only difference being that in the 'drawings,' the white is bare paper, while in the 'paintings,' the white is paint. In other words, a close examination of de Kooning's drawings first of all tends to dissolve any possible definition of 'drawing.'" Compare Susan Lake and Judith Zilczer, "Painter and Draftsman," in Zilczer, ed., *Willem de Kooning from the Hirshhorn Museum Collection* (Washington, D.C.: Hirshhorn Museum and Sculpture Garden; and New York: Rizzoli, 1993), 172–79; and my "The Gravity of Willem de Kooning's Twist," in Enrique Juncosa and Teresa Millet, eds., *Willem de Kooning* (Valencia, Spain: IVAM, 2001), 54–89.

3 So, too, in Cubist works. This might explain why a number of critics have associated de Kooning's style with Pablo Picasso's.

4 In a succession of writings on de Kooning, Hess stressed ambiguity and multiplicity as his interpretive theme, apparently influenced by a similar stress on the part of the New Critics of the 1930s, 40s, and 50s, such as Cleanth Brooks, William Wimsatt, R. P. Blackmur (cited directly by Hess), and William Empson (author of the famous *Seven Types of Ambiguity,* 1930). See, for example, Thomas B. Hess, *Abstract Painting: Background and American Phase* (New York: Viking, 1951), 103–04 ("shapes become ambiguously interpretable… this continual outpouring of ambiguity"); and "De Kooning Paints a Picture," *Art News* 52,

shiff

no. 1 (March 1953): 32 ("the painter makes ambiguity into actuality"). Ambiguity was also mentioned as a significant factor by Clement Greenberg, "Review of an Exhibition of Willem de Kooning" (1948), in *Arrogant Purpose, 1945–1949*, vol. 2 of *Clement Greenberg: The Collected Essays and Criticism*, ed. John O'Brian (Chicago: The University of Chicago Press, 1986–1993), 229. Today, despite the anachronism, de Kooning's "ambiguity"—for example, his conflation of acts of enclosure and extension—is more likely to be related to the deconstructive criticism of the 1960s and 70s, which remained a current preoccupation among American academic writers at least through the 1990s. Compare the problematics of the frame or margin as developed in Jacques Derrida, "Outwork, Prefacing," in *Dissemination*, trans. Barbara Johnson (Chicago: The University of Chicago Press, 1981), 1–59; and "Parergon," in *The Truth in Painting*, trans. Geoff Bennington and Ian McLeod (Chicago: The University of Chicago Press, 1987), 15–147. Any textual and linguistic analogies to de Kooning's manner have their own "limitations" (a dangerous word to use in this interpretive context) because the painter was attending to habits of visual and tactile perception as opposed to verbal conceptualization.

5 De Kooning, audiotaped statement, interview by Michael C. Sonnabend and Kenneth Snelson, summer 1959, typescript, Willem de Kooning Office, New York; prepared for the film *Sketchbook No. 1: Three Americans—Willem de Kooning, Buckminster Fuller, Igor Stravinsky*, directed by Robert Snyder, written by Michael C. Sonnabend, distributed by Time Inc., 1960. In 1993, I interviewed a number of people who had known de Kooning over many years. Several of them (including John McMahon, Joan Ward, and Allan Stone) emphasized his tendency to consider numerous alternatives as he addressed a topic, avoiding conclusiveness and termination; he often shifted or reversed the drift of the conversation. In formal interviews, too, he would argue by association, allowing himself to move from thought to thought without making a definitive judgment. For discussion of these habits of thought, see my "Water and Lipstick: De Kooning in Transition," in *Willem de Kooning: Paintings*, exh. cat. (Washington, D.C.: National Gallery of Art; and New Haven: Yale University Press, 1994), 32–73, esp. 50–55.

6 "He remains a late Cubist.... who continues Cubism without repeating it." In Clement Greenberg, "'American-Type' Painting" (1955), in *Affirmations*

and Refusals 1950–1956, vol. 3 of *Clement Greenberg: The Collected Essays and Criticism*, 222. Hess (*Willem de Kooning: Drawings*, 22) later referred to de Kooning as "reinventing Cubism."

7 "It is disastrous to name ourselves." Willem de Kooning, quoted in Robert Goodnough, ed., "Artists' Sessions at Studio 35" (1950), in *Modern Artists in America*, eds. Robert Motherwell and Ad Reinhardt (New York: Wittenborn, Schultz, 1951), 22. See also Willem de Kooning, "What Abstract Art Means to Me," 7.

8 Greenberg, "'American-Type' Painting," in O'Brian, 222.

9 Hess, "De Kooning Paints a Picture," 66. Compare Judith Zilczer, "De Kooning and Urban Expressionism," in *Willem de Kooning from the Hirshhorn Museum Collection*, 49–53. Zilczer states: "American social values during [the 1950s] included repressive ideals of femininity and sexuality that writer Betty Friedan would later term 'the feminine mystique.' With their bulbous breasts, grimacing faces, and graceless poses, de Kooning's women represented a mockery of that feminine ideal" (52). The history of response to *Woman I* with regard to issues of gender has been traced in Eleanor Kathryn Siegel, "Willem de Kooning's 'Woman' Paintings of 1950–1953," master's thesis, University of Texas at

Austin, 1990; see also my "Water and Lipstick," 38–50. Hess, editor of *Art News*, was close to de Kooning's wife Elaine, who frequently wrote for the magazine. Along with critic Harold Rosenberg, also an *Art News* writer, they collaborated informally with de Kooning on statements by and about him, as well as on titles for his paintings. See, among many anecdotal sources, Lee Hall, *Elaine and Bill: Portrait of a Marriage* (New York: HarperCollins, 1993), 71–82; and Florence Rubenfeld, *Clement Greenberg: A Life* (New York: Scribner, 1997), 174–75. Although both books are inadequately specific regarding their sources (especially relating to elements of scandal), the essential validity of what has been written about this network of liasons—Willem de Kooning, Elaine de Kooning, Hess, Rosenberg—was confirmed by Conrad Fried, Elaine de Kooning's brother (author's interview, 1997).

10 James Fitzsimmons, "Art," *Arts and Architecture* 70 (May 1953): 8, 6. Fitzsimmons mistakenly identifies *Woman II* as *Woman III*.

11 Greenberg, "Foreword to an Exhibition of Willem de Kooning" (1953), in *Affirmations and Refusals*, 122, 121.

12 Clement Greenberg, *Art and Culture* (Boston: Beacon, 1961), 214.

13 "Willem the Walloper," *Time* 57 (30 April 1951): 63.

14 Alfred H. Barr, Jr., *Cubism and Abstract Art* (1936) (Cambridge, Mass.: Harvard University Press, 1986), 11.

15 Alfred H. Barr, Jr., "Introduction," in The New American Painting (New York: The Museum of Modern Art, 1959), 17.

16 Hess, *Abstract Painting*, 27.

17 A reviewer of de Kooning's first exhibition stated: "One of the stronger currents of abstract art today has become an obsession with the medium of paint itself for its internal dramatic possibilities" (Sam Hunter, "By Groups and Singly," *The New York Times*, 25 April 1948, X–11).

18 "In our everyday life we experience not solid and immediate facts but stereotypes of meaning... To quite small circles the appeal of modern art—notably painting and sculpture, but also of the crafts—lies in the fact that in an impersonal, a scheduled, a machined world, they represent the personal and the spontaneous. They are the opposite of the stereotyped and the banalized.": C. Wright Mills, "The Man in the Middle," *Industrial Design* 5 (November 1958): 70, 75.

19 De Kooning, in Goodnough, "Artists' Sessions at Studio 35," 12–13.

20 Compare Hess, "De Kooning Paints a Picture," 65.

21 See Elaine de Kooning, "Edwin Denby Remembered—Part I," *Ballet Review* 12 (Spring 1984): 30.

22 For a commercial project, de Kooning would draw in pencil, cover the surface with shellac, and then develop the image further with layers of printer's ink. If the client failed to approve the result, he could remove the printer's ink with a solvent that the shellac would resist, maintaining the initial pencil design as a guide to further variation. Conrad Fried and Connie Fox (artist friend of Elaine de Kooning and Fried), interviews by author, 1993. For examples of de Kooning's commercial work, see *Harper's Bazaar* (1 March 1940): 81; *Life* (1 February 1943): 97; and *Life* (1 March 1943): 59.

23 "By noon [of opening day], 19 of the show's 22 oils were sold.... At week's end a new de Kooning was not to be had." "Big Splash," *Time* 73 (18 May 1959): 72.

24 Thomas B. Hess, *Willem de Kooning* (New York: Braziller, 1959), 31. When Ad Reinhardt drew a cartoon of the art world viewed as a horse race, he named Hess as de Kooning's jockey; Jackson Pollock had two jockeys, Clement Greenberg and James Johnson Sweeney. See Ad Reinhardt, "Museum Racing Form," *trans/formation* 1 (1951): 89.

25 Helen Frankenthaler, in Irving Sandler, ed., "Is There a New Academy? (Part I)," *Art News* 58 (Summer 1959): 34.

26 Barnett Newman, in Dorothy Gees Seckler, "Frontiers of Space," *Art in America* 50 (Summer 1962): 86. In a letter to Jean Lipman, editor of *Art in America*, 9 July 1962 (Barnett Newman Foundation archives, New York), Newman confirmed that it was his intent "not to discuss any names" directly.

27 Newman, in Seckler, "Frontiers of Space," 83.

28 De Kooning, quoted in "Big Splash," 72.

29 De Kooning, audiotaped statement, *Sketchbook No. 1*. On "slipping" and the related notion of the "slipping glimpser," see my "Water and Lipstick," 50–55.

30 James Fitzsimmons, "Art," 7.

31 Renée Arb, "Spotlight On: De Kooning," *Art News* 47 (April 1948): 33.

32 John McMahon, author's interview, 1993.

33 Conrad Fried and Connie Fox, author's interviews, 1993. Fried occasionally worked in de Kooning's studio during the late 1940s and early 1950s. Confirming McMahon's memories, he recalls that de Kooning's use of the knife would produce a sharpened pencil point nearly an inch long.

34 Hess, *Abstract Painting*, 100.

35 Hess, "De Kooning Paints a Picture," 65. See also Hess, *Abstract Painting*, 107.

36 The work appears in *Willem de Kooning: Paintings*, 124.

37 Hess, *Willem de Kooning* (1959), 117.

38 Quoted in "Willem the Walloper," 63. Compare *Willem de Kooning: Paintings*, 102.

39 Maurice Merleau-Ponty, "Cézanne's Doubt" (1945), in *Sense and Non-Sense*, trans. Hubert L. Dreyfus and Patricia Allen Dreyfus (Evanston: Northwestern University Press, 1964), 9. The abridged, earlier translation by Juliet Bigney appeared in *Partisan Review* 13 (1946): 464–78.

40 Paul Cézanne, letter to Emile Bernard, 21 September 1906, in John Rewald, ed., *Paul Cézanne, correspondance* (Paris: Grasset, 1978), 326–27. Translations from French are mine unless otherwise indicated.

41 See Elaine de Kooning, "De Kooning Memories" (1983), in *The Spirit of Abstract Expressionism: Selected Writings*, (New York: Braziller, 1994), 214.

42 Willem de Kooning, interview by Bibeb, "Willem de Kooning: Ik vind dat alles een mond moet hebben en ik zet de mond waar ik wil," *Vrij Nederland* (Amsterdam), 5 October 1968, 3 (translation by Mette Gieskes).

43 Compare Hess, "De Kooning Paints a Picture," 31: "He needs such doubt to keep off-balance."

44 De Kooning was born in 1904, Merleau-Ponty in 1908.

45 Maurice Merleau-Ponty, "Eye and Mind" (1961), in *The Primacy of Perception and Other Essays*, ed. James M. Edie, trans. Carleton Dallery

shiff

(Evanston: Northwestern University Press, 1964), 185.

46 Merleau-Ponty, "Cézanne's Doubt," 20.

47 Henri-Edmond Cross, "Le dernier carnet d'Henri-Edmond Cross—II" (1908–09), ed. Félix Fénéon, *Le bulletin de la vie artistique* 3 (1 June 1922): 255.

48 Thomas B. Hess, "U.S. Painting: Some Recent Directions," *Art News Annual* 25 (1956): 98.

49 Greenberg, "The Present Prospects of American Painting and Sculpture" (1947), in *Arrogant Purpose*, 164.

50 Cézanne's words as recalled (not necessarily verbatim) by Joachim Gasquet, *Cézanne* (Paris: Bernheim-jeune, 1926), 132.

51 On Cézanne's sensitivities, see my "Sensation, Movement, Cézanne," in Terence Maloon, ed., *Classic Cézanne* (Sydney: Art Gallery of New South Wales, 1998), 13–27.

52 See Cézanne's comments on Paul Gauguin and Vincent van Gogh, letter to Emile Bernard, 15 April 1904, in *Paul Cézanne, correspondance*, 300.

53 On "sensation," see my "Sensation, Movement, Cézanne," 13–14, 26.

54 See Christian Zervos, "Conversation avec Picasso" (1935), in Marie-Laure Bernadac and Androula Michael, eds., *Picasso: Propos sur l'art* (Paris: Gallimard, 1998), 36.

55 Merleau-Ponty, "Cézanne's Doubt," 20.

56 Greenberg's impetus may have been the reissuing of the monograph that had accompanied The Museum of Modern Art's Rousseau retrospective in 1942. See Daniel Catton Rich, *Henri Rousseau* (New York: The Museum of Modern Art, 1946).

57 Greenberg, "Henri Rousseau and Modern Art" (1946), in *Arrogant Purpose*, 94.

58 Arthur Rimbaud, letter to Paul Demeny, 15 May 1871, *Lettres du voyant*, ed. Gérald Schaeffer (Geneva: Droz; and Paris: Minard, 1975), 137. See also Théophile Gautier, "Le club des hachichins," *Revue des deux mondes* 13 (1 February 1846): 520–35.

59 Greenberg, "The Present Prospects of American Painting and Sculpture," 164–65.

60 Greenberg, "Henri Rousseau and Modern Art," 95.

61 C. J. Bulliet, *Apples and Madonnas: Emotional Expression in Modern Art* (Chicago: Pascal Covici, 1927), 12. Bulliet preceded Greenberg in grouping Rousseau with Cézanne and Van Gogh.

62 They also appear, in less developed form, when Arb and Hunter review de Kooning's 1948 exhibition; see above, notes 31 and 17, respectively.

63 Greenberg, "Henri Rousseau and Modern Art," 94.

64 Greenberg, "The Necessity of the Old Masters" (1948), in *Arrogant Purpose*, 250–51.

65 Greenberg, "Review of an Exhibition of Willem de Kooning,"

229–30. Greenberg would later comment similarly on Newman, who "happens to be a conventionally skilled artist... But if he uses his skill, it is to suppress the evidence of it." Greenberg, "After Abstract Expressionism" (1962), in *Modernism with a Vengeance, 1957–1969*, vol. 4 of *Clement Greenberg: The Collected Essays and Criticism*, 132–33.

66 Greenberg, "Review of an Exhibition of Willem de Kooning," 230.

67 De Kooning, "A Desperate View" (1949), reprinted in Thomas B. Hess, *Willem de Kooning* (New York: The Museum of Modern Art, 1968), 15.

68 I've discussed a number of the techniques in other contexts: see my "Water and Lipstick," 32–73; "Willem de Kooning: Painting's Potential," *Willem de Kooning: Paintings 1983–84* (New York: Matthew Marks Gallery, 1997), 7–17; "The Gravity of Willem de Kooning's Twist," 54–89; and "'With Closed Eyes': De Kooning's Twist," *Master Drawings* 40 (Spring 2002): 73–88.

69 Compare Hess, *Willem de Kooning* (1959), 21: "An ear, the nape of the neck are thought through by the moving pencil or brush as phenomena experienced by all the senses except the eye's."

70 Willem de Kooning, *Drawings* (New York: Walker, 1967), n.p.

71 De Kooning, interview by Bibeb, 3 (translation by Mette Gieskes). De Kooning's earlier published statements from around 1950 discuss space as something determined by the body, with clear implications for later practices, such as the drawings with closed eyes. See especially "What Abstract Art Means to Me" (1951); and "The Renaissance and Order," *trans/ formation* 1, no. 2 (1951): 85–87. The contribution of Elaine de Kooning (and perhaps others) to these writings may be substantial; see above, note 9. According to Annalee Newman, de Kooning refused to read "The Renaissance and Order" as planned for February 1950 at Studio 35 because Elaine had edited it too extensively. Annalee Newman, interview by Yve-Alain Bois, 1996, Barnett Newman Foundation archives (I thank Yve-Alain Bois, John O'Neill, and the Barnett Newman Foundation for access to this material).

72 De Kooning, interview by Sam Hunter, "De Kooning: Je dessine les yeux fermés," *Galerie Jardin des Arts* 152 (November 1975): 69.

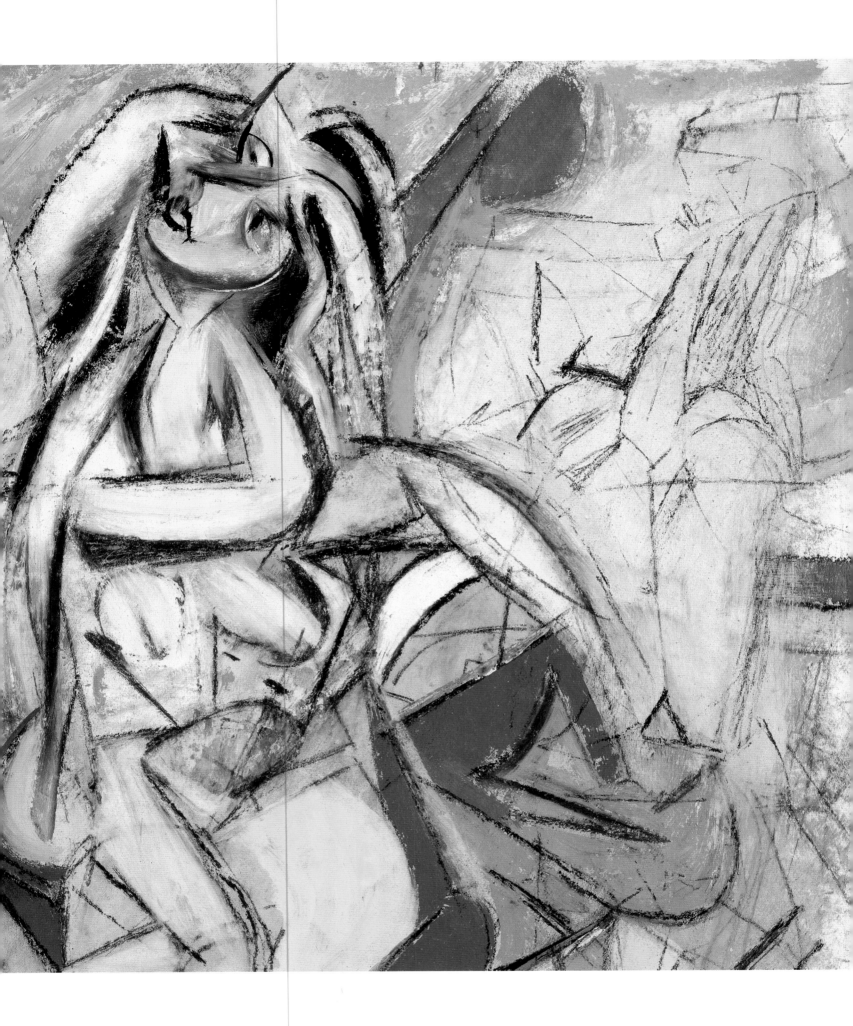

anne m. wagner

de kooning, drawing, and the double
or, ambiguity made clear

Emotion that demands singular, original expression tends to be censored out by a really great facility, for facility has a stubbornness of its own and is loath to abandon easy satisfactions. The indeterminateness or ambiguity that characterizes some of de Kooning's pictures is caused, I believe, by his effort to suppress his facility. There is a deliberate renunciation of will in so far as it makes itself felt as skill, and there is also a refusal to work with ideas that are too clear.[1] —CLEMENT GREENBERG (1948), IN HIS REVIEW OF DE KOONING'S FIRST SOLO SHOW

1. the procrustean method

Let us begin by turning to a text that for Willem de Kooning's critics and viewers has served as something of a primal scene. This was the *Art News* article "De Kooning Paints a Picture," published by Thomas B. Hess in March 1953 that showed a suite of Rudolph Burkhardt photographs through which readers entered the artist's studio for the first, and not the only, time. Work room, rather than bedroom: on view were a painter, his tools and products and setting, but this is the *Urszenen* nonetheless, the catalyst of a whole set of *Urphantasien* about the nature of the artist's work and passions, fantasies that are with us still. Enter de Kooning playing the aggressive Father in a sado-masochistic drama of painting as a kind of intercourse, with us as dumbstruck spectators on the thrilling scene; in the place of Mother as Father's first victim find his *Woman I* (1950–52, page 141). In Hess's article "she," or at least a version of that notorious image, was given a color plate all to herself. (When the essay was published, her first public showing was still weeks away.) I say "version," for as the caption explains, after the photo was made the artist, finicky and hesitant down to the very end of what had been at least a two-year process, added an eight-inch strip of canvas along the right side. Flat and grey and with only a few seemingly errant drips and spatters, this is the amplifying and unsettling addition we see there now.

It was Hess who in this same article first described de Kooning's method of painting—particularly the process the artist used to make *Woman I*— as directly linked to drawing in fundamental and practical terms. Drawing prepared and assisted painting in what, on first reading, might seem a deeply traditional way. The links between them were forged at the outset, most spectacularly via two enormous sheets of paper hung side by side against a paint-splattered wall. Photographs by Burckhardt preserve the paired arrangement with the artist himself, purportedly at work. The *Art News* layout crops and uses the more active image—the one that gives the greater sense of eye and hand and body all focused together on the making of a single mark.

opposite: *Untitled*, 1947 (detail)

Rudolph Burckhardt
Willem de Kooning drawing *Woman I*, 1950

Rudolph Burckhardt
Willem and Elaine de Kooning, 1950

The charcoal markings de Kooning made on the curtain of paper were "later roughly translated," Hess tells us, onto an outsize canvas of similar proportions—the surface on which, in slow stages, *Woman I* finally found its form.[2] That elaborate process too was drawing-dependent, and Hess famously characterized this new method of using graphic imagery as having a logic all its own: the comment evokes its own violent and primal painterly scene. He claimed the technique was "Procrustean," meaning that de Kooning, working in the manner of his monstrous robber forebear, "cut apart, reversed, exchanged and otherwise manipulated" a "continuous series of drawings."[3] The resultant shards and spoils might for a time be accumulated—two slightly later photographs show them tacked to a wall, several to a peg, the way a housewife hangs laundry when she's rushed or untidy or careless—but their eventual destiny saw them stuck on the picture's planar surface in a bodily mosaic whose outlines were not yet final or clear. Think of them as lifting away from the woven fabric like sheets of peeling skin—at least this is how they sometimes looked when photographed. Yet this is skin with discrete, not ragged, forms and edges, and other documents of the painting in progress show the bits of paper making limbs that suggest the flat stiffness of a cut-out doll. Later in the process, large paper tracings were made as overlays that could record and, once scissored into fragments, dismember the canvas's imagery at its maker's will. As the whole extant series of in-process photographs memorializes, the final picture itself also graphically remembers the splintered drawings in its zones and edges, though it recalls them vaguely, like fast-fading dreams.

Yet if de Kooning is "like Procrustes, who cut or stretched travelers to fit his bed," there is still a distinction to be made between the two.[4] The difference lies not in the kinds of violence the artist wreaks on

170

notions of body—stretching and amputating both the body of the drawing, and the image it depicts—but in the simple fact "that this Procrustes does not know the dimensions of his bed." The declaration is pointed and piquant; it could wring questions from a stone. What does this not-knowing add up to? How exactly did de Kooning decide to cut and trim each drawing as it traveled from wall to canvas and elsewhere? Where and why were the cuts made and to what effect? Where did the cutting stop? And how do all these matters figure in our sense of the fate of figuration at mid-century, a practice whose limits de Kooning did much to destroy and redraw? The answer to this last question requires that we reflect on our own posture towards painting, as well as our stance towards bodies and their behavior in depiction, and in the wider world.

There are as many answers to my litany as there are writers on de Kooning—or at least one might wish that were the case. Instead, if commentators are many, their answers are few, not least because they are reluctant to focus on anything other than how the artist felt and his viewers feel about real women and/or the women that de Kooning painted and drew. Accusations are leveled, defenses raised, both in response to what David Sylvester termed the "disturbing double-sidedness of the presumed misogynist aggression."[5] It is striking how little attention has been paid to the exact genealogy of this empathic response, despite the fraught place the artist has been allotted in the recent history of figural art. The result is that what is laborious and intentional about de Kooning's process, what pictorially is worked over and through, has ceded to a focus on personal pathology, his "obsessive dismantlings" of figures giving evidence of passionate love or hate, whether unconscious, avowed, or both.[6] Yet such feelings about how de Kooning might have felt risk obscuring what is purposeful, perhaps even historical, in the process

he used to achieve a goal. It may be time to think again of how drawing might have helped to secure quite explicit pictorial ends. Let me state the key question again: How did de Kooning dismember drawing in the effort to remember a version of figuration of some interest to his own day? Dismember: the word at once taps into the issue that dogs de Kooning's art, and more queries quickly spurt forth. How bloody-minded is this particular Procrustes? How seductive is his initial invitation to the passer-by? How violent his violence? Are his wounds lethal? These and similar issues have seemed irresolvable, with the result that each writer inevitably finds the need to repeat the same interrogation, claiming and disclaiming violence as the content of de Kooning's art.

Hess of course stands at the source. The force of his chosen terminology is with us to this day. Yet not only was he the one to summon a bloody myth as metaphor, he was also quick to point out the technical and conceptual advantages of the so-called "method." The technical benefits were the more obvious, given the possibilities for both study and record-keeping, however partial, which the traced outlines allow. Yet the result Hess envisioned as stemming from technique alone already gives his reading a conceptual twist: "Off-balance is heightened; probabilities increase; the painter makes ambiguity into actuality. And ambiguity, as we shall see, is a crucial element in this (and almost all important) art."[7] Hess's claim is tendentious and insistent: why is ambiguity for him an interpretive necessity, a prime requirement? What does art—Art—need to keep unclear?

The main conceptual advantage of the traced and scissored drawing, still following Hess, is that it yields an approach to the "intimate proportions of anatomy"—a form of knowledge that is oddly uncensored and idiosyncratic, as well as distinctly myopic, with surrealizing results. The experience it stems

from and aims to reproduce, Hess reports the artist as saying, is "the feeling of familiarity you have when you look at somebody's big toe when close to it, or at a crease in a hand or a nose or lips or a necktie."[8] How to recreate such moments of odd recognition? The process is sparked, we learn, through the repetitions and disjunctions, exchanges and equivalencies that a duly manipulated drawing can supply. A knuckle is made to do duty for a thigh, say, or an arm for a leg. Such procedures aim at recalling or recreating moments of familiarity—"intimate perceptions"— that are less domestic than urban, the product and residue of travels through the metropolitan nature park, where roam "birdlike Puerto Ricans, fat mamas in bombazine, or a lop-sided blond at a bar."[9] One of several problems with Hess's gloss on de Kooning's efforts to render the *flâneur*'s (duly updated) encounters with this bestiary of urban exotica is that it leaves out men. Never mind the "necktie"—a synecdoche for "man"—which the artist so unexpectedly names as catching and holding his gaze. The omission may be unwitting but it is also telling, maybe even tactical. Hess celebrates ambiguity, even while (shades of Procrustes!) trimming down the varieties of difference that might possibly be at stake. Any lack of clarity concerning who and what attracts the artist, for example—the variety of intimate perceptions and ecumenical desires, which de Kooning admits but Hess occludes—cedes to a congerie of female otherness all too legible in its casual condescension: we are being served up almost automatic prejudices, a classed and gendered cocktail that chokes us as it goes down.

What is striking about Hess's founding article is that a text so evidently bent on tasks of description and documentation—on conjuring the present-tense immediacy of the artist at work ("De Kooning Paints a Picture" is its testimonial title, remember, with its note of "right before your very eyes!")—ends up

casting its lot with ambiguity as its chief descriptive term.[10] The moment is decisive in its implications; for (to cite Hess once more) "if Procrustes does not know how long and wide his bed is, *he knows exactly what kind of a bed* the visitor must fit."[11] The critic is trying to secure a key distinction; some idea of quality versus quantity is at stake. For he then asserts: "The refusal to define the dimensions becomes another link in the chain of ambiguities that will finally measure the surface of *Woman* to the artist and the spectator." We can only savor the oxymoron of a scale of measurement that takes ambiguity as a draconian rule. And this makes for one last ambiguity: for the artist, like the viewer, is finally caught in *Woman*'s Procrustean snare. The canvas itself accosts and harms, if only metaphorically.

I have said that Hess's article is foundational, yet that status does not mean that its key idea is original with him. Tracing its roots is not hard, for they do not and could not lie deep. Hess wrote his piece in the winter of 1952–53, a scant five years after de Kooning's first solo show. For Clement Greenberg the debut was epochal, not least because of the decisive and potentially fatal role of drawing in the artist's painted work. Drawing, Greenberg contended, was the painter's greatest gift, yet one which could not be exercised at will; it must be submitted to the (again paradoxical) discipline of ambiguity.

As Greenberg argues in the brief passage I chose as the epigraph for this essay, ambiguity is needed so as to surrender the easy satisfactions that facility so confidently and tenaciously provides. Hence the self-censorship, the aggressive denial famously (and to some, dismayingly) at the crux of Greenberg's aesthetic requirements of the artists he rates. Those strictures make for the vaguely psychoanalytic subtext—the whiff of ego and superego—that haunts his words. Too often overlooked, however, are the ends his intransigence aims to serve. Greenberg con-

172

demns facility not to suppress emotion—a synonym for "contemporary feeling"—but because technical pyrotechnics defeat such emotional expression as is singular or original in kind. It's anybody's guess what such content adds up to; Greenberg (whose writing was his superego) will not allow himself to say. No wonder, given that his endorsement lies precisely in de Kooning's refusal to work with ideas that are too clear. As with Hess, ambiguity again supplies the critic's rule. It seems a modernist necessity, the regnant period style. For further light on the paradigm, look no further than to a good handbook on poetics. Here is what we find: "In twentieth-century literary criticism, ambiguity has become a key concept particularly for critics interested in the complex problem of distinguishing the language of poetry from the precise, literal, univocal language required by scientific and other expository prose."[12] These are Greenberg's purposes in a nutshell—the very essence of what his writing tried to do.

It is true that for Greenberg, at least, de Kooning's Women were not ambiguous enough. He eventually came to see them as "inferior by and large to [the artist's] previous work."[13] Not because the paintings are overtly figural, mind you. On the contrary, the critic saw and conceded the impressive modernist ambition behind the effort "to recover a distinct image of the human figure, yet without sacrificing anything of abstract painting's decorative and physical force."[14] The means by which to do so was line, that disembodied contour whose necessary divorce from literal description motivated the whole set of draftsmanly devices—the cutting, pacing, tracing, and so on—that Hess first spelled out. This path has its dangers: persisted in too long it can result in the kind of "busy proceduralism" that, according to the poet J. H. Prynne, too often takes over the artist's work.[15] And even for Greenberg, line alone—however sculptural, however abstract, however disjunctive—did not finally redeem

the Women from the literal and legible aspects of their bodily forms.

I don't propose here to defend de Kooning against Greenberg, and thus to side with Hess's championing of the painter's art (the latter was tireless in this effort; there are no less than nineteen Hess entries in the standard bibliography, as opposed to Greenberg's two). Instead I want to take a different tack, one which makes *ambiguity*— "double or dubious signification" as defined in the OED—emerge even more concretely as a main conceptual problem of and for de Kooning's art. The issue involved something other than a set of formal moves and procedures an artist sought and found. To speak of ambiguity rather differently—as a representational posture or purpose—is what I aim to do. For there is no reason to believe that de Kooning did not actively share some of the same critical commitments that guided the champions of his art. Can ambiguity be a look or strategy that is consciously mobilized to frame problems for art? Can the "double and dubious" be actively sought? "We call it ambiguous, I think, when we recognise that there could be a puzzle as to what the author meant, in that alternative views might be taken without sheer misreading."[16] This sentence comes from William Empson's *Seven Types of Ambiguity*, first published in 1930 and reprinted in a revised edition in New York in 1947. The text is dedicated to grasping how ambiguity figures in writing; its re-edition suggests that the whole topic seemed newly relevant during the postwar years.[17]

Like Hess and Greenberg, I think there is a certain measure of ambiguity built into what de Kooning meant to say and show. This effect seems to have been aimed at from the start by his way of drawing, with its disjunctions, repetitions, and unhingings, producing the means to pursue some such purpose as a value or goal. Yet ambiguity—the "double and dubious"—is not merely a matter of form. Like

de Kooning himself, we need to work at a larger scale and optic: to consider legs and neckties, and to speak of women and men. Women, not Woman: insisting on the plural might even help us to think of the relevance of men.

2. two's company

To start that process, look back at de Kooning drawing (or seeming to draw) in his Fourth Avenue studio. The year is 1950; the month June. One striking aspect of this particular encounter is that although the artist is routinely described as shown while working on preliminary drawings, plural, for *Woman I*, in fact there is every reason to conclude that he actually stands before a single composition. Call it *Two Women* for lack of another name.[18] Why else, except in pursuit of a single image and surface, would the unfurled sheets of paper have been so carefully joined? Why would so many lines travel across the taped-up midpoint, linking angles and vectors and background passages, if not to fuse the space the women occupy into a continuous whole? The result stages a scenario that harks back to an extended series of drawings of two women aligned in just this way. According to Hess, the group was begun about 1948, and was much worked on in summer 1952.[19] As do the smaller works, the chosen proportions of the wall-sized version insist on a landscape format, rather than framing or forcing an encounter through the setup of portraiture.[20] (I am using "landscape" to name not just the erratic appearance of spatial locators—the occasional window, or the signature windmill, or sometimes just a ground plane hectic with marks—but rather a surface whose measure is amply horizontal, distinctly wider than it is tall.) Such dimensions insist on place and space as their idiom: they locate figures within the frame of a conjured world, even if few of its concrete elements—those windows and windmills and sometimes, what the title declares a wharf—are actually invoked. And the formatting, with its emphasis on presence, raises the issue of what it means for de Kooning to draw while simultaneously encountering two such bristlingly skeletal figures standing together, side by side. The two would dwarf him handily in height and girth, if and when their linear frameworks (look at the winging breast/buttocks and stick-figure legs) were filled out. This never happened, at least in oil at a finished painting's scale. Why seek such plenitude, only to surrender it? Why even consider picturing two women, rather than the signature one? And why make that process such an elaborate preliminary and accompaniment to the final much-condensed result?

The answer lies in the simplest of facts. Together the women make two. So much is obvious, yet the suggestion in its very baldness sends us back to a similar pairing, *Self-Portrait with Imaginary Brother*, a 1938 drawing that is one of the artist's earliest double-figure works. Not that its poignant romanticism summons any particular sense of place— there is at most a baseboard, and perhaps a dado above. On the contrary, in lieu of place are vivid persons:

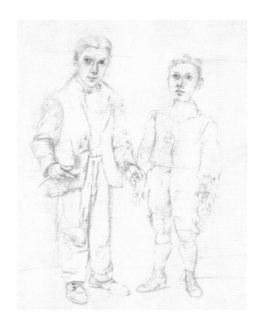

174

Self-Portrait with Imaginary Brother, c.1938
Pencil on paper
13 1/8 x 10 5/6 inches
Estate of Saul Steinberg
Courtesy Mitchell-Innes & Nash, New York

two protagonists, a youth (a teenaged de Kooning drawn from a photograph) and his younger brother, are called up in all the delicately detailed presence that drawing can provide—rough clothes, clunky shoes, wide eyes, all sketched in with fine pencil point. There has never been a writer on this image who hasn't invoked Ingres, with reason. Yet note that however deft de Kooning's powers of observation—however vividly he, like Ingres, can make a person's individual presence felt—these proud young grandees are insistently street kids, Bowery patricians who will never visit Rome. Surely the sentiment behind this image mines all the skill Greenberg so mistrusted—facility is put on full (and fancy) dress display. Hence the greater irony to be found in the one place skill falls short: the rubbery claw-like hand of the de Kooning figure breaks with its otherwise gently regular, even conventional forms. Strange that the artist could not draw the very body part he so relied on; I don't think it helps much to say that the hand eluded him because it was actively in use.[21]

There are two things to note about this drawing. One is the chief visual operation that the pair of figures sets in train. The relation is comparative and clarifying. The paralleled bodies mean that we cannot help looking back and forth between them, assessing who is who. One is older and wiser, the other more distant, despite his youth. This is the child who is clearly dressed as a boy, while the other, as his senior and guardian, wears clothes that mimic a man's. Next notice the use of drawing to summon an *imaginary* double; the boy is a brother, who though not quite the likeness of his sibling, is named as someone even closer than a friend. He is, we might say, the very figure of the double, stylistically and otherwise, who offers a version of resemblance able to supplement the self. De Kooning summons a sibling who is the same but different, with the proximal relationship all the more emphatic, given the family

romance—the discovered history—to be invented via the princeling of a brother one can dream (that is, draw) into life.

De Kooning's series of two women mines this imaginary scenario and begins to rewrite it along different bodily and narrative lines. It is clear that a certain concept of the couple or double has by this time begun to come unstuck. The artist continues to double his figures, certainly—to use two, instead of one—but the scrupulous pencil-point illusionism of the earlier moment has ceded to aggressively disjointed bodily effects. The explosive planes cut and slice as boldly as the scissors the artist also used. Drawing itself no longer doubles—directly imitates—the world; de Kooning, we might say, has started down the road towards "ambiguity" as performance and posture, though he is not yet there. Take *Two Women with Still Life* (1952, plate 64) as the exemplary instance, not least because it is one of the most fully elaborated images in the set. What is different about the revision is not just the gender of his paralleled bodies, but the confident incoherence with which they make their presence felt. The pair now clearly has what we might call an axial backbone, from and around which hang curves and planes and colors like a clutch of bright objects tethered to a pole. And there is a certain pleasure in the motley presence of the duo; as do so many others in the series, their eyes stare out at the viewer with a kind of loony joy. Does this affect come from being possessed of so much bodily equipment, or because they serve to showcase so many of the draftsman's newly chosen cubist wares?

Yet however disjointed these bodies, together they spark an encounter that is less spectral than social, less confrontational than potentially interactive. Again the double format means that we read back and forth between the duo, comparing them as they stand, all eagerness and energy, before our eyes. There is much about them we can reasonably

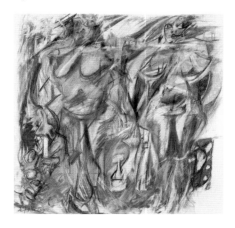

Two Women with Still Life, 1952

ask. What brings the two of them outside, into the landscape? A pastoral picnic? (There is that still life, with its fruity array.) Are they alike or different in their pneumatic nakedness? Why are they so friendly? What are their bodies made of, and where do they stop and start? What surrounds them? What are we to see in the vivid sprays of color that fill the spaces between their legs? Relationships and differences are proposed along all these axes and grasping them is a necessary and inevitable part of simply beginning to take hold of the work. The double setup is evaluative: the two women are made to surrender their singularity (literally and figuratively), as if to heighten the measure of sociability—and even, oddly enough, the sheer mundane normalcy—the artist can build into the operations of the work, even while holding on tight to its explosive complexity of form.

To speak of the sociability offered by the Two Women studies is to suggest something of what it has in common with *Self-Portrait with Imaginary Brother*. De Kooning clearly relies on a process of contrast and analogy generated within the confines of each picture: knowing these figures, in other words, is structured both descriptively and as a comparative task. Body, stance, visage, presence—each has its counterpart. Likeness and difference are the order of the day. No wonder de Kooning rang the changes on the various possible pairings—boys, men, women. The naked man plugged into the system in *Two Nude Figures* (1950, plate 34) is presumably as "imaginary" as every other figure, brother and woman, assigned to this same slot. Perhaps it doesn't really matter who stands there: the comparative process is still set working whenever this grammar

is used. Or, to quickly shift the metaphor: such pictures set up a laboratory—a theater of operations—where certain kinds of knowledge and pleasure are sought and secured. By all means let us stress the rarefaction of that knowledge: if these bodies are laboratories, they explore not only anatomy, but also depictive technique. Laid open for comparative inspection are a set of devices to fabricate bodies: the doubling means that their uses are opened to view.

By now it must be clear that this argument is inevitably heading towards *Woman I*. Nothing can stave off the impact, for the picture offers the context in which de Kooning's ambitions for large-scale painted figuration were brought down to size. Two ceded to one. The artist replaced his huge double drawing with a single large canvas and went to work picturing one woman, instead of two. Drawings were cut and pasted, added and subtracted, layered on the surface, then stripped away. Stages accumulated like memories; so as not to forget them, the painter brought in the camera six different times, at slow intervals, a couple of times a year. The pace seems oddly domestic, as well as commemorative; this is the way parents record the growth of a child, knowing how quickly the present wipes away the past, not knowing what the future will bring. But paintings aren't children. It is worth wondering exactly why de Kooning used a photographic double to remember what had gone before. The effort is comparative, so much seems certain: it is as if the course of the painting, whatever its direction, needed to take its bearings and measure its distance from what had gone before.

For a single figure has none of the visual checks and balances a double format provides. I think this is precisely why de Kooning made his singular turn. Who would not be ready to find the "double and dubious" in these staring eyes? And what of the flailing limbs and white picket teeth? Is this movement or disintegration? A smile or a rictus? Pleasure or pain?

176

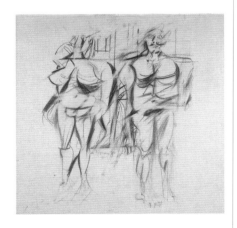

Humor or madness? We are certainly meant to ask such questions; but we are not helped to decide. Nowhere is the task staged more graphically than in and on the surface of the picture, where we are forced unaided to puzzle out what each mark mimes, to say nothing of what it says and does in the overall whole. Some sections clearly show built-up layers that vary in thickness and liquidity of stroke (this is true of that vertical silver border washed in to cover the right-hand edge; it ends damply, in a fringe of drips). Others—the breasts in particular—have been scraped back to the near-blank smoothness of a thinly gessoed wall. What logic is in play, when two breasts offer the maximum absence, both pictorially and in the tactile logic of the whole? Not for nothing are these signature organs of fullness made so empty—formed and framed by two gaping noughts.

Other touches on the surface ring further changes on absence and presence: sometimes a stroke is a broad deposit of paint, while elsewhere pigment is subtracted via a line scratched with the butt end of a brush. Sometimes, as at upper left, a brushstroke seems to perform its identity with a kind of cartoon-like energy. At moments like these, the Pop ironies of Lichtenstein and Rauschenberg stand waiting in the wings. I don't think such later witti-cisms, when they happened, told de Kooning much he didn't already know, or wouldn't himself pursue as the 1950s and 60s wore on.[22] Yet elsewhere—as in the sooty stroke that flies at a tangent along the top of *Woman I*'s right eye—the touch imitates a bodily feature as well as performs abstractly: in its blackness, it conjures a thickly mascaraed lash. There even seems to be a dusting of charcoal in this particular zone, like scrapings from the various drawings with which the artist prefaced and accompanied the work. Drawing as makeup, perhaps. Like so much else in the picture, these black marks are ambiguous, not as literal presence, obviously, but as a figural

device. Ambiguity works best, in fact, when some agreed-upon otherness of a depicted figure is already distinctly in play; conventions of identity need to be stretched and altered to make its motor run. (Perhaps this is what Greenberg meant by the "refusal to work with ideas that are too clear.") Enter the female body, cherished avatar of otherness: amplitude and absence all in one. These are the dualities, in other words, routinely attributed to women, whether there are two or one. Yet this whole interrogative process is set humming when the viewer confronts this one work.

If I were to name the point of maximal ambiguity in this canvas, my choice would fall on a feature that I have for many years ignored. This is the welter of marks beneath the woman's breasts. They make a mis-shapen hand, one just bulbous and pointed enough to recall the strange appendage found in *Self-Portrait with Imaginary Brother*. In both cases, moreover, the right hand is the one to be deformed. It is tempting to think that the hand in the later canvas, though clearly belonging to the woman, is also the artist's own, which thus is sited like an odd set of genitals, smack in the woman's lap. Of course this feature is far from clear. But if we are to call more details ambiguous, perhaps we should return to Empson's maxim, just to be *un*ambiguous in our own claims. "We call it ambigu-ous, I think, when we recognize that there could be a puzzle as to what the author meant, in that alterna-tive views might be taken without sheer misreading." If I insist on clarity in this context, it is to avoid possible misreading of what I aim to show.

Thus far I have argued along two lines. First, that drawing offered de Kooning a means both to pursue, then turn from, mimesis—away, that is, from his early will towards and mastery of resemblance and figural form. Here is an artist who could quite easily make a pencil mimic the things in the world—and fictions not in it, too. Imaginary brothers and

disintegrating women—both could come into being with a kind of confident, even urgent presence that is the measure of the artist's skill and will. Making figures present is what he aims to do. Who cannot be struck by how insistently the artist's figures fill the page? Top to bottom is the same as head to toe. Such a scale squeezes and blocks out context, even while it binds vision tightly to the figures in frame. And the urgency is only heightened once de Kooning began to fragment forms and paper both; cubist destruction was taken to its logical ends. Logical, that is, if we grant that what is to be destroyed and refigured by cubist procedures is the presence—the magic—of the objects and people in the world. Note, however, that de Kooning left objects to their own fate: he made only a few still-life images, no more. Instead it was the fate of the human figure that he took into his hands. If this is Procrustean violence, what it aims to rob from its victims is the sense of likeness (however magical)—the feeling, that is to say, of having been *already seen and known*. I think that in some sense these motivations are deeply part of how de Kooning drew. We might say he worked with eyes wide shut. I know the borrowed formula seems facile: shades of Hollywood, you say. But shades of de Kooning, too. The phrase conjures not just the glamorous smiles and empty eyes of his Women and his many memorials to Marilyn Monroe, but also the set of drawings showing women and crucified men that he made in the mid-1960s, with his eyes tightly closed.[23] At least some of these were dashed off while watching television, from whose facile (and magical) solicitations we can imagine him turning away. I wonder what programs were being broadcast on such occasions, and how they deployed their casts of "neckties" and "lopsided blondes." Facility and emotion: with de Kooning, the risk of the former and the payoff of the latter are always waiting in the wings. Surely it might be conceded that he did not always turn far enough away from facility to let emotion come through.

My second line of argument has tried to link the double of drawing to an odd circumstance in the history of what is certainly de Kooning's most notorious work, *Woman I*. Why, I have asked, did the artist produce a parallel sequence of images that focused on two women, instead of one? The versions coexisted side by side, one seeming to double the other like a movie star's stand-in, who is paid to spare the more valuable performer from boredom, risk, and harm. So things work in Hollywood, at any rate. And in the end, just as at the movies, we are willing to believe that the "star" herself—the final canvas—was the one who took the risks. This is the case, at least in part, because in the end it is the single canvas we confront. *Woman I* stays mostly mute about its past, the laborious process in which drawings and photographs did so much of the work. Nor does it speak to the future, the whole sequence of further Woman canvases that both replay and supplement installment one. Or perhaps these later doubles continue to explain and justify the milestone picture, in that they continue the exchange and analysis that the plural sometimes hopes to yield.

◆

Rudolph Burckhardt
Willem de Kooning, 1938

wagner

1 Clement Greenberg, "Review of an Exhibition of Willem de Kooning," in *Arrogant Purpose, 1945–1949*, vol. 2 of *Clement Greenberg: The Collected Essays and Criticism*, ed. John O'Brian (Chicago: The University of Chicago Press, 1986), 229–30. Greenberg's review was first published in *The Nation*, 24 April 1948.

2 Thomas Hess, "De Kooning Paints a Picture," *Art News* 52, no. 1 (March 1953): 30–33, 64–67; this quotation, 30, within caption.

3 Ibid., 31.

4 Ibid.

5 David Sylvester, "The Birth of 'Woman I,'" *Burlington Magazine* 137, no. 1105 (April 1995): 222. Sylvester provides this phrase in the course of a brief discussion of Richard Shiff's claims, in "Water and Lipstick: De Kooning in Transition," in *Willem de Kooning: Paintings*, exh. cat. (Washington, D.C.: National Gallery of Art; and New Haven: Yale University Press, 1994), 33–73.

6 The phrase "obsessive dismantling" occurs in Marla Prather's catalogue contribution to *Willem de Kooning: Paintings*, 129.

7 Hess, "De Kooning Paints a Picture," 32.

8 Ibid.

9 Ibid.

10 The series of articles published in *Art News* with a shared format title—"De Kooning Paints a Picture," "Kline Paints a Picture" (1953), "David Smith Makes a Sculpture" (1951), etc., became something of an art-world institution, one reason it provides such a useful archive for studying both artistic procedures, and identity and self-fashioning.

11 Hess, "De Kooning Paints a Picture," 64. Italics mine.

12 *The New Princeton Encyclopedia of Poetry and Poetics*, eds. Alex Preminger and T. V. F. Brogan (Princeton: Princeton University Press, 1993), 40.

13 Greenberg, "A Critical Exchange with Fairfield Porter on 'American-Type' Painting," in *Affirmations and Refusals, 1950–1956*, vol. 3 of *Clement Greenberg: The Collected Essays and Criticism*, ed. John O'Brian (Chicago: The University of Chicago Press, 1993), 240; first published in *Partisan Review*, Fall 1955.

14 Greenberg, "Foreword to an Exhibition of Willem de Kooning," in *Affirmations and Refusals*, 122. Originally published in *Willem de Kooning Retrospective* (Washington, D.C.: Workshop Center for the Arts; and Boston: School of the Museum of Fine Arts, 1953).

15 J. H. Prynne coined the phrase "busy proceduralism" to name the way that de Kooning handles the necessity of making an abstract painting build into its internal order "a structure of reference to the origins of its consequential freedom." Prynne is thinking particularly of the artist's insistent reiterations of the structures and habits of analytic cubism. See his "A Discourse on Willem de Kooning's *Rosy-Fingered Dawn at Louse Point*," *act* 2 (1996): 45.

16 William Empson, *Seven Types of Ambiguity* (1930; revised, New York: New Directions, 1947), x. Note that the phrases I quote appear in the first U.S. edition of Empson's fundamental text—a publication apparently widely read by intellectuals at the time.

17 My "Pollock's Nature, Frankenthaler's Culture," in Kirk Varnedoe and Pepe Karmel, eds., *Jackson Pollock: New Approaches* (New York: The Museum of Modern Art, 1999), 181–200, offers a discussion of Helen Frankenthaler's uses of Empson in a 1956 canvas; the picture uses Empson's title as its own.

18 This large double sheet drawing did not survive. In his later study Hess recognizes the two papers as vehicles for preliminary drawings for *Woman I*, but does not develop the implications of this observation at any length.

19 Thomas R. Hess, *Willem de Kooning: Drawings* (Greenwich, Conn.: New York Graphic Society, 1972), 24.

20 Prynne has recently raised the issue of de Kooning's chosen formats, particularly where the implications of *portrait* versus *landscape* are concerned. See Prynne, "A Discourse on Willem de Kooning's *Rosy-Fingered Dawn at Louse Point*," 35.

21 Sally Yard, in her "De Kooning's Men," *Arts Magazine* 56, no. 4 (December 1981): 134–43, reads this picture as an expression of the artist's "sense of loneliness as a poor, young foreigner" (136); she also notes its strong relation to the figural art of Arshile Gorky, particularly his canvas *The Artist and His Mother* (c. 1926–36; Whitney Museum of American Art). Yard's account likewise points to several drawn compositions on the theme of Two Men, and notes the ambiguities of gender that crop up within this series. It seems likely that de Kooning drew on a photographic source for his own figure—perhaps the portrait of the artist in his studio made by Harry Bowden in 1946. In that image, the artist has his right hand in his pocket, while his left holds a cigarette. For a reproduction see *Willem de Kooning*, exh. cat. (Paris: Centre Georges Pompidou; and New York: Whitney Museum of American Art, 1984), 189.

22 The uses de Kooning made of the 1960s—as well as those the 60s made of him—is still a story waiting to be told.

23 For reproductions, see Klaus Kertess, *Willem de Kooning: Drawing Seeing/Seeing Drawing* (New York: The Drawing Center, 1998), plates 12–35.

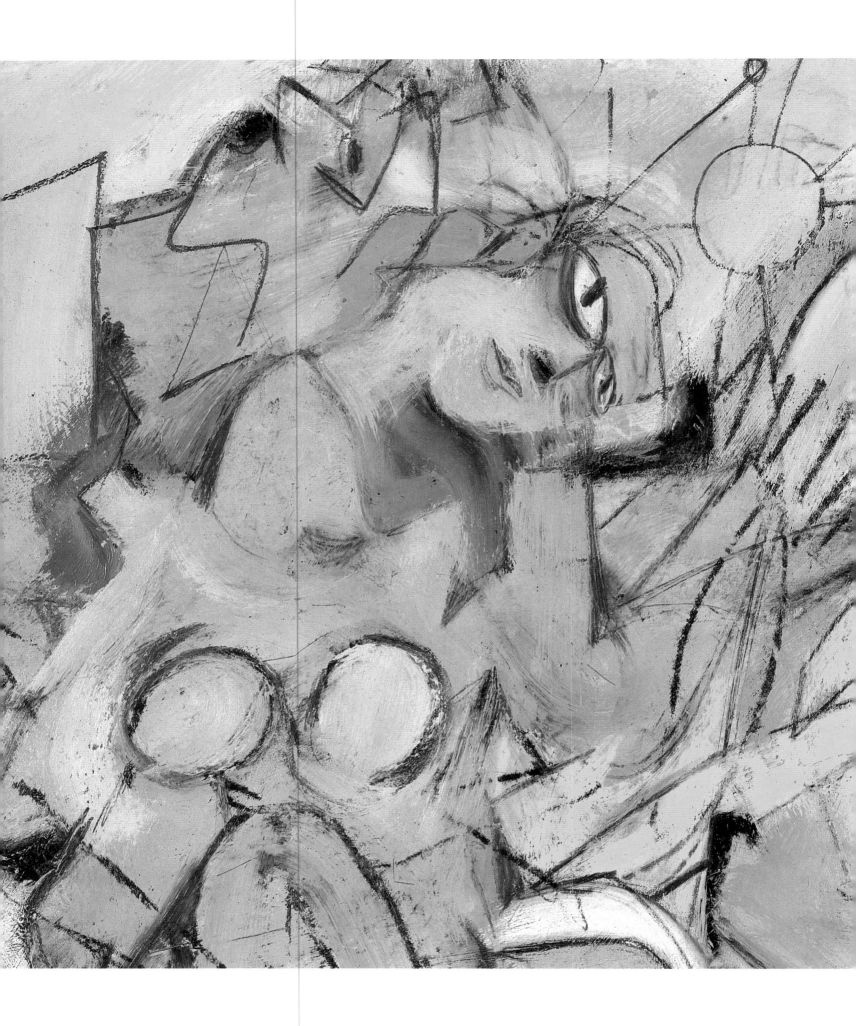

cornelia h. butler

the woman problem
on the contemporaneity of de kooning's women

The installation of Willem de Kooning's *Woman I* (1950–52, page 141) in the 2001 "Collection Highlights" exhibition at The Museum of Modern Art, New York, safely reclaims the painting's rightful place among its canonized, most beloved cohorts. However, it belies its recent history within the very same institution. Like many American museums, MoMA has answered the call of revisionist art history and attempted a reshuffling of its collections—mixing media, juxtaposing historical periods, and generally granting the full range of its collections the right to rub elbows with unprecedented fluidity. In three consecutive collection installations, collectively referred to as "MoMA 2000," the museum attempted to rewrite its own history valiantly, but with considerable awkwardness. During the second installation, titled "Making Choices," one would have viewed de Kooning's fantastic picture in somewhat unfamiliar historical and thematic territory alongside such artists as Lee Krasner, Agnes Martin, and Tony Smith, in an installation titled "New York Salon." Rather than foregrounding its content, an imposition made on other works in the collection, this grouping seemed to allow the work its own unique status as simultaneously abstract and representational, both in concert with and in opposition to painting and sculpture by three other arguably iconoclastic artists. Pushing *Woman I*'s socially inscribed meaning while privileging its formal attributes as abstraction was a provocative move that would seem to put to rest, once and for all, the question of whether or not it is an icon of misogyny. The fact that the woman in de Kooning's *Woman I*—a figure that underwent a well-documented series of studies and furious reworkings—can now be somehow emblematic of the contemporary discourse around the body, gender, and sexuality is a remarkable example of the mutability and resilience of the picture itself. It also represents a major shift in critical thinking around the role of works of art within a public museum collection and their function as socio-historical texts.

Undeniably, we are presently negotiating an unsettled moment in terms of painting and the body. Museums organize exhibitions that privilege technology and suggest the much-anticipated crisis of the body, even as there is a remarkable rise of figurative painting in museums, galleries, and auction houses. Artists such as John Currin, whose traditionally rendered, partially clad women disturb even as they seduce, are hailed as radically reworking academic painting. In 1997, when hung in MoMA's project space in vague proximity to the permanent collection, Currin's paintings apparently caused an uproar among curatorial staff who weren't comfortable with the juxtaposition.[1] Mel Ramos's pinups from the 1960s have returned from banishment due to political incorrectness to garner high prices at auction. Painter-turned-performance-producer Vanessa Beecroft stages elaborate tableaux in which women stand around in strangely stilted groups, naked

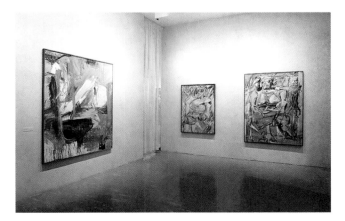

opposite: *Pink Lady (Study)*, c. 1948 (detail)

Installation view of *Woman I*, 1950–52, "New American Painting, as shown in Eight European Countries, 1958–59," The Museum of Modern Art, New York, 1959

except for Gucci bathing suits and heels (*VB35* at the Guggenheim Museum, New York) or red stockings and pumps (*VB40* at the Museum of Contemporary Art, Sydney), causing feminists to wonder if these performances are actually compelling or just vaguely pornographic. Indeed, women artists don haute couture and eagerly embellish the pages of *Vanity Fair*, and Linda Nochlin, who once changed the course of feminist art history by asking "Why Are There No Great Women Artists?," now champions the salacious figuration of young artists like Cecily Brown and the distended, sugary girls of Lisa Yuskavage's lurid fantasies. In her recent review of Yuskavage's work, critic Carey Lovelace aptly summarized, "In this postfeminist age, we are used to having images of desire that feature women 'captioned' with a sense of the artist's awareness that, yes, this is a sexist image.... three decades of women's studies have made artists all too aware of how inextricably the representation of women in paint is interwoven with issues of power."[2] Something is clearly up with figurative painting.

The present post-identity, post-AIDS moment, which morphed out of the pluralistic and more politically engaged 1990s, is characterized by a crisis around the representation of the body. A decade ago, when a brief consensus formed around so-called feminist painting, exhibitions such as 1991's "Plastic Fantastic Lover" at Blum Helman Gallery, New York, and the 1993 Whitney Biennial positioned the work of a range of artists including Suzanne McClelland, Shirley Kaneda, Mary Beyt, and Sue Williams as gendered. Their work was characterized by a kind of abstraction which incorporated embedded signifiers of a feminized iconography.[3] Willingly or not, these women carried the torch of feminism in painting. But the in-your-face, naked bodies of current practice push issues of sexuality and gender to the forefront even as the artists frequently disclaim their debt to feminist practice. They are, it seems, genuinely interested in working within an academic tradition of the figure. A kind of ironic detachment has replaced any earnest entanglement on the part of the artists, or any confusion on the part of the critics about our collective relationship to the female figure. What exactly, we might ask, have three decades of women's studies wrought?

De Kooning's Women have always posed a similar challenge, and their current resonance has to do with how, both in their time and now, they problematize the time-worn, art-historical trope of the female form. And they looked both shocking and time-worn when they first disrupted the furiously evolving discourse of New York School abstraction in the early 1950s. The group of Women paintings and drawings that cycled around the great *Woman I* were executed between 1950 and 1955 and compose what is arguably the core of de Kooning's artistic production. The Women were and are some of the most potent and visceral images of the human form, male or female, of the twentieth century, and the literature around these works spans the hateful to the elegiac.

182

Mel Ramos
I Still Get A Thrill When I See Bill, no.12, 1977
Watercolor
30¹/₂ x 22¹/₂ inches
Collection Louis K. Meisel Gallery, New York

Vanessa Beecroft, *SHOW*, performance at the
Solomon R. Guggenheim Museum, New York, 23 April 1998

It is by now well documented that critics ranging from insiders Harold Rosenberg and Clement Greenberg to marginal writers in the popular press were alternately horrified and thrilled by de Kooning's raw and ambitious works.[4]

In attempting to understand how they functioned in their own time and now as resonant and even radical expressions of human embodiedness, it is helpful to look at the critical writing with an emphasis not on the formal aspects of the work, but rather on the subject of woman. How can we revise our understanding of the content of these works which refuse to be historicized even within the span of the artist's own oeuvre? It has always seemed to me that the misogynist and frequently psycho-biographical readings of de Kooning's work of this period miss the point and are certainly intimately connected to the reception of de Kooning's turn from abstraction to figuration in the late 1940s. In fact, by his own numerous accounts, he oscillated between the two comfortably until the very end of his career. About his subject he often said such things as "I have no opinion on women…I do not particularly stress the masculine or the feminine viewpoint. I am concerned only with human values,"[5] or later describing its conventionality, "the female painted through all the ages…a thing in art that has been done over and over."[6] What is more interesting to pursue perhaps than de Kooning's relationship to women, his mother, or his wife as the source of his relentless reworking of the woman theme is to track the so-called feminist readings in the critical literature, elements of which surfaced as early as the 1960s, and try to reconcile these with a contemporary reconsideration of how the Women function.

Unquestionably, the critical outcry in the wake of de Kooning's turn away from abstraction is linked to the equally vehement reaction against the apparent violence done to the representation of the subject he chose. The expressive cutting and collaging in the drawings, and the well documented series of alterations made to *Woman I* leading up to its startling debut, were somehow proof that de Kooning was flaunting art history even as his subject pretended to remain within its grasp.

In 1953, the same year as de Kooning's first retrospective and the year his infamous Sidney Janis exhibition of the Women created seismic waves throughout the New York art world, Robert Rauschenberg erased one of de Kooning's Women. Called a "symbolic (if good-natured) patricide"[7] by Calvin Tomkins, the now famous *Erased de Kooning Drawing* (1953), which hangs in the collection of the San Francisco Museum of Modern Art, is usually interpreted as a proto-conceptualist gesture on the part of Rauschenberg, who himself bridges the expressionist 1950s and the postmodern 60s. Explaining this work and its relationship to his forefather de Kooning, Rauschenberg said "I'd been trying with my own drawings, and it didn't work, because that was only fifty per cent of what I wanted to get. I had to start with something that was a hundred per cent art, which mine might not be; but his work was definitely art, he was the clearest figure around so far as quality and appreciation were concerned."[8] What seems clear is that within this dramatic act of homage is a kind of negation of history and specifically an effort to neutralize the figure by rendering it abstract. In other words, Rauschenberg understood that in de Kooning there was an equivalence between abstraction and its opposite, figuration, the obliteration and equivalency of which he sought in his own black and white paintings. Erasure is the reverse of gesture; the absence of color in the white paintings is equivalent to the lack of line and color in the erased de Kooning. Most probably, de Kooning chose to give Rauschenberg for this exercise a woman drawing on which he had been working at the same time as he prepared

his all-Woman show for Sidney Janis. He certainly understood the humor and gravity of his selection and what was at stake for painting.

It is almost as if de Kooning understood, with some prescience endowed to nonnatives in the art capital that was New York in the 1950s, his own position within the narrative of modernism. In the contemporary accounts of discussions with colleagues Jackson Pollock, Franz Kline, and others, he seems to have appreciated and even cultivated the degree to which his own struggle with figuration disturbed his cohorts and agitated Clement Greenberg, their champion and critical mentor. Rather than seeing art history as a trajectory of enlightened evolution towards the fragmentation of Picasso and culminating in the complete spatial obliteration of Pollock, de Kooning may have recognized that his own free sampling of art history was ahead of its time. We are now accustomed to artists such as Gerhard Richter or Roy Lichtenstein moving effortlessly between figuration and abstraction, borrowing at will from art history's canon. But this was edgy stuff at mid-century. De Kooning's flaunting of the figure challenged the mandate of Abstract Expressionism as an agreed-upon movement, style, and zeitgeist. One might even wonder if de Kooning wasn't effectively calling its bluff.

What is ironic is that his ongoing dialogue with the Women—his apparently easy vacillation between representation and the figure—was seen by some as a retreat, a "failure of nerve."[9] It is as if de Kooning had derailed the relentless drive forward of art history's grand parade. Far from being understood as a radical break in emphasis from the artist's body—as in action painting—to the body as subject, the Women were unanimously rejected as a conservative backward glance in the direction of traditional European painting. In one of the many conflicted reviews of de Kooning's Sidney Janis show, Hubert Crehan falls back on the Medusa myth to explain the artist's supposed psychological enslavement to his subject. If painting is a kind of seduction, how could anyone be knowingly seduced by such a Medusa as de Kooning's glaring goddess:

> He has been traumatized by the subject: a fatal mistake for an artist, art and psychology being mutually exclusive. Striving after an apocalyptic vision of the *Woman*, he has produced for us a Medusa and for himself a dilemma. I believe this dilemma results from his tactic of returning to the subject after his earlier divorce from it. He can't paint without the *Woman*, yet he can't connect with her.[10]

A common reaction in the critical literature was to attribute the artist's evolution to an entrapment by his alluring and apocalyptic subject. Adding to the confusion was the fact that the viewer-cum-critic was clearly stymied in the gaze of the painted subject. Situating the paintings as gendered, empowered presences before which the (male) viewer/artist was literally rendered impotent was the convenient justification for such a seismic formal move and effectively reinforced the existing problematic reading of the artist's relationship to the female nude. Even Greenberg, who championed de Kooning as the most skilled of all the Abstract Expressionist painters, insists on anchoring his female form in Cubism in order to legitimize it historically. Though clearly invested in de Kooning's legacy as an abstract painter, Greenberg, whose views were shared by Pollock, can only come to terms with these meddlesome women by tying them to tradition. In his now famous essay "'American-Type' Painting," he writes:

> On the face of it, de Kooning proposes a synthesis of modernism and tradition, and a larger control over the means of abstract painting that

184

would render it capable of statements in a grand style equivalent to that of the past. The disembodied contours of Michelangelo's and Rubens's nude figure compositions haunt his abstract pictures… No more than Picasso can he tear himself away from the human figure, and from the modeling of it for which his gifts for line and shading so richly equip him.

And later:

When he left outright abstraction several years ago to attack the female form with a fury greater than Picasso's in the late '30s and '40s, the results baffled and shocked collectors, yet the methods by which these savage dissections were carried out were patently Cubist. De Kooning is, in fact, the only painter I am aware of at this moment who continues Cubism without repeating it. In certain of his latest *Women*, which are smaller than the preceding ones, the brilliance of the success achieved demonstrates what resources that tradition has left when used by an artist of genius. But de Kooning has still to spread the full measure of that genius on canvas.[11]

As art historian David Cateforis has rightly pointed out, contrary to the conventional mythology surrounding these works, the early criticism was not entirely negative but rather nervous in terms of what he characterizes as an anxiety around their subject.[12] While the early outcry focused on a kind of struggle to reconcile and perhaps neutralize the crisis believed to be at the heart of the images, by 1960 the reaction turned to "the women problem"—the debate over women's rapidly changing roles in postwar American society which was gathering momentum in the popular imagination.[13] The only two women critics to take up de Kooning's work of this period were New York School advocate and historian Dore Ashton and curator and chronicler of the 1960s Lucy Lippard. While too early to be overtly feminist in nature, these responses are worth looking at because they were written by two of the most prominent and respected women critics at the time: Ashton, a known observer of the New York scene; and Lippard, at the beginning of her critical career. In a 1955 review that also covered a Brancusi exhibition at the Guggenheim Museum, Ashton takes on her fellow critics and their "panegyrics about 'returns'" to the "earthmother."[14] While distancing herself from de Kooning's other male critics she is clearly relieved that the Women—the "ladies"—have, by 1955, been tamed by the "large, full-blooded abstraction" de Kooning was reintroducing by this time. She understands the Women—whipped by the masculinized bravura of abstraction—in terms of de Kooning's larger humanism and sees the abstraction as an extension of them:

De Kooning's existence is a continuous arduous research. When he first painted the blousy, frowzy, horrifying woman, it was no other than this search for first principles whether or not he would have stated it that way. The fact that he implied an environment through and in the woman figure seems to bear it out. In coping with the human figure, and later, with the figure in landscape or specific place, de Kooning extended his intelligence of the universe and deepened his intuitive knowledge of relationships. His way back to abstraction is not back at all. It is the logical step.[15]

What is interesting here is how Ashton sidesteps what she clearly considers to be the somewhat retrograde interpretations of her male counterparts and allows the woman to be a fully integrated subject within de Kooning's oeuvre rather than a masterfully

painted lateral move on his prodigal way back to abstraction. She is clearly less daunted or disturbed by the subject itself.

By the time Lucy Lippard takes on what she calls the "de Kooning myth" in 1965, reviewing the artist's first retrospective exhibition and his "Three Generations of Women" (also the title of her article), times have changed and the rhetoric is much calmed down. And, though Lippard considers de Kooning's figuration (and Pollock's) to be an aberration, she understands it in terms of the abstraction, his handling of paint, and the persistent characterization of his consistently inconsistent style. She traces the progression from the iconic Women of the 1950s to the "vulgar" Women of the 60s and, in language that anticipates today's return to figuration, looks to the paint itself as a physical locus of an embodied presence:

> De Kooning's style is characterized by an intense unrest, manifested most strongly in the shifting, anxiously arrested motion of the figure and, later, of the entire surface. This suspension of static and specific is implied by the use of brushstroke, which is the direct bond between the man and the painting. De Kooning, even more than Pollock, made this act an integral element of his style. [16]

Lippard's review of de Kooning is the most sober and contextually cognizant of any up until this point. She takes to task the critical writings of her fellow authors and the "throbbing language" used to cope with the supposed ferocious (painted) sexuality of the Women. Just a year later Lippard would write about Eva Hesse's abstraction in terms of the body, and just a few years after that she would turn her full attention, as a curator and writer, to feminist art and articulating a new language for the representation of the female body.[17] Without digressing too much, it's worth looking briefly at Lippard's characterization of a new kind of abstract, body-based sculpture she calls "Eccentric Abstraction."

The article opens with the Champfleury quote: "Only the ugly is attractive." She goes on to suggest that the embodied sculptural abstraction of the 1960s has to do with painting's legacy of the vulgar: "allied to the non-formal tradition devoted to opening up new areas of materials, shape, color and sensuous experience...it was Pop that made palatable parts of the contemporary environment previously considered vulgar, ugly, and inferior to the 'beauty' required by tastemakers in art, fashion and commerce." And later, "The giggles it provokes are, however, giggles of uneasiness and perhaps even awe, like the giggles provoked by aspects of death, love, sex, excretion, any natural function too naturally exposed."[18] Part visceral and extremely present, part lifted from popular culture's generic tabloids, de Kooning's Women might be seen in this context as they would only much later be understood, as the unnamed link between Abstraction Expressionism and Pop. And the link is through this notion of the vulgar which gets to the heart of the changing and deeply threatening way women were perceived by the dominant culture of mid-century America.

Writing much more recently and briefly about the Women, T. J. Clark has argued for the term "vulgar" as a way—and for him the best way—to describe and come to terms with Abstract Expressionism. While he focuses on its relationship to class, Clark allows for the gendered reading of the term and its impact on the subject of the Women:

> (...Greenberg's silence...was telling above all by contrast with the general run of journalism at the time, which took it for granted that, love 'em or hate 'em, the Women were Abstract Expressionism's truth.) What Greenberg was recoiling from, I think,

Woman, 1950

Lee Krasner
Bald Eagle, 1955
Oil, paper, and canvas collage on linen
77 x 51½ inches
Collection Mrs. Audrey Irmas

is the way in which choosing *Woman* as his subject allowed de Kooning to extrude a quality of perception and handling that stood at the very heart of his aesthetic, and fix it onto an Other, a scapegoat…. Only when de Kooning found a way to have the vulgarity be his own again—or rather, to half-project it onto cliché landscape or townscape formats, which were transparently mere props—did he regain the measure of meretriciousness his art needed…. What was wanted was generalized paranoia, not particular war of the sexes.[19]

Although clearly Lippard and Clark are speaking to different kinds of vulgar—Lippard referring to the handling of materials and the violence done to the figure and Clark using the term to situate Abstraction Expressionism in relationship to the class for which it was made—for both, the paintings' vulgarity is somehow inseparable from the subject of the woman. While Clark locates vulgarity with a heterosexual impulse, he makes the case with de Kooning for the woman, the Other, as the object of the artist's liberation. Lippard too speaks of the "raucous beauty-fiends of 1950–1954" as the apex of de Kooning's vulgarization of his abstraction. De Kooning's hubris seems to lie not only in his affront to the New York School doctrine, but in his direct confrontation with the elephant in the room: the newly empowered, if not fully liberated, American woman.

And the nagging particularities of the war of the sexes were in evidence everywhere. In 1953 Simone de Beauvoir's *The Second Sex* was translated into English and began to reach the broader American consciousness. As one testament to the "woman problem," the social sea change that was altering women's position in postwar culture, the book was taken seriously in intellectual circles yet slyly smirked at in the popular press. In a review published in *The*

New Yorker by Brendan Gill, the author manages to complement de Beauvoir on the timeliness of her study even as he winks at his (presumed to be male) reader, quibbling over the veritable "otherness" of the book's subject.[20] (As if referring to such critics, de Beauvoir later writes, "People offered to cure me of my frigidity or to temper my labial appetites."[21])

The most frequently cited evidence of de Kooning's engagement with the popular configuration of women's identity is his repeated use of collaged elements, specifically the mouths of women cut from a dizzying array of magazine representations of the modern woman. The discussion usually focuses on several key works including *Woman* (1950, plate 32) and *Marilyn Monroe* (1954) or types of women as exemplified by the iconic *Clam Diggers* (1963). The two earlier works each include famously excerpted magazine imagery—the so-called "T-zone" of the Camel girl and the pouty smile of Marilyn Monroe—while the later painting apparently draws on a series of well documented images of cavorting cheerleaders.[22]

In terms of the formal language of painting, what is remarkable in *Woman* is how contemporary everything about the rendering is and how it seems to problematize its subject in ways that reflect the newly feminized discourse of the time. What Lippard calls de Kooning's stylessness is not only his restless oscillation between figuration and abstraction, but the constant disruption of his own practice as both a style and a method of picturing. The aggression of his collaging and the insistent disruption of the picture plane are exercised on the figure with a kind of intensity and urgency that is unparalleled among de Kooning's abstractionist colleagues. Only Lee Krasner was perhaps his equal in this kind of free appropriation

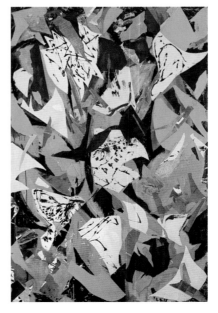

of already realized forms and materials. The making of templates of one figure, which are then traced onto the foundation of another as a way of initiating a deconstruction for which the brushstroke becomes the mechanism, was de Kooning's working method at the height of his production. The process of making an image by erasing, cutting, tracing, and in a sense negating what came before, clearly liberated the artist to move in all directions at once. In *Woman* for example, the legs and right arm are not only disjointed like the much tugged-at limbs of a doll, but they are painted in a way that separates them from the rest of the body and indeed the rest of the space of the painted composition. The figure seems to have two right arms that gesture wildly, cinematically altering the figure's pose. The brushy lower half of the body seems pasted over the painted quadrants of the background, which seem to imply de Kooning's frequent cutting and pasting but are, in this case, painted planes of color. The primitivist face that floats over the torso yields to the contemporary mask of the woman with the alluring, almond eyes and gleaming, pasted smile, which seems to burst through the chaotic brushwork like the Cheshire Cat's disembodied appearance in the trees above Alice's Wonderland. The body is loosely held together by the sharp edges inscribed where the artist has masked-off regions to work his material. Not until Gerhard Richter would there be another instance of a strategic preoccupation with different modes of painting and indeed different art histories concurrently inhabiting one work.

Much has been written about de Kooning's Women and their relationship to the European tradition of the female nude, with particular attention to the artist's certain ties to Picasso's Cubism and the confrontation with the brutalist *Les Desmoiselles d'Avignon* (1907).[23] Certainly many formal comparisons are possible and have been exhaustively labored elsewhere in the scholarship. However,

de Kooning's apparent interest in the generic female in her guise as the girl next door seems to reflect the popular media's obsession with the persistence of some stabilizing vision of woman that ran counter to what was actually going on with women in the increasingly contested zone of everyday American life. Though the history of women's liberation is much too extensive to elaborate here, one can say that de Kooning quite obviously appropriated a culturally established type. Perhaps rather than contributing to a history of oppressive representation of the female body, de Kooning can be seen as almost anthropologically attracted to the particularly American version of its construction. One reading of his use of space and architectonic framing might provide evidence of this. Lippard elaborates on the "no-environment" de Kooning's Women share with British painter Francis Bacon's Popes and isolated naked male wrestlers and Giacometti's attenuated sculptural figures who move in a stark landscape of existentialist solitude. Like de Kooning with his Women, Bacon arrived at the Pope as an iconic figure that would dominate his work from the late 1940s and early 50s and which, like the Women, was laden with European tradition and postwar existentialist angst. While

188

Francis Bacon
Study After Velasquez's Portrait of Pope Innocent X, 1953
Oil on canvas
60$^{1}/_{4}$ x 46$^{1}/_{2}$ inches
Purchased with funds from the Coffin Fine Arts Trust; Nathan Emory Coffin Collection of the Des Moines Art Center, 1980.1

Alberto Giacometti
Tall Figure II and *Tall Figure III,* both 1960
Bronze
109$^{1}/_{2}$ x 10$^{1}/_{2}$ x 21$^{3}/_{4}$ inches; and 93 x 10$^{3}/_{4}$ x 20$^{1}/_{2}$ inches
The Museum of Contemporary Art, Los Angeles
The Rita and Taft Schreiber Collection. Given in loving memory of her husband, Taft Schreiber, by Rita Schreiber

much more somber and perhaps disturbing than the almost kitschy parade of Women, the Popes combine "the great art of the past with the 'modernity' of a film strip."[24] They, like the Women, exist in a kind of spatial void, an airless, claustrophobic place where the remnants of art history's painted genres float, barely tethering the figures to an identifiable interior or a moment in time. Like de Kooning, Bacon acknowledged no connection to the interpretation of these images as bleak imaginings of contemporary life with its fluctuating morals and newly complicated personhood. For de Kooning, signs of domestic, pre-industrial life in the form of disjointed windows and truncated bridges, for example, float in the background of the Women, barely anchoring them to this side of pure abstraction. The lead-paned window that threatens to disappear under the gangly arm of *Woman* and the remnant of landscape that barely tethers her to the ground are token gestures at modes of painting de Kooning could intellectually engage in and dispense on his way to the figure. Thomas Hess was virtually alone among de Kooning's critics in viewing these disjointed bits of culture as signs of their times.[25]

Instead of seeing de Kooning's totemic Woman in terms of Picasso, to which she is undoubtedly indebted, her social milieu is less 1920s Paris than mid-century Madison Avenue. Take the striking image of Lauren Bacall (a woman hard to envisage as anything but sexy, single and tough as nails) on the cover of *Life Magazine* in 1953. She wears a Rudi Gernreich dress and stands practically astride her own young daughter who is perched like a trophy on top of a pillow on the floor. Hands on hips, legs spread, Bacall is the unapologetic image of the modern woman—glamorous, strong, yet never far from the domestic sphere. ("Just put 'em together and blow.") Often pictured in advertising as washing the floors in pearls, lipstick, and a flared skirt, the woman of the

1950s impossibly holds down the home front while wearing Rudi Gernreich—the designer famous for his liberating, topless bathing suit. De Kooning's Women of that period frequently strike a similar pose. Legs apart, arms planted anywhere but at the side, often dressed in brassy high heels and short skirts, his Women seem simply to ignore their blatant European heritage and declare themselves as complicated, hybridized beings.[26] Like the vision of the female realm represented in Grace Hartigan's *Grand Street Brides* (1954), which makes explicit the dispensability of one bridal costume for another, the then-disturbing notion of women occupying multiple cultural identities was symptomatic of what Stephen Polcari describes as the "assault on prewar morality": "The brutality of the war altered men and women's feelings about themselves, sex, and love. *Woman I* is not just an icon of desire but of human folly…an involuntary response to the recent experience of women as talismans, the wartime and GI obsession, Women and sex."[27]

Strangely there is little writing that takes a feminist stance, or takes on the Women at all, in the

Lauren Bacall in a Rudi Gernreich design, pictured with daughter Leslie in *Life*, April 1953. From the Rudi Gernreich Scrapbooks, 1950–1977, at The Fashion Institute of Design and Merchandising, Los Angeles

Grace Hartigan
Grand Street Brides, 1954
Oil on canvas
72 x 102½ inches
Collection of Whitney Museum of American Art, New York
Gift of anonymous donor

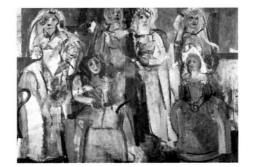

1970s. One has the impression that, like most great artists and works of art, de Kooning had cycled in and out of fashion for a brief time, and the artist himself devoted the later part of his career to a kind of lyrical abstraction that never elicited the same passionate critical response. In 1978 Sally Yard wrote one of a number of well-argued articles titled "Willem de Kooning's Women" which were devoted largely to formal analysis including, in 1981, an article in which she reintegrates the Women into a discussion of de Kooning's men. A scholar of Francis Bacon, Yard provides extremely helpful comparisons with de Kooning's European contemporaries and argues convincingly for his debt to Ingres and Soutine in addition to Picasso.[28] Thomas Hess, de Kooning's primary champion and mentor throughout the 1960s, wrote "Pinup and Icon," a 1972 article published in *Woman as Sex Object: Studies in Erotic Art, 1730–1970*, co-edited with Linda Nochlin.[29] What is interesting is that Hess turns out to be the most sympathetic of critics to de Kooning's disclaimers about his Women. Not unlike Ashton and Lippard, Hess is somehow able to allow for de Kooning's own declarations about the Women while finding an internal logic for them within the pictures themselves. For her part, Nochlin states in 1998 that "even their pneumatic bubble-gum pink breasts [suggest] a kind of armor against potential aggression…. I am not sure I can agree with any single evaluation of the 'Woman' series from the viewpoint of 'positive' or 'negative' gender representation. There is too much ambivalence here. And what, precisely, constitutes 'positive' or 'negative' when a cultural concept like 'woman' (in general) is at stake?"[30]

One text in which the cultural stakes are indeed high and the concept of gender representation is vehemently argued is "The MoMA's Hot Mamas" by Carol Duncan.[31] Written in 1989, this text is perhaps the only one in the de Kooning literature that is overtly feminist. Using MoMA as the example of high

patriarchy, Duncan attacks the institution and the hegemony it represents using the example of *Woman I* and its life as an institutionalized object. She argues for some curatorial breathing room for de Kooning's muse, looking first at its debut as a female icon in the context of Abstract Expressionism and tracing its movement through to the early 1980s reinstallation of the permanent collection in the museum's new addition. What is striking to me in re-reading this text is how passionately Duncan pleads with her reader for the negotiation of the meaning of this object, how moved she is by the work's materiality and presence. Clearly advocating by default the power of the figure and the power of the woman in art history, Duncan raises the specter of authority, which seemed so vital then yet is strangely absent in discussions of today's new figuration. What kind of image can rile us to action or shake our attention as profoundly as de Kooning's Women did at mid-century? Perhaps the answer lies in part in his magnificently fractured surfaces and enervated, even manic handling of paint. The Woman problem persists as a challenge, not only in terms of the quietly apolitical time in which we now find ourselves, but as an ongoing issue for painting and its history.

◆

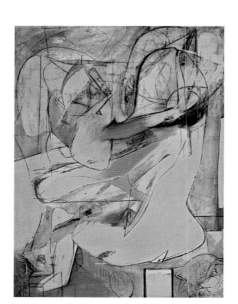

Pink Angels, c.1945
Oil and charcoal on canvas
52 x 40 inches
Frederick R. Weisman Art Foundation,
Los Angeles, California

butler

1 I refer to Laura Hoptman's 1997 exhibition, which included the work of John Currin, Elizabeth Peyton, and Luc Tuymans. The exhibition was a watershed in terms of an institutional acknowledgment of the recent return of figuration.

2 Carey Lovelace, "Lisa Yuskavage: Fleshed Out," *Art in America* 89, no. 7 (July 2001): 82, 83.

3 "The Question of Gender in Art," *Tema Celeste*, no. 37–38 (Autumn 1992): 54–73.

4 For a comprehensive survey of the critical literature on de Kooning's Women see David Cateforis, *Willem de Kooning's "Women" of the 1950s: A Critical History of Their Reception and Interpretation*, Ph.D. dissertation, Stanford University, 1991.

5 Quoted in Storm de Hirsch, "A Talk with De Kooning," *Intro Bulletin* 1 (October 1955): 1.

6 David Sylvester interview with de Kooning as published in "De Kooning's Women," *The Sunday Times Magazine* (London, 8 December 1968): 52. I am indebted to David Cateforis's text for this citation.

7 Calvin Tomkins, *Off the Wall: Robert Rauschenberg and the Art World of Our Time* (New York: Penguin Books, 1981), 96.

8 Ibid.

9 Cateforis, *Willem de Kooning's "Women" of the 1950s*, 46.

10 Hubert Crehan, "A See Change: Woman Trouble," *Art Digest* 27, no. 14 (15 April 1953): 5.

11 Clement Greenberg, "'American-Type' Painting" (1935), in *Affirmations and Refusals, 1950–1956*, vol. 3 of *Clement Greenberg: The Collected Essays and Criticism*, ed. John O'Brian (Chicago: The University of Chicago Press, 1993), 221–22. Originally published in *Partisan Review* (Spring 1955).

12 Cateforis, *Willem de Kooning's "Women" of the 1950s*, 18.

13 David Cateforis refers to "the woman problem" and cites William Henry Chafe, *The American Woman: Her Changing Social, Economic, and Political Roles, 1920–1970* (New York: Oxford University Press, 1972), 180–84.

14 Dore Ashton, "Art," *Arts & Architecture* 72, no. 12 (December 1955): 33.

15 Ibid., 34.

16 Lucy R. Lippard, "Three Generations of Women: De Kooning's First Retrospective," *Art International* 9, no. 8 (20 November 1965): 30.

17 Lucy Lippard, "Eccentric Abstraction," *Art International* (November 1966).

18 Ibid.

19 T. J. Clark, *Farewell to an Idea: Episodes from a History of Modernism* (New Haven, Conn.: Yale University Press, 1999), 393, 394.

20 Brendan Gill, "No More Eve," *The New Yorker* (28 January 1953): 97–99. Full of irony, the following typifies Gill's tone: As for women, maybe it is letting them off easy to describe them as the second sex, since to be one of a series, even of a series of two, implies a fitting relationship to something else, and everyone knows that women are really no more than what is left of the human race when men have been subtracted from it" (97).

21 Simone de Beauvoir, *Force of Circumstance* (1963; reprint, New York: Penguin Books, 1978). Quoted in de Beauvoir, *The Second Sex* (1953; reprint, New York: Vintage Books, 1989), vii.

22 See Richard Shiff, "Water and Lipstick: De Kooning in Transition," in *Willem de Kooning: Paintings*, exh. cat. (Washington, D.C.: National Gallery of Art; and New Haven: Yale University Press), 36–45.

23 For a thoughtful analysis of de Kooning's relationship to such painters as Ingres and Picasso, see Sally Yard, "Willem de Kooning's Women," *Arts Magazine* 53, no. 3 (November 1978): 96–101.

24 Sam Hunter, "An Acute Sense of Impasse," *Art Digest* 28 (15 October 1953): 16, as quoted in Hugh Davies and Sally Yard, *Bacon* (New York: Abbeville Press, 1986), 27.

25 See Thomas B. Hess, "De Kooning Paints a Picture," *Art News* 52, no. 1 (March 1953): 30–33, 64–67.

26 Stephen Polcari expands upon this idea of the continuum of art history and its quotability. He describes Elaine de Kooning's feeling that this was in the air in New York: "[de Kooning] abstained from the belief…that one could create art anew…. He felt that as an artist, he could not realistically go back to scratch, but merely to academy representationalism, which is in fact where he started…. Elaine recently described the feeling in the 1940s as a 'continuum' in which all past art was equally present. She noted that in New York in the 1940s there was the idea that avant-garde Paris no longer existed and that, uniquely in New York, all periods and kinds of art were equally available, perhaps for the first time in history. To her the feeling in the early 1940s anticipated Andre Malraux's concept of 'museums without walls.'" It seems to me that what Polcari reads as de Kooning's conservatism is, in fact, the beginning of a new and liberating way of viewing history that anticipates postmodernism. See Polcari, "Willem de Kooning: A Fever of Matter," *Abstract Expressionism and the Modern Experience* (New York: Cambridge University Press, 1991), 275.

27 Ibid., 287.

28 See Yard, "Willem de Kooning's Women," and her "Willem de Kooning's Men," *Arts Magazine* 56, no. 4 (December 1981): 134–143.

29 Hess, "Pinup and Icon." In *Woman as Sex Object: Studies in Erotic Art, 1730–1970*, eds. Hess and Linda Nochlin (New York: Newsweek, 1972), 222–237.

30 Linda Nochlin, "Painted Women," *Art in America* 86, no. 11 (November 1998): 111.

31 Carol Duncan, "The MoMA's Hot Mamas," *Art Journal* 48, no. 2 (Summer 1989): 171–78.

selected bibliography

With an emphasis on Willem de Kooning's works on paper, this bibliography includes writings about de Kooning's controversial images of women from the early 1950s, their critical reception at the time, and their subsequent place within art history.

Alloway, Lawrence. "Iconography Wreckers and Maenad Hunters." *Art International* 5, no.3 (5 April 1961): 32–34, 47.

———. "De Kooning: Criticism and Art History." *Artforum* 13, no.5 (January 1975): 46–50.

Ashton, Dore. "Willem de Kooning." In *Willem de Kooning: A Retrospective Exhibition from Public and Private Collections.* Exh. cat. Northampton, Mass.: Smith College Museum of Art, 1965.

———. "Art." *Arts and Architecture* 72, no.12 (December 1955): 10, 33–34.

Barber, Fionna. "De Kooning's 'Women' and the Performance of Femininity." *Make*, no.77 (September–November 1997): 14–18.

Barron, Stephanie. "De Kooning's *Woman*, ca.1952: A Drawing Recently Acquired by the Museum." *Los Angeles County Museum of Art Bulletin* 22 (1976): 66–72.

Brown, Lyvia Morgan. "Sexism in Western Art." In Jo Freeman, ed., *Women: A Feminist Perspective*, 309–22. Palo Alto, California: Mayfield Publishing Company, 1975.

Carmean, Jr., E. A. "Willem de Kooning: The Women." In Carmean, Eliza E. Rathbone, and Thomas B. Hess. *American Art at Mid-Century: The Subjects of the Artist*, 156–82. Exh. cat. Washington, D.C.: National Gallery of Art, 1978.

Cateforis, David Christos. *Willem de Kooning's "Women" of the 1950s: A Critical History of their Reception and Interpretation.* Ph.D. dissertation, Stanford University, 1991.

Coates, Robert M. "The Art Galleries: Exhibition of New Paintings by Willem de Kooning." *The New Yorker* 29, no.7 (4 April 1953): 96.

Crehan, Hubert. "A See Change: Woman Trouble." *Art Digest* 27 (15 April 1953): 5.

Cummings, Paul. "The Drawings of Willem de Kooning." In *Willem de Kooning: Drawings, Paintings, Sculpture*, 11–23. Exh. cat. New York: Whitney Museum of American Art, 1983.

De Kooning, Willem. "The Renaissance and Order" (1950). For a lecture series at Studio 35 on Eighth Street in New York, reprinted in *Trans/formation* 1, no.2 (1951): 85–87.

———. "What Abstract Art Means to Me: Statements by Six American Artists." *The Museum of Modern Art Bulletin* 18, no.3 (Spring 1951): 4–8.

De Kooning: The Women. Works on Paper, 1947–1954. Exh. cat. New York: C & M Arts, 1995.

"De Kooning's Masterwork: *Women* of 1950–55." *Time* 93, no.10 (7 March 1969): 61.

Duncan, Carol. "The MoMA's Hot Mamas." *Art Journal* 48, no.2 (Summer 1989): 171–78.

[Eliot, Alexander]. "Big City Dames." *Time* 61, no.14 (6 April 1953): 80.

Faison, Jr., S. Lane. "Art: Exhibition at the Sidney Janis Gallery." *The Nation* 176, no.16 (18 April 1953): 334.

Fitzsimmons, James. "Art" [review of exhibition at Sidney Janis Gallery]. *Arts and Architecture* 70, no.5 (May 1953): 4, 6–10.

Gage, Otis. "The Reflective Eye: The Success of the Failure." *Art Digest* 27, no.14 (15 April 1953): 4.

Gaugh, Harry F. "The Women." In *Willem de Kooning*, 44–53. New York: Abbeville Press, 1983.

Geist, Sidney. "Work in Progress." *Art Digest* 27, no.13 (1 April 1953): 15.

Glimcher, Mildred. "De Kooning/Dubuffet: The Women." In *Willem de Kooning, Jean Dubuffet: The Women*, 7–33. Exh. cat. New York: The Pace Gallery, 1990.

Goodman, Merle. *"Woman" Drawings by Willem de Kooning.* Exh. cat. Buffalo, New York: James Goodman Gallery, 1964.

Greenberg, Clement. "'American-Type' Painting." In *Affirmations and Refusals, 1950–1956*, vol.3 of *Clement Greenberg: The Collected Essays and Criticism*, ed. John O'Brian, 217–36. Chicago: The University of Chicago Press, 1993.

Hess, Thomas B. "De Kooning Paints a Picture." *Art News* 52, no.1 (March 1953): 30–33, 64–67.

———. *Willem de Kooning: Drawings.* Greenwich, Conn.: New York Graphic Society Ltd., 1972.

———. "De Kooning's new Women." *Art News* 64, no.1 (March 1965): 36–38, 63–65.

———. "Pinup and Icon." In Hess and Linda Nochlin, eds., *Woman as Sex Object: Studies in Erotic Art, 1730–1970*, 222–37. New York: Newsweek, 1972.

Larson, Philip. "De Kooning's Drawings." In Larson and Peter Schjeldahl, *De Kooning: Drawings/Sculptures.* Exh. cat. Minneapolis: Walker Art Center, 1974.

Leja, Michael. *Reframing Abstract Expressionism: Subjectivity and Painting in the 1940s.* New Haven, Conn.: Yale University Press, 1993.

Lippard, Lucy R. "Three Generations of Women: De Kooning's First Retrospective." *Art International* 9, no.8 (20 November 1965): 29–31.

Mathews, Cathie. "Acts of Aggression, Acts of Obsession: A Feminist Perspective on Willem de Kooning's Woman Series, 1930–1970." In *Women's Power and Roles as Portrayed in Visual Images of Women in the Arts and Mass Media.* Valerie Malhotra Bents and Philip E. F. Mayes, eds. Lewiston, New York: The Edwin Mellen Press, 1993.

McBride, Henry. "Abstract Report for April. Three Americans: De Kooning, Tobey, Tomlin; Two Europeans: Manessier, Sutherland." *Art News* 52, no.2 (April 1953): 16–18, 47.

Paulson, Ronald. *Figure and Abstraction in Contemporary Painting.* New Brunswick, N.J.: Rutgers University Press, 1990.

Picasso's Dora Maar, de Kooning's Women. Exh. cat. New York: C&M Arts, 1998.

Polcari, Stephen. "William [*sic*] De Kooning: A Fever of Matter." In *Abstract Expressionism and the Modern Experience*, 263–300. Cambridge: Cambridge University Press, 1991.

Pollock, Griselda. "Killing Men and Dying Women: A Woman's Touch in the Cold Zone of American Painting in the 1950s." In Fred Orton and Griselda Pollock, *Avant-gardes and Partisans Reviewed*, 219–94. Manchester: Manchester University Press, 1996.

Rosenblum, Robert. "The Fatal Women of Picasso and de Kooning." *Art News* 84, no. 8 (October 1985): 98–103.

Sawyer, Kenneth B. "Three Phases of Willem de Kooning." *Art News and Reviews* (London) 10, no. 22 (22 November 1958): 4–16.

Shapiro, David, and Cecile Shapiro, eds. *Abstract Expressionism: A Critical Record.* Cambridge: Cambridge University Press, 1990.

Schimmel, Paul. "The Women." In *The Figurative Fifties: New York Figurative Expressionism*, 53–56. Exh. cat. Newport Beach, Calif.: Newport Harbor Art Museum, 1988.

Sylvester, David. "De Kooning's Women: Interview with Willem de Kooning." In *Ramparts* 7, no. 71 (1969). Reprinted in David Shapiro and Cecil Shapiro, eds. *Abstract Expressionism: A Critical Record*, 225–28. Cambridge: Cambridge University Press, 1990.

Tillim, Sidney. "The Figure and the Figurative in Abstract Expressionism." *Artforum* 4, no.1 (September 1965): 45–48.

Willem de Kooning: Works from 1951–1981. Exh. cat. East Hampton, New York: Guild Hall Museum, 1981.

Yard, Sally. "Willem de Kooning's Women." *Arts Magazine* 53, no. 3 (November 1978): 96–101.

———. *Willem de Kooning: The First Twenty-Six Years in New York, 1927–1952.* Ph.D. dissertation, Princeton University, 1980.

COMPILED BY REBECCA MORSE

193

checklist

Reclining Nude (Juliette Brauner), c.1938
Pencil on paper
10 1/4 x 12 3/4 inches
Collection Courtney Ross Holst
plate 1

Elaine de Kooning, c.1940–41
Pencil on paper
12 1/4 x 11 7/8 inches
Private collection
Courtesy Allan Stone
Gallery, New York
plate 4

Portrait of a Woman, c.1940
Pencil on paper
16 1/2 x 11 inches
Collection Courtney Ross Holst
plate 3

Seated Woman, c.1940
Pencil on paper
11 1/2 x 8 7/8 inches
Collection Penny Pritzker and
Dr. Bryan Traubert, Chicago
Courtesy Thea Westreich Art
Advisory Services, New York
plate 2

Seated Woman, c.1941
Pencil on paper
7 x 5 inches
Private collection
Courtesy Allan Stone
Gallery, New York
plate 6

Woman, 1941
Pencil on paper
6 7/8 x 4 3/4 inches
Collection Mr. and Mrs.
Harry S. Parker
plate 5

Woman, c.1942
Pencil on vellum
11 13/16 x 12 5/16 inches
Private collection
plate 8

Seated Woman, c.1943
Pencil on paper
15 1/2 x 12 inches
Collection Mrs. Elizabeth M.
Petrie
plate 7

Still Life, c.1945
Pastel and pencil on paper
13 3/8 x 16 1/4 inches
Collection Frederick R.
Weisman Art Foundation,
Los Angeles, California
plate 12

Study for Backdrop, 1945
Pastel and pencil on paper
9 3/4 x 10 inches
Collection Ambassador and
Mrs. Donald Blinken, New York
plate 11

Study for "Pink Angels," 1945
Pastel and pencil on paper
12 x 13 7/8 inches
Private collection
Courtesy Allan Stone
Gallery, New York
plate 9

Untitled, c.1945
Pencil on paper
18 x 23 inches
Private collection
plate 10

Fire Island, 1946
Oil on paper
19 1/2 x 27 1/2 inches
Collection Martin Margulies
plate 13

Two Figures, c.1946–47
Oil, charcoal, colored chalk,
and pencil on paper
10 1/2 x 12 1/4 inches
Private collection
plate 18

Pink Angel, 1947
Oil on paper
10 x 15 inches
Private collection
plate 19

Seated Nude (Portrait of Elaine), c.1947–49
Pencil on paper
11 1/2 x 8 3/4 inches
Collection Nancy Ellison and
William D. Rollnick
plate 29

Untitled, 1947
Oil on paper
20 x 16 inches
Collection Samuel and Ronnie
Heyman, New York
plate 16

Untitled, c.1947
Charcoal and oil on paper
12 5/8 x 18 3/4 inches
Private collection
plate 15

Untitled, 1947
Oil, pastel, and charcoal
on paper
17 1/8 x 20 1/4 inches
Private collection
plate 17

Untitled (Two Figures), c.1947
Oil, watercolor, charcoal,
and graphite on paper
22 1/2 x 22 inches
Fine Arts Museums of San
Francisco, Achenbach
Foundation for Graphic Arts,
Museum Purchase
Gift of Mrs. Paul L. Wattis,
1999.131
plate 14

Asheville, 1948
Oil and enamel on cardboard
25 9/16 x 31 7/8 inches
The Phillips Collection,
Washington, D.C.
plate 24

Mailbox, 1948
Oil, enamel, and charcoal on
paper mounted on board
23 1/4 x 30 inches
The Donald L. Bryant, Jr. Family
Art Trust
plate 23

Pink Lady (Study), c.1948
Oil on paper mounted on
masonite
18 1/2 x 18 1/2 inches
Collection Ambassador and
Mrs. Donald Blinken
plate 21

Untitled Study (Women), c.1948
Oil, crayon, and graphite
on paper
21 x 32 1/8 inches
Frances Lehman Loeb Art
Center, Vassar College,
Poughkeepsie, New York
Gift of Mrs. Richard Deutsch
(Katherine W. Sanford,
class of 1940), 1953.2.6
plate 20

Untitled (Three Women), c.1948
Oil and crayon on paper
20 x 26 3/8 inches
Frances Lehman Loeb Art
Center, Vassar College,
Poughkeepsie, New York
Gift of Mrs. Richard Deutsch
(Katherine W. Sanford,
class of 1940), 1953.2.5
plate 22

Figure, 1949
Oil on cardboard
18 3/8 x 14 1/2 inches
The Cleveland Museum of Art,
Contemporary Collection of
The Cleveland Museum of Art,
1964.1
plate 27

Two Women, 1949
Oil on paper mounted on board
16 x 19 3/4 inches
Beatrice and Philip Gersh
Collection
plate 30

Two Women on a Wharf, 1949
Oil, enamel, pencil, and collage
on paper
24 7/16 x 24 9/16 inches
Collection, Art Gallery of
Ontario, Toronto. Purchase,
Membership Endowment
Fund, 1977
plate 31

Untitled, 1949
Black enamel on reverse side
of sheet of Bruning graph paper
21 7/8 x 29 7/8 inches
Sophie M. Friedman Fund
Courtesy, Museum of Fine Arts,
Boston
plate 25

Warehouse Manikins, 1949
Oil and enamel on buff paper,
mounted on cardboard
24 1/4 x 34 5/8 inches
Collection Mr. and Mrs.
Bagley Wright
plate 26

Woman, c.1949–53
Pencil and gesso on paper
12 5/8 x 8 5/8 inches
Private collection
plate 28

Two Nude Figures, 1950
Graphite and black crayon
on heavy cream paper
19 x 22 inches
Fogg Art Museum,
Harvard University Art Museums,
Gift of Lois Orswell
plate 34

Two Women, 1950
Pencil on paper
8 x 8^7/8 inches
Collection Mr. and
Mrs. David Pincus, Wynnewood,
Pennsylvania
plate 33

Two Women, c.1950–51
Pencil and crayon on paper
19 x 14 inches
Collection Adriana and
Robert Mnuchin
plate 40

Woman [verso: *Woman*], 1950
Graphite on paper
12^3/4 x 9^1/2 inches
Collection Constance R.
Caplan, Baltimore, Maryland
plate 35

Woman, 1950
Oil, cut and pasted paper
on cardboard
14^3/4 x 11^5/8 inches
The Metropolitan Museum of
Art, From the Collection of
Thomas B. Hess, Gift of the
heirs of Thomas B. Hess, 1984
plate 32

Woman, c.1950
Pastel, charcoal, pencil,
and collage
23^1/2 x 17^3/4 inches
Private collection,
Beverly Hills, California
plate 38

Woman, Wind, and Window II,
1950
Oil and enamel on paper,
mounted on board
16^1/2 x 20 inches
Private collection
plate 36

Untitled, 1950–51
Sapolin enamel on graph paper
22 x 30 inches
National Gallery of Art,
Washington, D.C.
Gift of the Woodward Foundation,
Washington, D.C., 1976
plate 37

Reclining Woman, 1951
Pencil on paper
8^7/8 x 11^3/4 inches
Collection Wilder Green
plate 43

*Study for "Marilyn Monroe,"*1951
Pastel and pencil on paper
16^3/4 x 9^{11}/16 inches
Collection John and Kimiko
Powers, Carbondale, Colorado
plate 39

Two Women, 1951
Pastel on paper
21^1/2 x 17^1/2 inches
Collection Steve Martin
plate 41

Two Women, c.1951
Pencil on paper
14 x 17 inches
Collection Carol Selle
plate 44

Woman, 1951
Pencil on paper
12 x 9^5/8 inches
Collection Charlotte and
Duncan MacGuigan
plate 42

Woman, 1951
Charcoal and pastel on paper
21^1/2 x 16 inches
Collection Kathy and
Richard S. Fuld, Jr.
plate 47

Woman, c.1951
Pencil on paper
11^5/8 x 7^1/4 inches
Private collection
plate 46

Woman, 1951–52
Pastel, crayon, and graphite
on paper
13^1/2 x 10^3/8 inches
Private collection
plate 48

Woman, c.1951
Graphite on paper
12^1/2 x 9^1/2 inches
Schorr Family Collection, on
long-term loan to The Art
Museum, Princeton University
plate 45

Seated Woman, 1952
Pastel, pencil, and oil on
two hinged sheets of paper
12 x 9^1/2 inches
The Museum of Modern Art,
New York, The Lauder
Foundation Fund 33.75
plate 51

Study for "Woman," 1952
Charcoal and gouache on
tracing paper
36^1/2 x 23^1/2 inches
Collection Milly and
Arne Glimcher
plate 55

Study for "Woman I," 1952
Pastel, crayon, and graphite
on paper
9 x 11^1/4 inches
National Gallery of Art,
Washington, D.C.; Andrew W.
Mellon Fund, 1978
plate 52

Study for "Woman I," 1952
Graphite and pastel on
wove paper
12^1/8 x 11^1/2 inches
National Gallery of Canada,
Ottawa
plate 50

Study for "Woman VI," 1952
Pastel, charcoal, and pencil on
tracing paper
22^3/4 x 18^1/2 inches
Hirshhorn Museum and
Sculpture Garden, Smithsonian
Institution, Gift of Joseph H.
Hirshhorn, 1966

plate 49
Three Women, 1952
Pencil on paper
14 x 16^3/4 inches
Collection Stephen and
Barbara McMurray
plate 58

Torsos, Two Women,
c.1952–53
Pastel on paper
18^7/8 x 24 inches
The Art Institute of Chicago,
Joseph H. Wrenn Memorial
Collection, 1955.637
plate 70

Two Women, 1952
Pencil and pastel on paper
12^3/4 x 12^3/4 inches
Collection Richard and
Mary L. Gray
plate 66

Two Women, 1952
Charcoal on paper
22 x 29 inches
Collection Robert and Jane
Meyerhoff, Phoenix, Maryland
plate 63

Two Women, 1952
Pencil, charcoal, and pastel
on vellum
21^1/2 x 29^1/8 inches
Collection John and Kimiko
Powers, Carbondale, Colorado
plate 57

Two Women II, c.1952
Graphite and colored pencil
on paper
14^1/4 x 15^3/4 inches
Private collection
plate 65

Two Women III, 1952
Pastel, charcoal, and graphite
pencil on heavy white
machine-made paper
14^3/4 x 18^1/2 inches
Allen Memorial Art Museum,
Oberlin College, Oberlin, Ohio
Friends of Art Fund, 1957
plate 67

Two Women IV, 1952
Graphite, colored chalk,
charcoal, and gouache
on paper
16^1/2 x 20^1/4 inches
Private collection
plate 68

Two Women with Still Life, 1952
Pastel on paper
22^1/2 x 24 inches
The Museum of Contemporary
Art, Los Angeles. Bequest of
Marcia Simon Weisman
plate 64

195

Untitled (Two Figures), 1952
Pencil on paper
8^1/$_2$ x 11 inches
Private collection
plate 62

Woman, c. 1952
Pastel, graphite, and charcoal
on paper
14^3/$_8$ x 12^1/$_8$ inches
Los Angeles County Museum
of Art, Purchased with funds
provided by the estate of David
E. Bright, Paul Rosenberg and
Co., and Lita A. Hazen
plate 54

Woman, 1952
Charcoal and pastel on paper
29^1/$_8$ x 19^5/$_8$ inches
Musée national d'art moderne,
Centre National d'Art
et de Culture Georges
Pompidou, Paris
Attribution de l'état, 1976 (P)
plate 56

Woman, c. 1952
Graphite and pencil on paper
14^3/$_4$ x 11^1/$_2$ inches
Musée national d'art moderne,
Centre National d'Art
et de Culture Georges
Pompidou, Paris
plate 61

Woman, 1952
Pastel and pencil on paper
21 x 14 inches
Collection Thom Weisel and
Emily Carroll
plate 59

Woman, c. 1952
Pastel and graphite on paper
13^1/$_2$ x 10^5/$_{16}$ inches
Collection Walker Art Center,
Minneapolis. Donated by
Mr. and Mrs. Edmond R. Ruben,
1995
plate 53

Women Seated and Standing,
1952
Pastel and charcoal on paper
21^5/$_8$ x 24^3/$_8$ inches
Private collection
plate 69

Woman (Seated Woman I),
1952
Pastel on paper
11^1/$_3$ x 7^3/$_4$ inches
Mr. and Mrs. Sherman H. Starr,
Boston, Massachusetts
plate 60

Two Women, 1953
Oil on paper mounted on
canvas
21^7/$_8$ x 28^1/$_2$ inches
Private collection/
Courtesy Richard Gray Gallery,
Chicago/New York
plate 71

Woman, 1953
Oil and charcoal on paper
mounted on canvas
25^5/$_8$ x 19^5/$_8$ inches
Hirshhorn Museum and
Sculpture Garden, Smithsonian
Institution, Gift of Joseph H.
Hirshhorn, 1966
plate 72

Woman, 1953
Charcoal on paper
36 x 23^1/$_2$ inches
Collection Michael and Judy
Steinhardt, New York
plate 75

Woman (Blue Eyes), 1953
Oil and crayon on paper
28 x 20 inches
Collection Samuel and Ronnie
Heyman, New York
plate 73

Monumental Woman, 1954
Charcoal on paper
28^5/$_8$ x 22^1/$_2$ inches
Private collection
plate 74

Two Women, 1954
Pastel, charcoal, and pencil
on paper
14^3/$_4$ x 14^1/$_2$ inches
Courtesy of Richard Gray
Gallery, Chicago/New York
plate 77

Two Women, 1954
Pastel, charcoal, and
pencil on paper
21^5/$_8$ x 26^1/$_4$ inches
Collection Jon and Mary Shirley
plate 76

Figure in Interior, 1955
Pastel on paper
26^1/$_2$ x 33^1/$_4$ inches
Private collection
plate 78

lenders to the exhibition

Allen Memorial Art Museum, Oberlin College, Oberlin, Ohio
Art Gallery of Ontario, Toronto
The Art Institute of Chicago
The Art Museum, Princeton University
Ambassador and Mrs. Donald Blinken, New York
The Donald L. Bryant, Jr. Family Art Trust
Constance R. Caplan, Baltimore, Maryland
The Cleveland Museum of Art
Nancy Ellison and William D. Rollnick
Fine Arts Museums of San Francisco, Achenbach Foundation for
 Graphic Arts
Fogg Art Museum, Harvard University Art Museums
Frances Lehman Loeb Art Center, Vassar College,
 Poughkeepsie, New York
Kathy and Richard S. Fuld, Jr.
Beatrice and Philip Gersh
Milly and Arne Glimcher
Richard and Mary L. Gray
Richard Gray Gallery, Chicago/New York
Wilder Green
Samuel and Ronnie Heyman, New York
Hirshhorn Museum and Sculpture Garden,
 Smithsonian Institution
Courtney Ross Holst
Los Angeles County Museum of Art
Charlotte and Duncan MacGuigan
Martin Margulies
Steve Martin
Stephen and Barbara McMurray
The Metropolitan Museum of Art
Robert and Jane Meyerhoff, Phoenix, Maryland
Adriana and Robert Mnuchin
Musée national d'art moderne,
 Centre national d'art et de culture Georges Pompidou, Paris
The Museum of Contemporary Art, Los Angeles
Museum of Fine Arts, Boston
The Museum of Modern Art, New York
National Gallery of Art, Washington, D.C.
National Gallery of Canada, Ottawa
Mr. and Mrs. Harry S. Parker
Elizabeth M. Petrie
The Phillips Collection, Washington, D.C.
Mr. and Mrs. David Pincus, Wynnewood, Pennsylvania
John and Kimiko Powers, Carbondale, Colorado
Penny Pritzker and Dr. Bryan Traubert, Chicago
Private collection
Private collection, Beverly Hills, California
Schorr Family Collection
Carol Selle
Jon and Mary Shirley
Mr. and Mrs. Sherman H. Starr, Boston Massachusetts
Michael and Judy Steinhardt, New York
Allan Stone Gallery, New York
Walker Art Center, Minneapolis, Minnesota
Thom Weisel and Emily Carroll
Frederick R. Weisman Art Foundation, Los Angeles, California
Mr. and Mrs. Bagley Wright

197

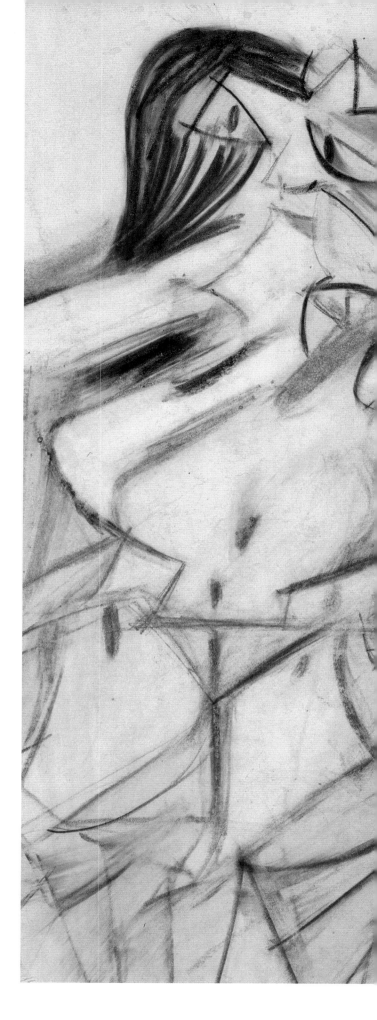

acknowledgments

Beginning in 1996, with the gift of Marcia Simon Weisman's monumental collection of works on paper, MOCA has increasingly emphasized the acquisition and exhibition of drawings. As a collector of contemporary art who later specialized in works on paper, Marcia Simon Weisman was passionate about the work of living artists and committed to American art of the postwar period. At the core of her bequest of eighty-three works on paper are outstanding drawings by mid-century artists Arshile Gorky, Jackson Pollock, Mark Rothko, and Clyfford Still, as well as Willem de Kooning's astounding *Two Women with Still Life* (1952). Perhaps more than any other, this drawing represents what Weisman understood about great works on paper. Drawings can express as much or more about an artist's fundamental inspirations and struggles than "finished" or primary works in other media. Many are of critical significance not only to an artist's career but to the history of art. De Kooning's *Two Women with Still Life* is such a work, and we have chosen to build an exhibition around it both as a way to contextualize it and to expand the scholarship and audience for our permanent collection and its great treasures of contemporary art. No previous exhibition has focused exclusively on de Kooning's drawings of women from the 1940s and 50s.

The fundamental importance of de Kooning's work lies in his ongoing commitment to figuration through the female form, and his sheer brilliance in handling materials and process. For this exhibition, we have chosen to focus on the period between 1938 and 1955 to trace the evolution of the figure—from the delicately drawn, graphite portraits of the artist's wife Elaine de Kooning, to painted abstractions that mix elements from genres including landscape and still life with fragments of the figure, to the early 1950s drawings of two and three women with their lurid pastel colors and bold contours. Gathered here are seventy-eight carefully selected works representing the artist's evolution and struggle with a vocabulary that is simultaneously figurative and abstract.

An exhibition of such historical significance is only possible with the assistance and commitment of a great many people. From the MOCA staff we thank Director Jeremy Strick, who contributed significantly by encouraging loans to the exhibition and was instrumental in negotiations with participating venues. As well we are grateful to our curatorial colleagues for their support of this project from its inception. The exhibition could not have been realized without the exceptional assistance of Curatorial Assistant Rebecca Morse, a wonderful colleague and tireless organizer whose work is always outstanding. Former Curatorial Intern Jennifer Brown provided invaluable research assistance in the early stages of the project. Manager of Exhibition Programs and Curatorial Affairs Stacia Payne was instrumental in negotiations with our colleagues at each venue and, as always, provided tremendous support at every stage of exhibition planning. Our wonderful and diligent Senior Editor Lisa Mark worked assiduously with our co-publisher, Princeton University Press, to create an important and meaningful document of the exhibition. Editor Jane Hyun and Assistant Editor Elizabeth Hamilton offered invaluable assistance at all stages of the book's development. Tracey Shiffman's beautiful design reflects both de Kooning's history and the contemporary resonance of his work, and she was a pleasure to work with, as always. Chief Registrar Robert Hollister and Assistant Registrar Karen Hanus were instrumental in securing loans and making shipping arrangements to ensure the safe handling of these valuable works. Director of Development Paul Johnson was an enthusiastic supporter of the exhibition and secured critical support for it. We are grateful to Exhibitions Production Manager Brian Gray and his staff for orchestrating a smooth and handsome installation.

In preparing the tour, it has been a pleasure to work with our colleagues at the National Gallery of Art and the San Francisco Museum of Modern Art. We thank Director Earl Powell, Deputy Director and Chief Curator Alan Shestack, and Chief of Exhibitions Dodge Thomson in Washington. We would also like to extend special thanks to Curator of Twentieth-Century Prints and Drawings Ruth Fine for her commitment to this exhibition. In San Francisco we have worked closely with Co-Acting Director Ruth Berson, Curator of Painting and Sculpture Janet Bishop, as well as Madeleine Grynsztejn, the Elise S. Haas Curator of Painting and Sculpture. We are delighted and honored that the itinerary for "Tracing the Figure" includes these prestigious institutions.

A historical exhibition such as this often relies on the diligence of dedicated people who are critical in locating important works as they change hands over the years. For their support and assistance we thank Amy Schichtel and Roger Anthony at the Willem de Kooning office. We hope our research will aid them in maintaining the legacy of this great artist. As well, Allan Stone has been a key supporter of this project since its inception. Others who have worked with the de Kooning material for years and who provided valuable insight and assistance include Mike Goldberg, Matthew Marks, Lucy Mitchell-Innes, and Jill Weinberg. We are deeply grateful for Robert Mnuchin's boundless energy and love of this material. His generosity in sharing his own knowledge of the location of works was particularly helpful and greatly enhanced the overall quality of the exhibition. Numerous colleagues provided support at every stage of the project and we gratefully acknowledge their assistance: Neil Benezra, Tony Berlant, James Cuno, Larry Gagosian, Gary Garrels, Sherri Geldin, Richard Gray, Robert Flynn Johnson, William Lieberman, Duncan MacGuigan, Suzanne Folds McCullough, Helen Molesworth, Bob Monk, Linda Norden, Harry S. Parker, Laura Paulson, Bernice Rose, Nan Rosenthal, Mary Rozell, Stephen Sczepanek, Jonas Storáve, Bettina Sulser, Anne Temkin, Jo Wheeler, Billie Milam Weisman, Jennifer Yum, and Mary Zlot.

We are most indebted to the numerous lenders whose contributions made this exhibition possible; understandably it was not an easy decision for the owners of these beloved works on paper to let them be coaxed out of their hands. We deeply appreciate that they recognized the historical importance of this exhibition enough to part with them for awhile. In particular, an anonymous lender, Ambassador Blinken, Donald Bryant, Beatrice Gersh, Martin Margulies, and Thom Weisel loaned key pieces.

MOCA's outstanding Board of Trustees is always supportive of great exhibitions and particularly enthusiastic when those exhibitions contribute to the scholarship of the art of our time. In particular we acknowledge Lenore Greenberg and Beatrice Gersh who were founding trustees of MOCA, great friends of Marcia Simon Weisman, and committed collectors of drawings themselves. Their generous support has meant a great deal to us.

Finally, we are deeply grateful for the generous support of The Sydney Irmas Exhibition Endowment, Maria Hummer and Bob Tuttle, the National Endowment for the Arts, Genevieve and Ivan Reitman, Audrey M. Irmas, Beatrice and Philip Gersh, The Mnuchin Foundation, and Betye Monell Burton, as well as the Frederick R. Weisman Art Foundation for their assistance with the publication. Special thanks go to Wells Fargo for supporting the exhibition tour.

Cornelia H. Butler, Curator **Paul Schimmel**, Chief Curator